Ifengspace

LANDSCAPE
INSTALLATION
ART

II

BASHEER
GRAPHIC BOOKS

Contents

Chapter 2

Public Application **Facilities**

Chapter 3

Public Leisure **Facilities**

Public Activity **Facilities**

The Mobile Orchard

Design Firm: *Atmos Studio*

Real orchard trees donated by: *YouGarden and the Worshipful Company of Fruiterers*

Materials: *600 243×121cm sheets 4 mm Latvian birch plywood, 300 sheets 1,250 x 2,500 'Priplak' Polypropylene, 3 243×121cm sheets 1.2 mm aluminum, 90 m 12W/m IP65-rated LED strips, 22 3W IP65 LED spots, 160 hours CNC time*

Location: *London, the United Kingdom*

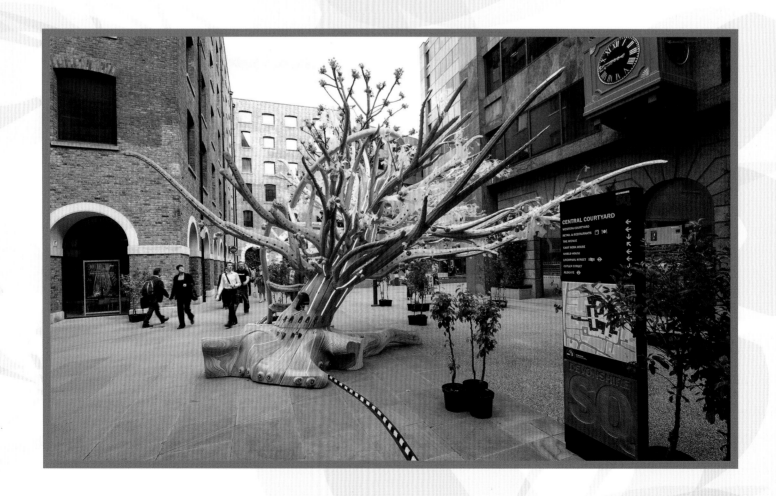

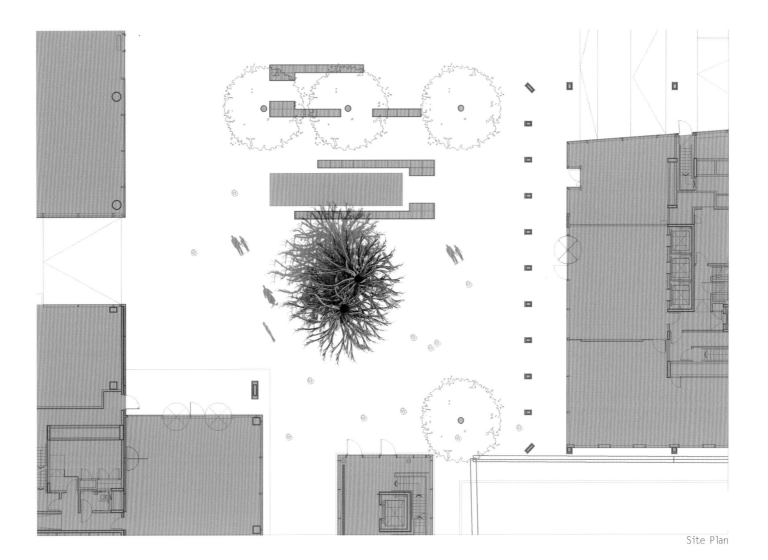

Site Plan

Summary

The Mobile Orchard is an inhabitable public art installation by atmos. It's a hymn to the urban fruit tree - a celebration of the 2013 theme set by its commissioners, the City of London Festival.

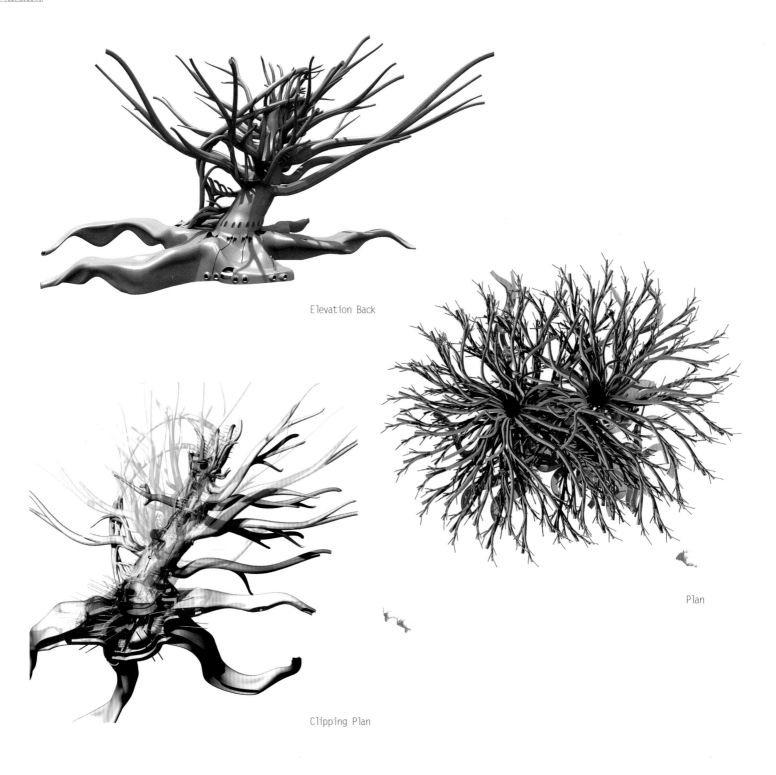

Elevation Back

Plan

Clipping Plan

Its exuberant design mutates the wonder of natural trees with a structure ergonomically tailored to humans, offering a labyrinth of complex and inviting spaces that seek to nourish all the senses - celebrating both the formal structures of nature, and the social structures of cities.

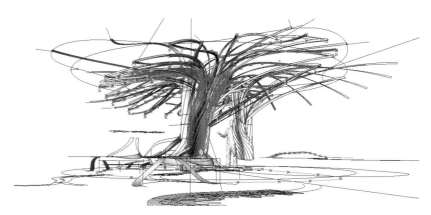

Early Design Drawing 1

It previewed in Paternoster Square before commencing a weekly journey that stopped at Devonshire Square, the Gherkin, and Finsbury Avenue Square.

The Cast

The Mobile Orchard centers on a sculptural timber oasis that doubles as immersive summer street furniture - morphing into seating, shelter, stairway and sky-throne. Its undulating roots offer a landscape for lounging, including sinuous benches and a molten armchair that cradle the gaze upwards through the hollow trunk.

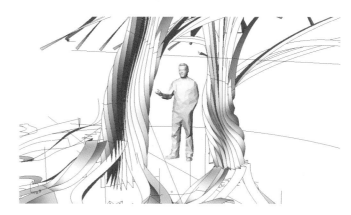

Early Design Drawing 2

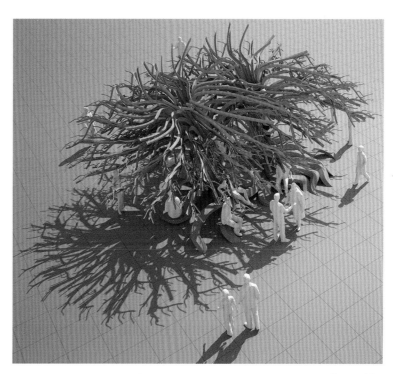

Perspective

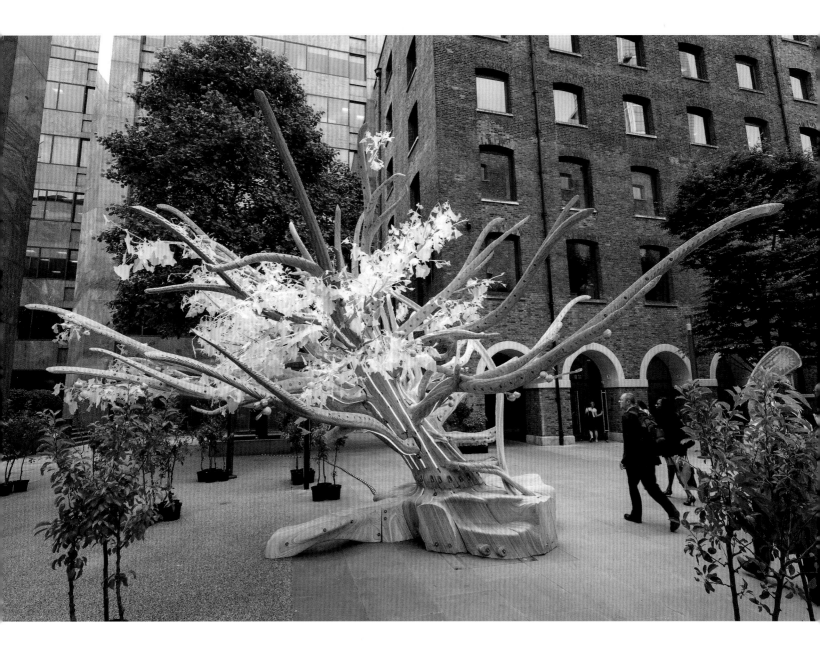

Massive branches worm outwards from a dramatically leaning trunk to offer further seats, splaying to form steps

that spiral upwards around the undulating trunk to a throne at the tip.

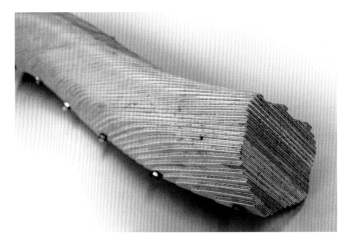
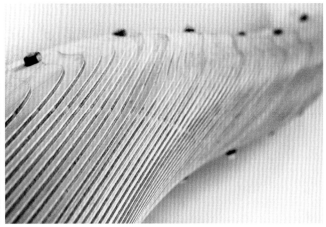

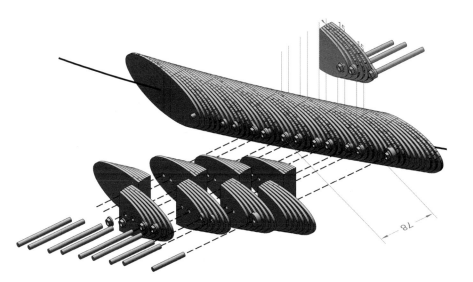

Trunk Partitions

Branch Partitions

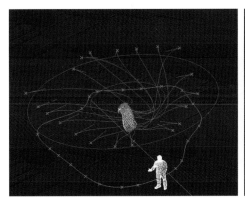
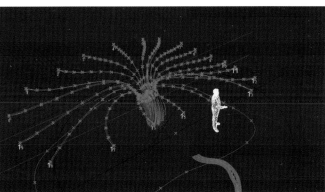

Early Design Drawing 3

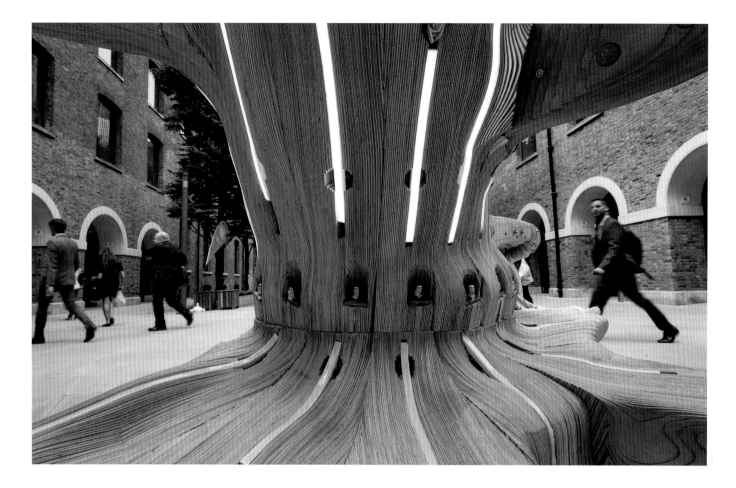

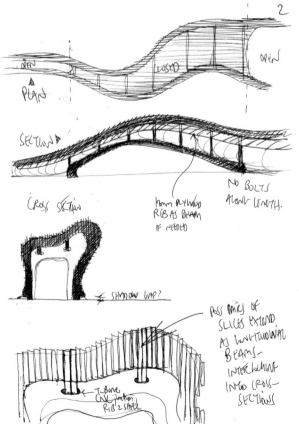

OPEN CLOSED OPEN

PLAN

SECTION A

CROSS SECTION

12mm PLYWOOD
RIB AS BEAM
IF NEEDED

NO BOLTS
ALONG LENGTH.

SHADOW GAP?

POSS BANDS OF
SLICES EXTEND
AS LONGITUDINAL
BEAMS-
INTERLOCKING
INTO CROSS-
SECTIONS

T-BONE
CNC Junction
RIB 2 SHELL

Trunk Base Roots Design Drawing 1

A lightweight latticework of curved and folded aluminium unfurls from the laminated plywood grains to support a canopy of laser cut leaves - each blade was cut in the shape of a local London borough, with the host borough further subdivided into wards - the blossom and seeds of the project. The branches cradle a constellation of Braeburn apples, refreshed as quickly as the local City workers can pluck and eat them.

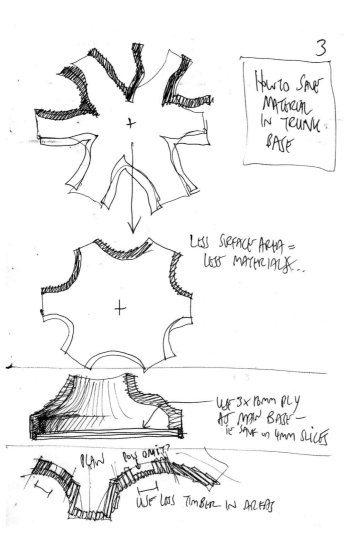

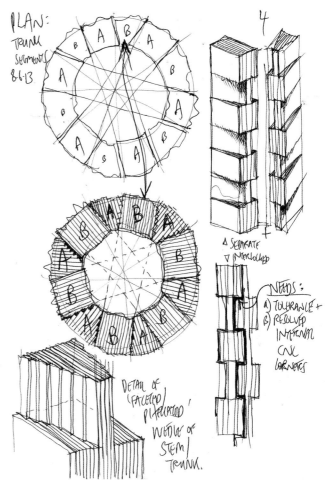

Trunk Base Roots Design Drawing 2

Trunk Base Roots Design Drawing 3

The trunk houses a miniature processor that illuminates its bark with glowing Xylem, waterproof LED veins uniting sky and soil, their sinuous lines graphically delineating the segments of the tree's core geometry, each terminating in a glowing spot of LED moon-light.

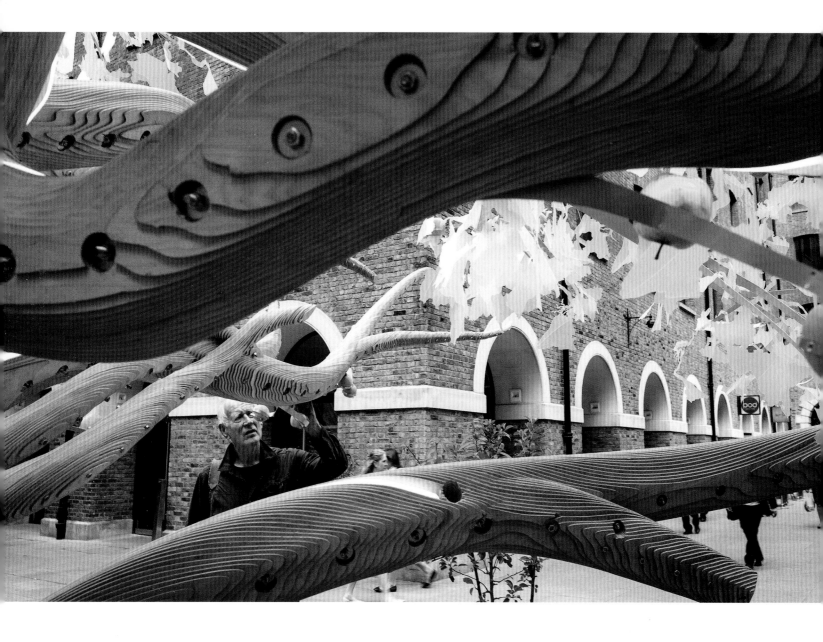

Overview

The design of the Mobile Orchard furthers atmos's ongoing investigations of natural forms, organic structures, experiential ergonomics, digital fabrication, and innovative public landscapes. It was parametrically designed using scripts and algorithms that explore the mathematical rules of growth so brilliantly exemplified by nature, enabling an unprecedented level of highly-resolved complexity.

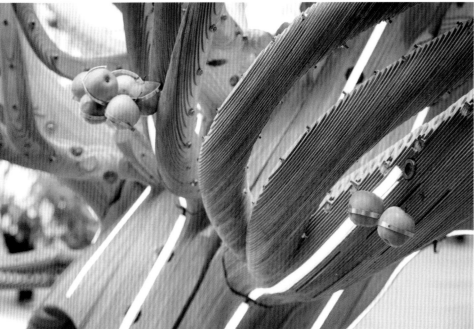

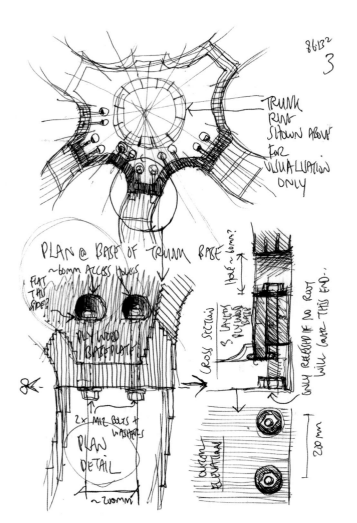

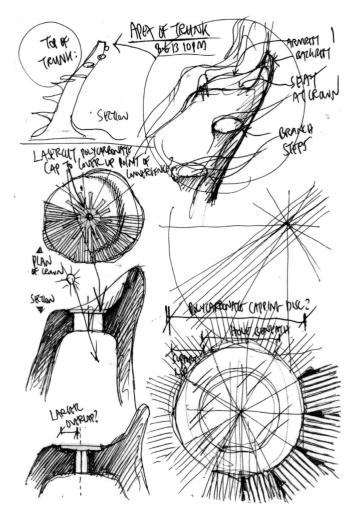

Trunk Base Roots Design Drawing 4

Trunk Base Roots Design Drawing 5

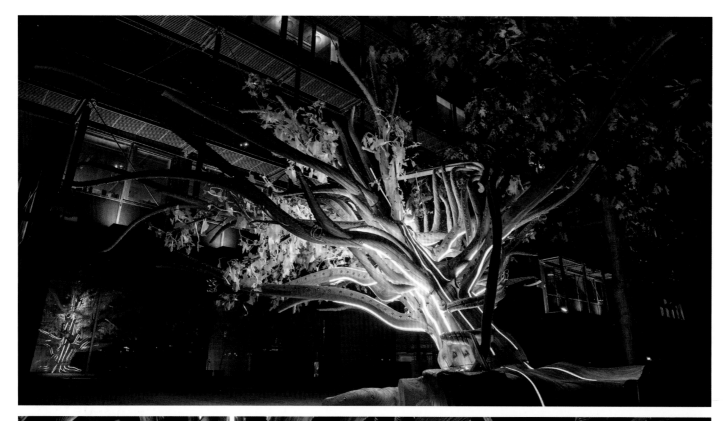

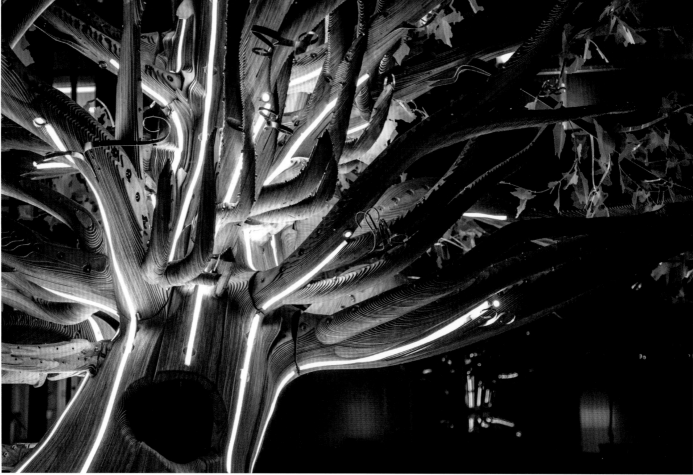

In homage to the surfaces of its modernist host borough, the design originally proposed lightweight interlocking laser cut steel sheets, using curved folds to economically achieve large spans. The evolution on towards a plywood solution developed for reasons of both cost and comfort, offering a warmer and more welcoming series of surfaces for the public to enjoy; the design of the secondary branches retains the only trace of the original curved-fold sheet metal design.

Though natural in form, the project is centrally about people and interaction, collectivity - and cities. Its forms ape humans, moulded to their bodies, mirroring their movements. Its branches offer its visitors food, and hosted a range of eating events - a core interest of the studio, whose director created Latitudinal Cuisine and Global Feast for the Olympics, merging design with fine-dining in the aspiration to stimulate both mind and body.

 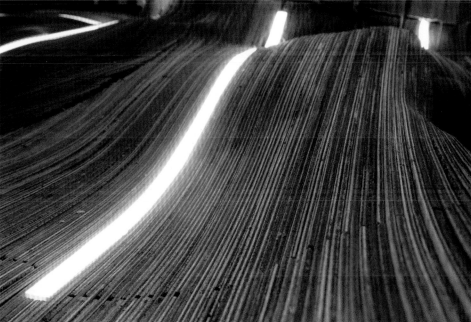

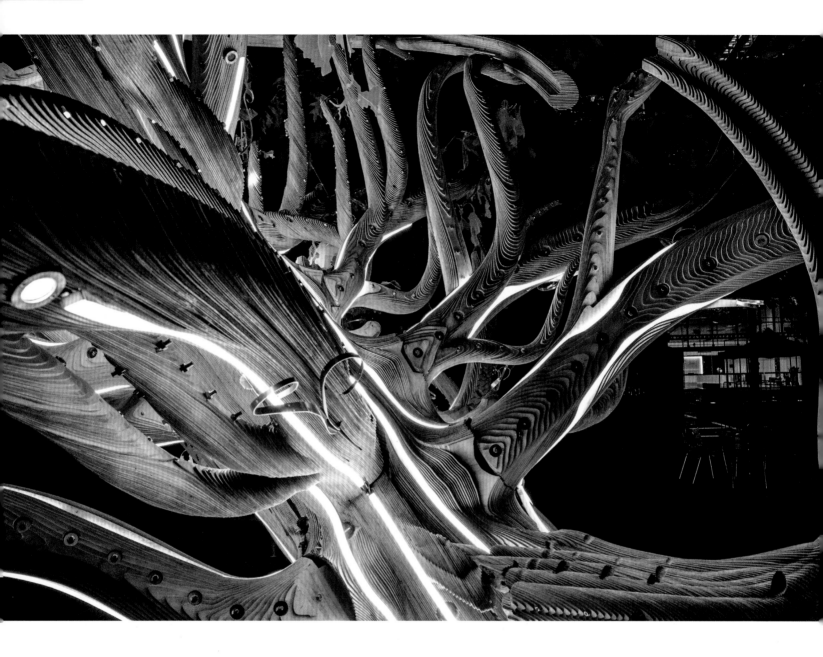

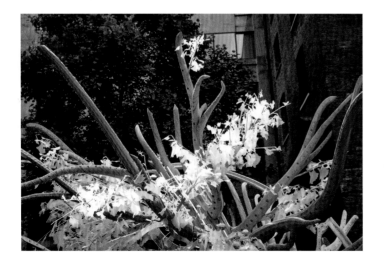

The Mobile Orchard is intended to challenge and inspire, to offer a background that becomes a prop for the actor and player in all of us, and to encourage exploration and interaction.

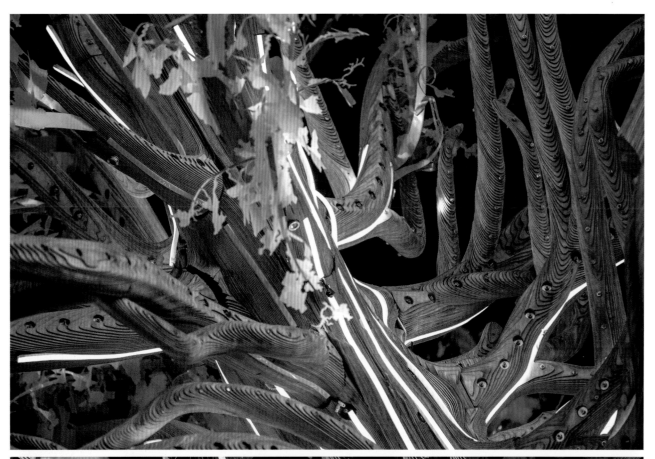

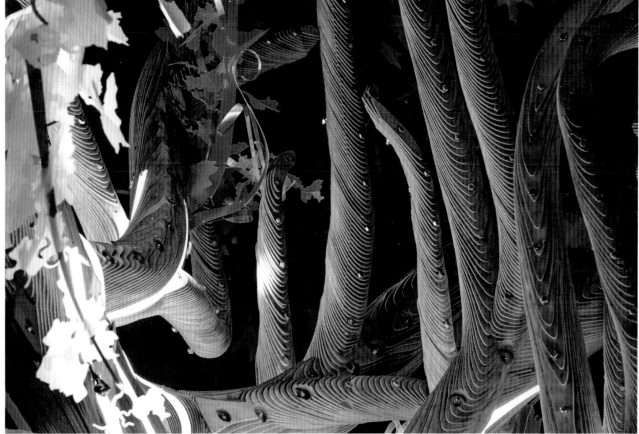

Pavilion of "Ninety Nine Failures"

Design Architects: *The University of Tokyo, Digital Fabrication Lab*

Structure: *Freeform Surface Tensegrity Structure*

Size: *9 m (L) x 7 m (W) x 4 m (H)*

Weight: *Stainless Steel Upper Structure 1.5 tons, Concrete Foundation 1 ton*

Location: *Tokyo, Japan*

Photographer: *Hayato Wakabayashi*

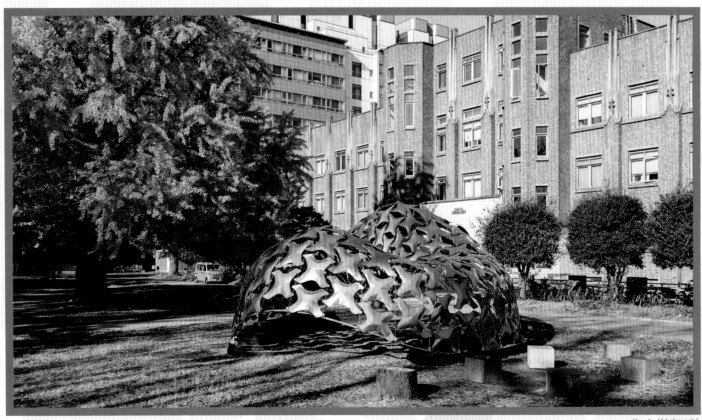

Hayato Wakabayashi

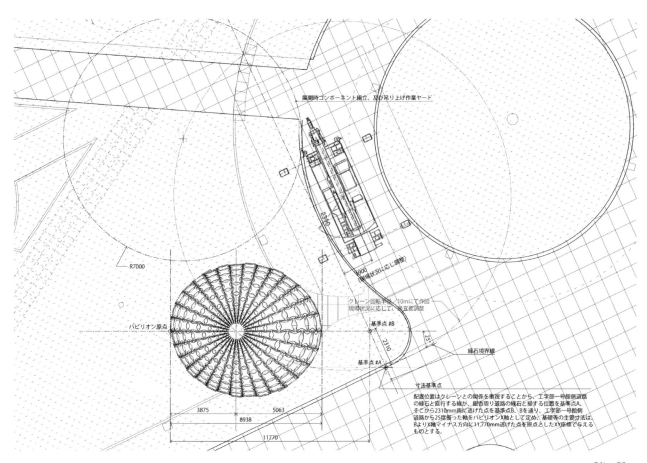

展開時コンポーネント組立、及び吊り上げ作業ヤード

R7000

パビリオン原点

クレーン回転半径 10mにて作図
現場状況に応じて、適宜要調整

基準点 #B

基準点 #A

縁石境界線

寸法基準点

配置位置はクレーンとの関係を重視することから、工学部一号館側道路
の縁石と道行する線が、銀杏周り道路の縁石と接する位置を基準点A、
そこから2310mm南に逃げた点を基準点B、Bを通り、工学部一号館側
道路から25度振った軸をパビリオンX軸として定め、基礎等の主要寸法は、
BよりX軸マイナス方向に11,770mm逃げた点を原点としたXY座標で与える
ものとする。

3875 5063
8938
11770

2310

2310

600

25°

Site Plan

The Obuchi Lab at the University of Tokyo originally conceived this pavilion project as a first year master's studio project. The exhibition was a continuation of the first year studies and a collaborative research project with Obayashi Corporation, a Japanese construction company.

The objectives of the project were to examine experimental design, fabrication, assembly, and construction processes, none of which can be performed solely by either a school or a professional practice. Additionally, "problems" as catalysts for innovative architectural design research were explored, which contributed conceptually to the name of the project, "Ninety Nine Failures." The pavilion is meant to introduce new sets of problems which students, researchers, and professional architects can share and pursue to expand the architectural discourse.

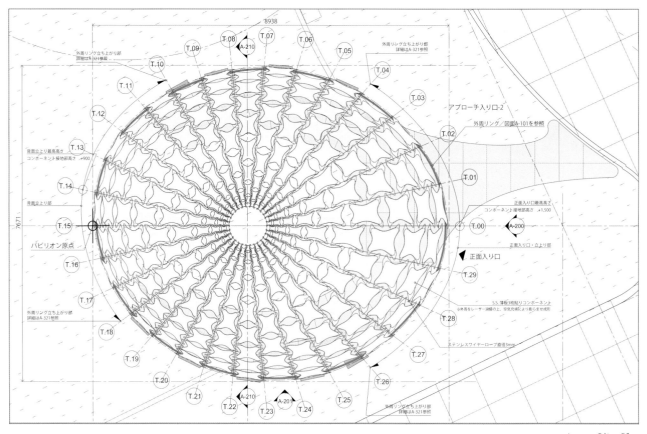

Large Site Plan

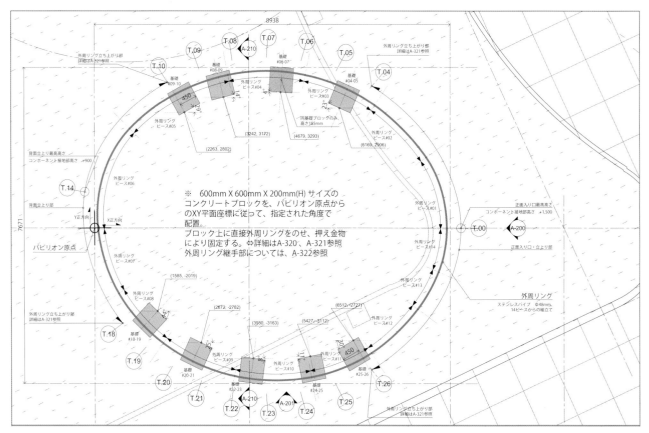

Floor Plan

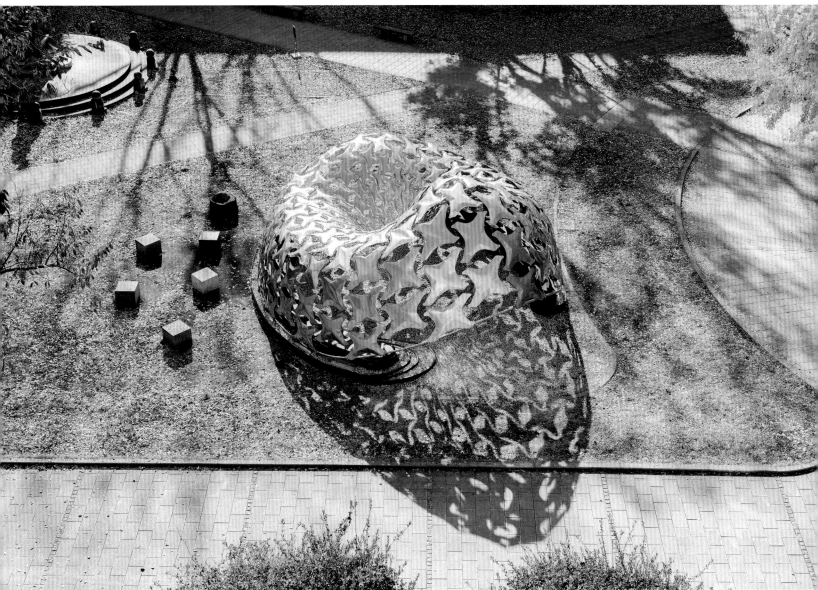

Hayato Wakabayashi

The global geometry of the pavilion was determined through a combination of digital simulations and a series of scale model tests. Roughly 50 variations of different possible geometries were tested to determine which geometries would allow the structure to unfold on a flat plane, but would also work as a stable structure when formed into the target shape. The chosen geometry fulfilled this technical requirement and also allowed the project to take on interesting spatial qualities both inside and outside the structure.

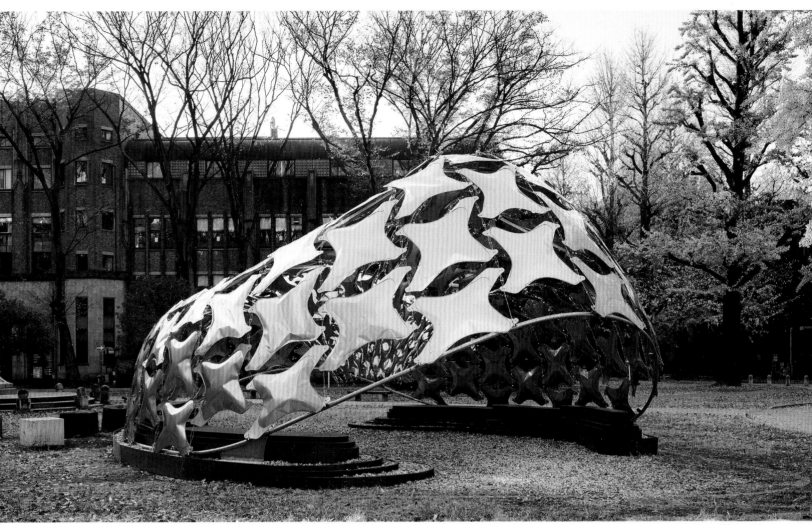

Hayato Wakabayashi

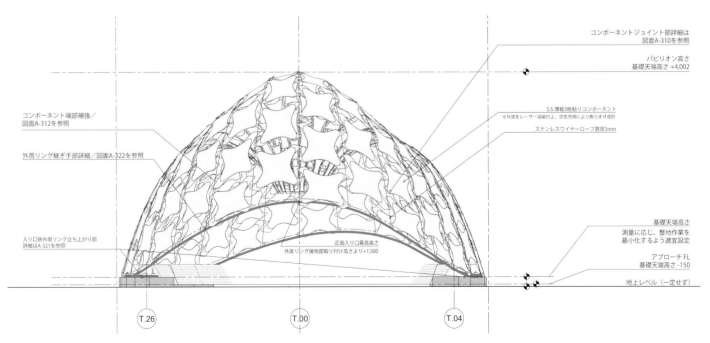

コンポーネントジョイント部詳細は
図面A-310を参照

パビリオン高さ
基礎天端高さ +4,002

コンポーネント端部補強／
図面A-312を参照

S.S.薄板3枚貼りコンポーネント
※外周をレーザー溶接の上、空気充填により膨らませ成形

ステンレスワイヤーロープ直径3mm

外周リング継ぎ手部詳細／図面A-322を参照

入り口側外周リング立ち上がり部
詳細はA-321を参照

正面入り口最高高さ
外周リング接地部取り付け高さより+1,500

基礎天端高さ
測量に応じ、整地作業を
最小化するよう適宜設定

アプローチ FL
基礎天端高さ -150

地上レベル（一定せず）

T.26 T.00 T.04

Elevation Drawing 1

Thin stainless steel sheets were used as compressive elements to achieve a super lightweight structure. Each component was composed of three metal layers. The middle layer was the thickest of the three and gave stability to each component. Components were hydraulically inflated like metal "pillows" after all component edges were welded together and sealed. This process ensured each component was watertight and capable of acting structurally.

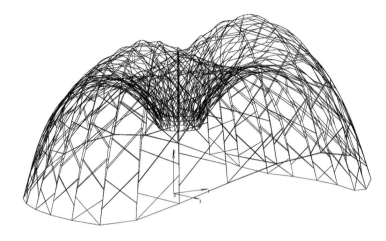

Structural Analysis

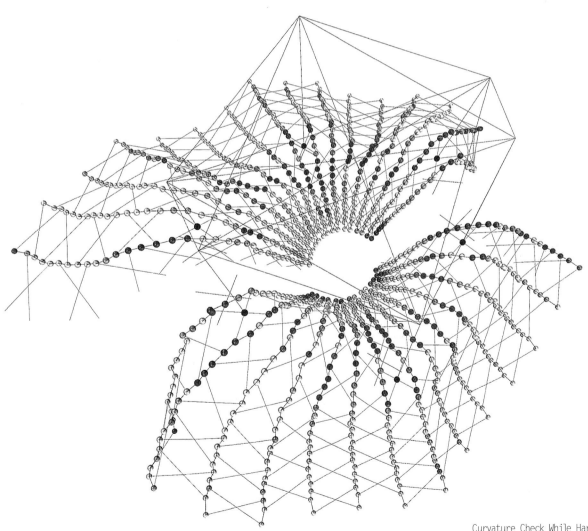

Curvature Check While Hanging

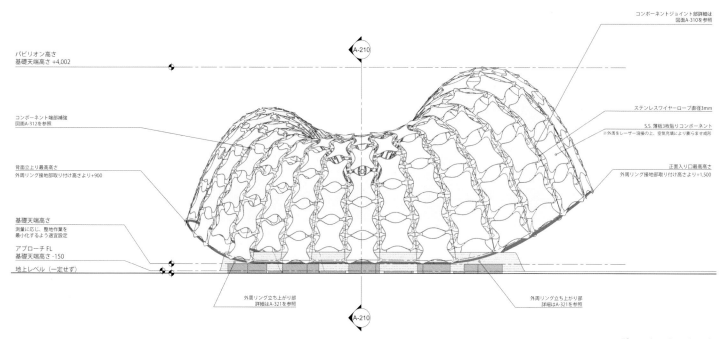

コンポーネントジョイント部詳細は
図面A-310を参照

ステンレスワイヤーロープ直径3mm

S.S. 薄板3枚貼りコンポーネント
※外周をレーザー溶接の上、空気充填により膨らませ成形

パビリオン高さ
基礎天端高さ +4,002

コンポーネント端部補強
図面A-312を参照

背面立上り最高高さ
外周リング接地部取り付け高さより+900

正面入り口最高高さ
外周リング接地部取り付け高さより+1,500

基礎天端高さ
測量に応じ、整地作業を
最小化するよう適宜設定

アプローチFL
基礎天端高さ -150

地上レベル（一定せず）

外周リング立ち上がり部
詳細はA-321を参照

外周リング立ち上がり部
詳細はA-321を参照

Elevation Drawing 2

S.S.薄板3枚貼りコンポーネント
※外周をレーザー溶接の上、空気充填により膨らませ成形
図面では厚みが表現されていないが、実際には膨らませによる厚み有り。

ステンレスワイヤーロープ直径3mm

コンポーネントジョイント部詳細、A-310参照

内周リング安定高さ
基礎天端高さ +1,246

基礎天端高さ
測量に応じ、整地作業を
最小化するよう適宜設定

コンポーネント、外周リングへの取付け詳細はA-323参照

外周リング・基礎への固定詳細はA-320、A-321参照

アプローチ高さ
基礎天端高さ -150

地上レベル（一定せず）

基礎ブロック

ベンチ／デッキ／アプローチは、
パビリオンと独立した構造とする。
東京大学が別途に制作。

Section Drawing

255 unique compressive components were all networked to function as a coherent, integrated structural system. A custom-created program was used to draw the shapes for the project.

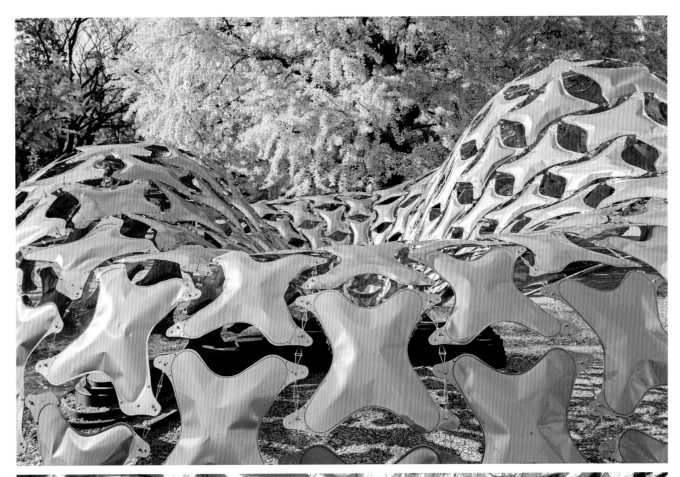

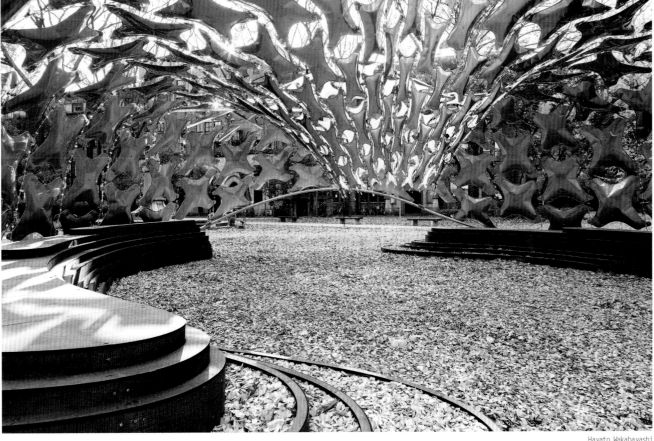

Hayato Wakabayashi

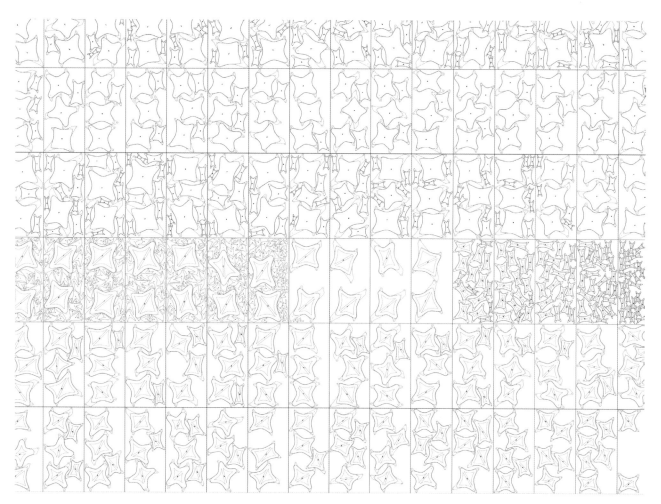

Cutting Data of Component

Component shapes were determined after consideration of a number of factors:

1) Geometrical constraints due to global composition

2) Coordination between components to avoid undesirable overlap/conflicts between components (both when completed and when hung)

3) Compatibility with welding jigs when fabricated with a robot arm

4) Capability of withstanding the hydraulic inflation process (directly influencing the structural performance of the component)

5) Pavilion porosity; to allow light penetration and minimized loading from wind pressure.

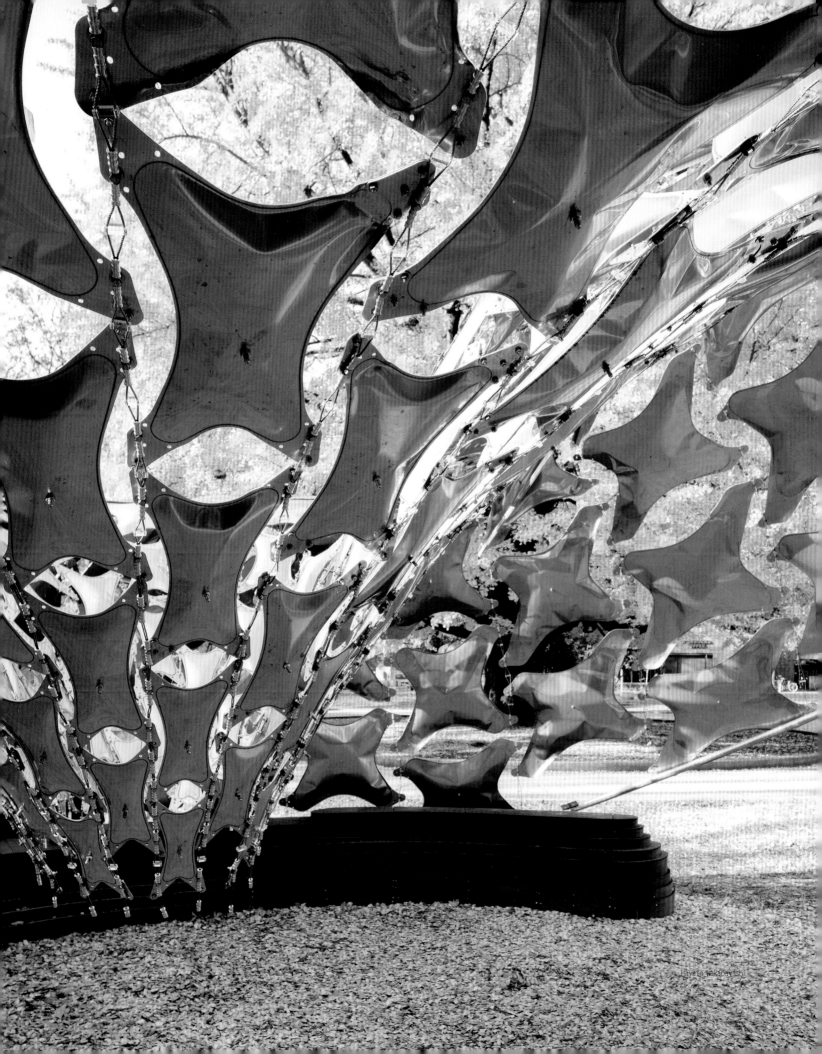

Hayato Wakabayashi

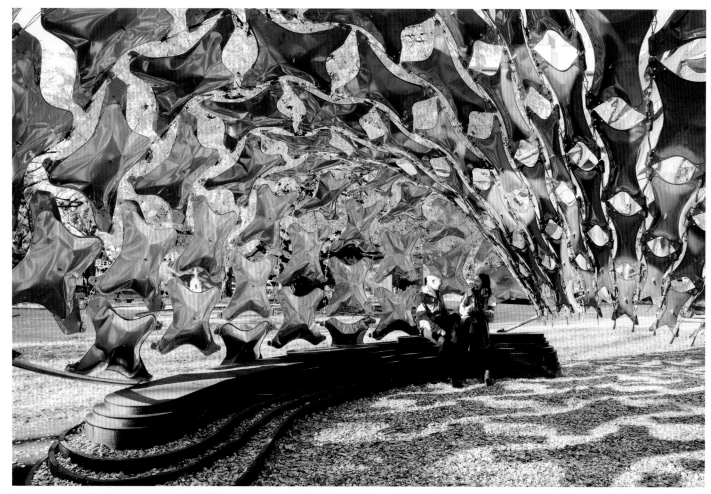

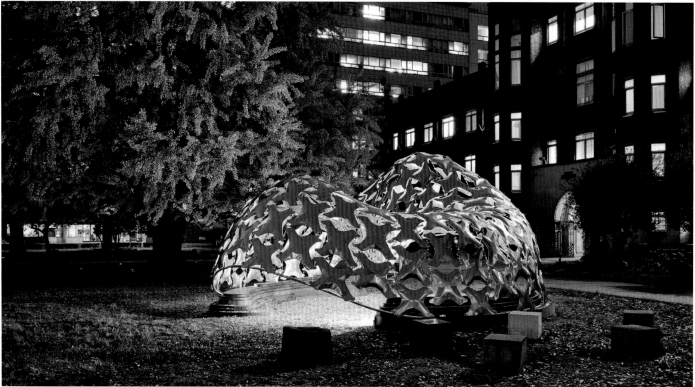

Hayato Wakabayashi

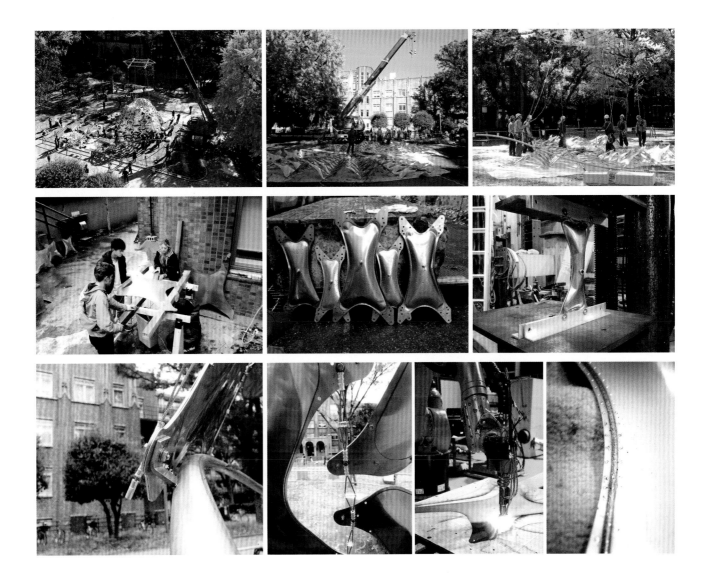

Components were fixed in place with stainless steel bolts attached to a stainless steel cable using aluminum crimps. Crimps were attached to bolt holes which were placed in the corners of the compressive components.

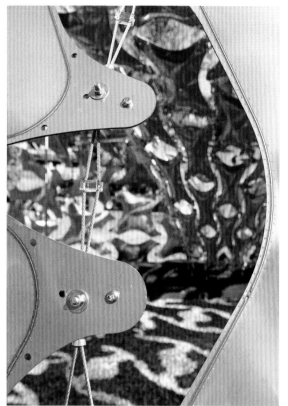

Hayato Wakabayashi

One of the most interesting challenges in terms of the computational design process of this pavilion was to program a digital simulation that would match physical models. Without this process the project would not have been possible. Another interesting challenge was the organization of a smooth component production process. Shapes were generated digitally, data was output, and a robot arm cut and welded each component.

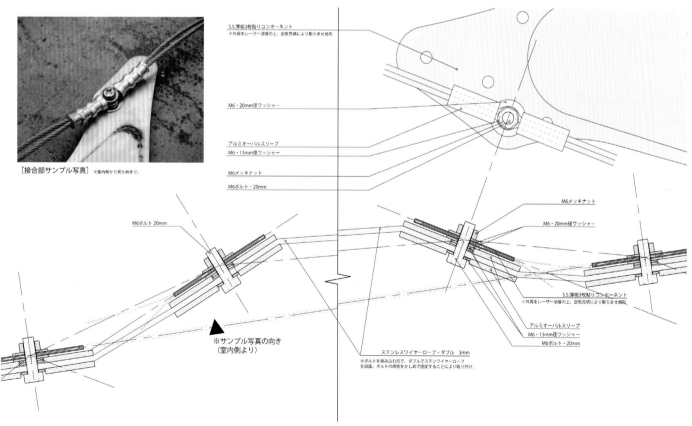

Component Joint Detail

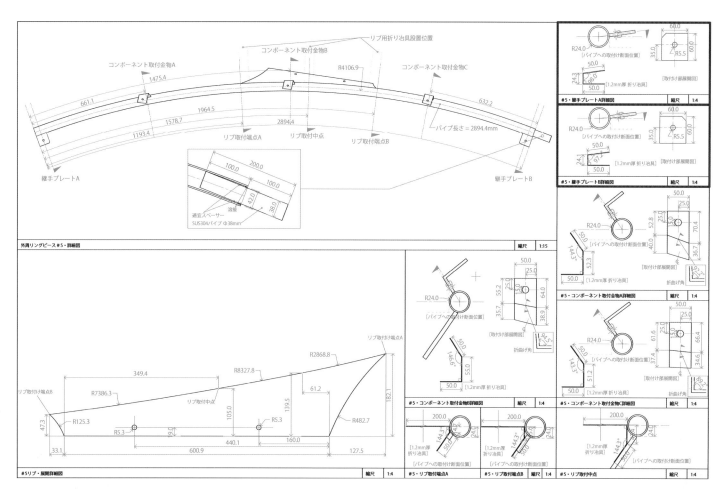

Base Ring And Its Joint Details

Hayato Wakabayashi

While we expect to pursue further research in the upcoming academic years related to the multiple "failures" we experienced during this project, we also plan to explore more research focusing on material behaviors and the hybridization of high/low-tech fabrication/assembly processes through the use of computational design.

Tourne around

Design Architects: *Dondecabentres (Cristina Bestratén, Aina Bigorra & Erik Herrera)*

Project Size: *93.7 ㎡*

Location: *Hotel Audessan, Montpellier, France*

Photographer: *Dondecabentres & Paul Kozlowski*

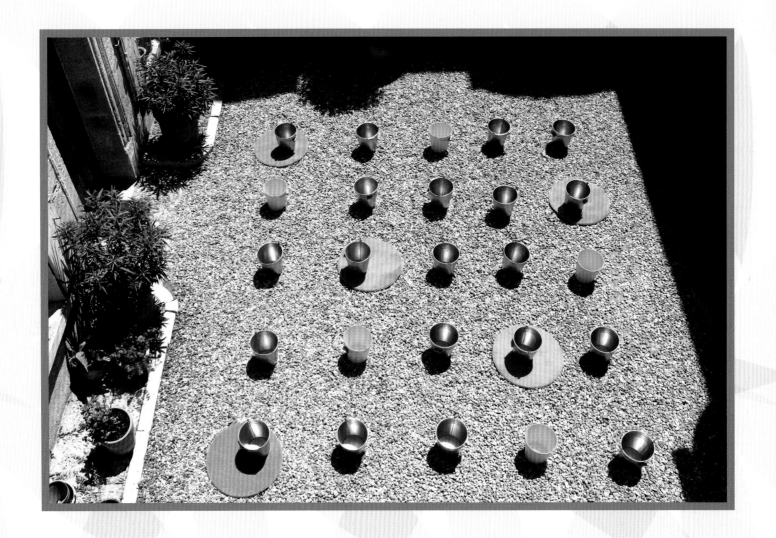

The project starts from the illusory capacity of the mirror, a capable element of being a surprise in itself. It functions from the creation of mirages which concern directly to what appears to be. Starting from a tangible reality, that surrounds us, the mirror can create a new reality, to multiply the existing one and transform it. The mirror is the support, but is something that is not at the same time: is the reflecting sky, the window, the curtain or the planter.

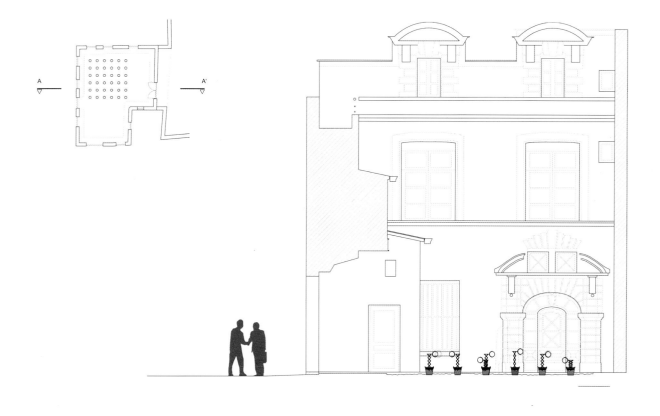

e_1/50

Sectioon

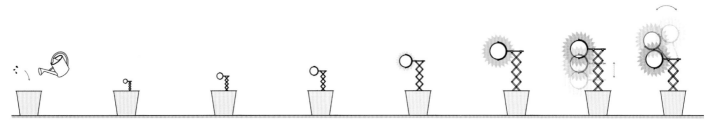

Elevation Drawing

Placing a mirror has intrinsic temporary modification of the place where it is placed. The patio with mirrors will never be again the same patio.

And with this premise of mirage and surprise start the installation "tournearound".

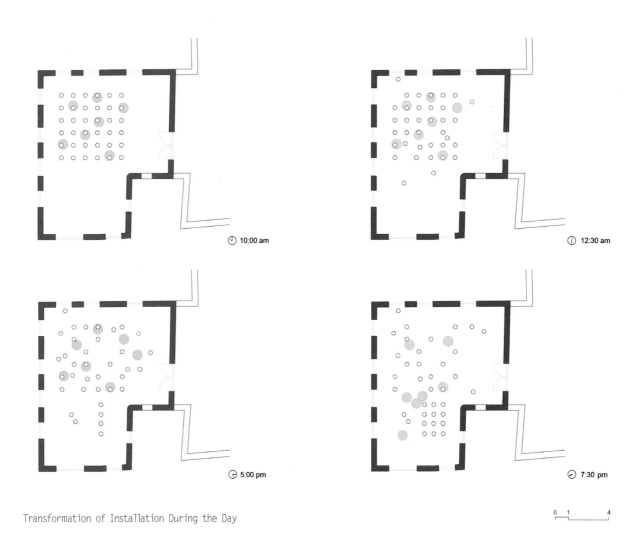

Transformation of Installation During the Day

The project seeks to revalue the place through the use of a mirror to multiply and triple in a chained way, details, spaces and forms. Achieve the most closely relationship with the place where the installation takes place. To do this, we focus on the placement of a series of telescopic mirrors, which like sunflowers, they can mutate, blend with what surrounds them; the interior walls of the patio, the floor, the front door, the piece of sky which cuts roofs, the inside emerging through the windows... Creating a fantasy inside the patio, where reality and reflect get mixed to find surprise.

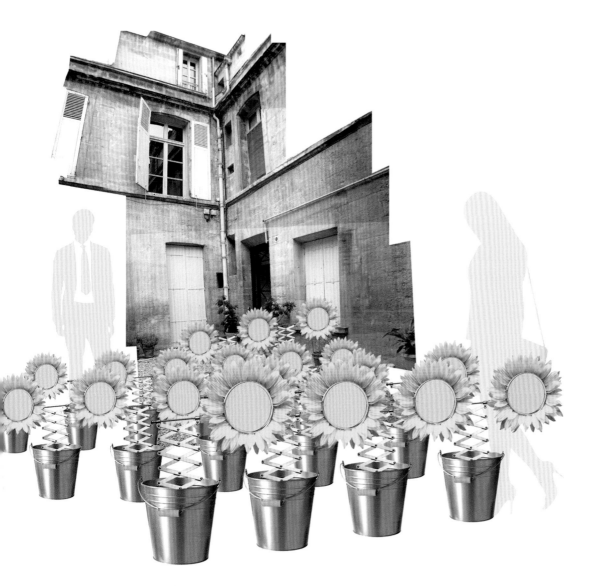

Design Sketch

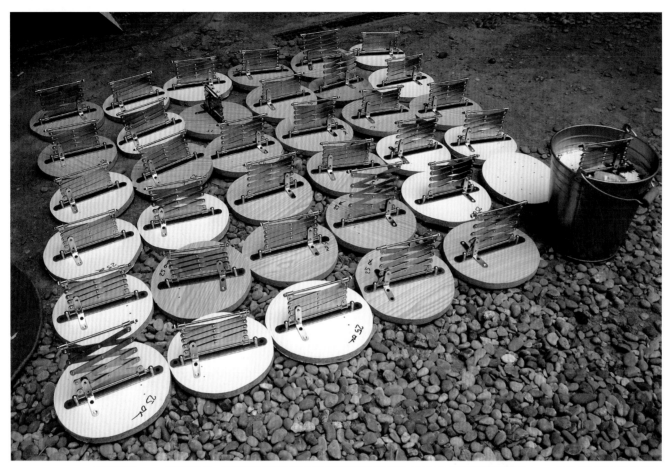

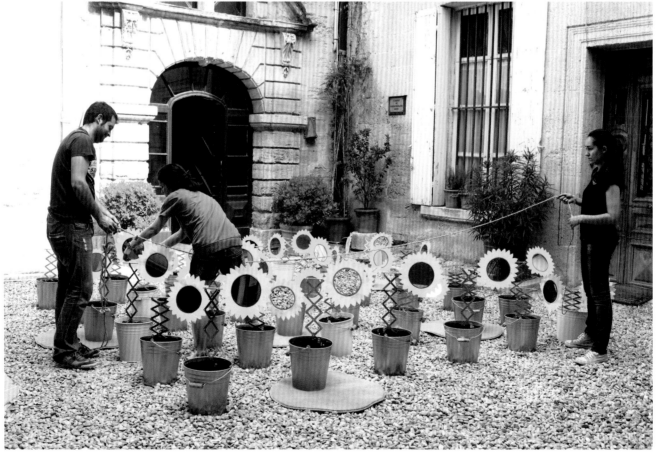

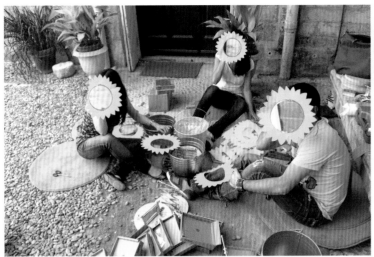
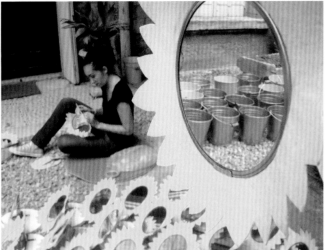
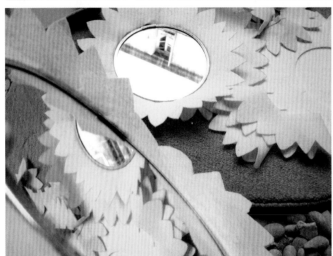
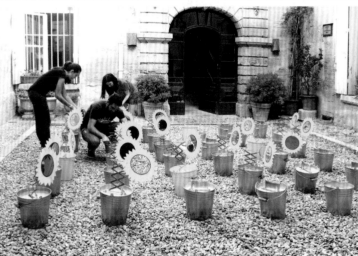

As if it was a chameleon, the installation is capable of changing its appearance constantly, adapting at all times to what is happening. Sunflowers and mirrors are acting only as a catalyst for establishing relations between the patio and its visitors, affecting favorably the reaction environment. The installation "tournearound" doesn't intend to be an element in itself, but that necessary ingredient to change reality and turn it into surprise.

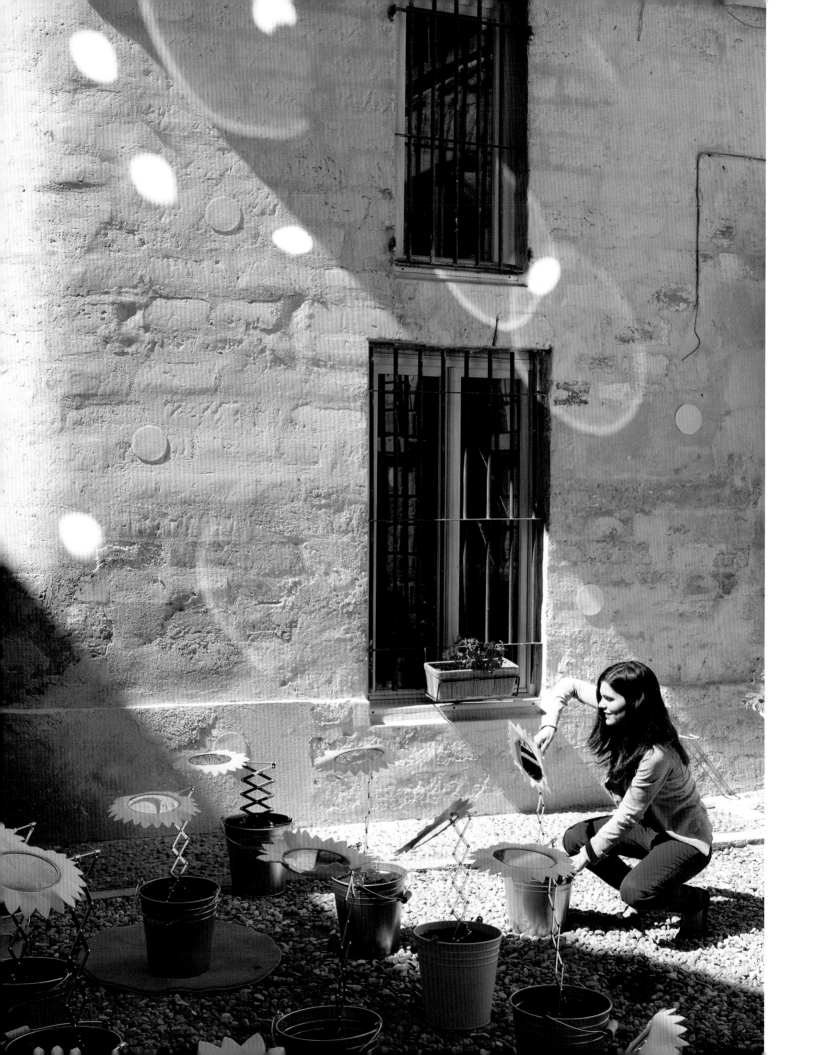

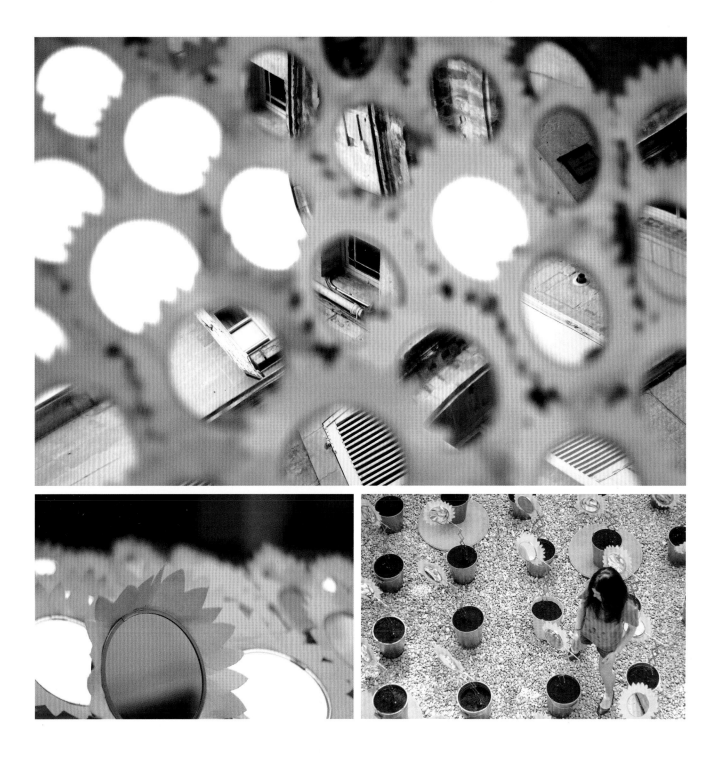

The installation "tournearound" intends, at the same time, convert surprise in something dynamic, able to mutate, by interacting with the visitor.

The introduction of a new variable, more social, of participation, interaction with the installation, allows giving the surprise a new interactive dimension. Transform it into something more complex, able to happen and, at the same time, to be created. Then the visitor becomes the author, the creator of a new reality; his own reality.

Introducing a portion of field of sunflowers inside the patio serves as thread for the proposal. Evoke the close relationship that the sunflower maintains with the sun; and how this symbiotic relationship can be extrapolated, in this case, to the mirror and the patio.

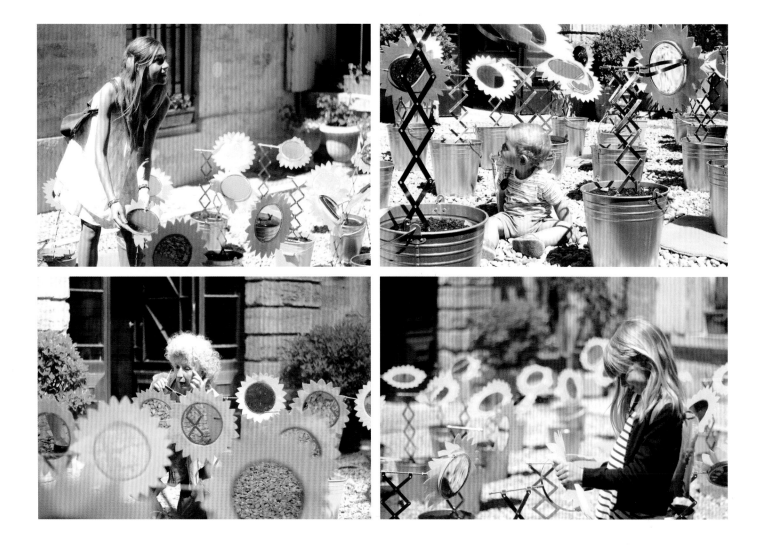

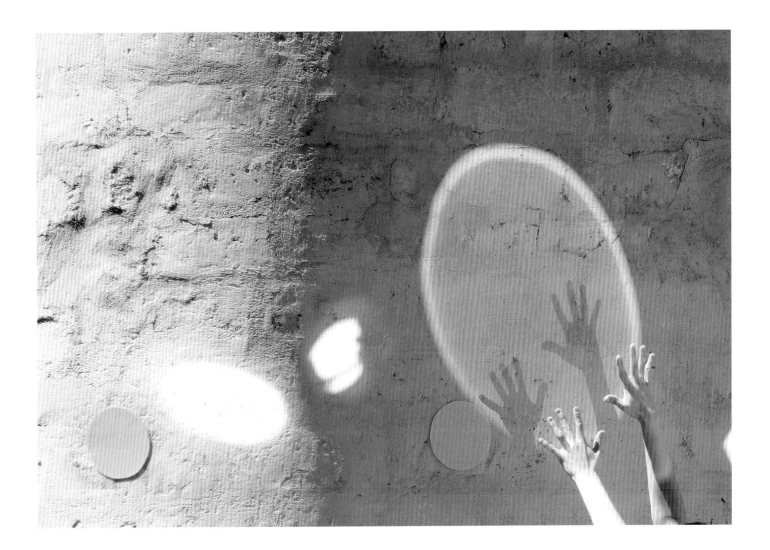

Playing with the improvisation factor is now the visitor who can turn the "tournearound" looking for the best view, the most curious detail, or the brighter ray of light. Avoiding rigidity and promoting interaction with the curious. The installation is reinvented every day, starting from state o and mutating throughout the day, being the final result, the amount of will and the ability to be surprised of its visitors.

The patio finally becomes a big periscope, a set of mirrors that allows observe what surrounds us from a different location to the expected.

Arena Teques

Design Architects: *AT 103*

Project Area: *102,500 m²*

Location: *Morelos, Mexico*

Photographer: *AT 103*

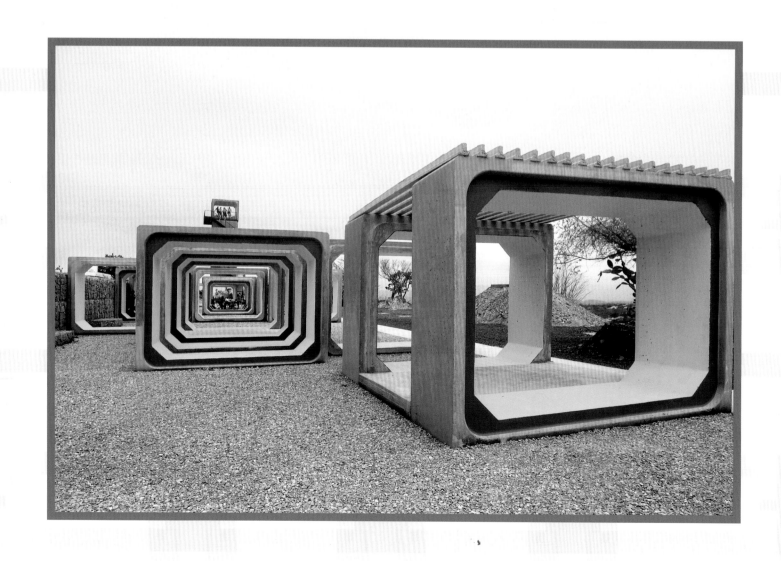

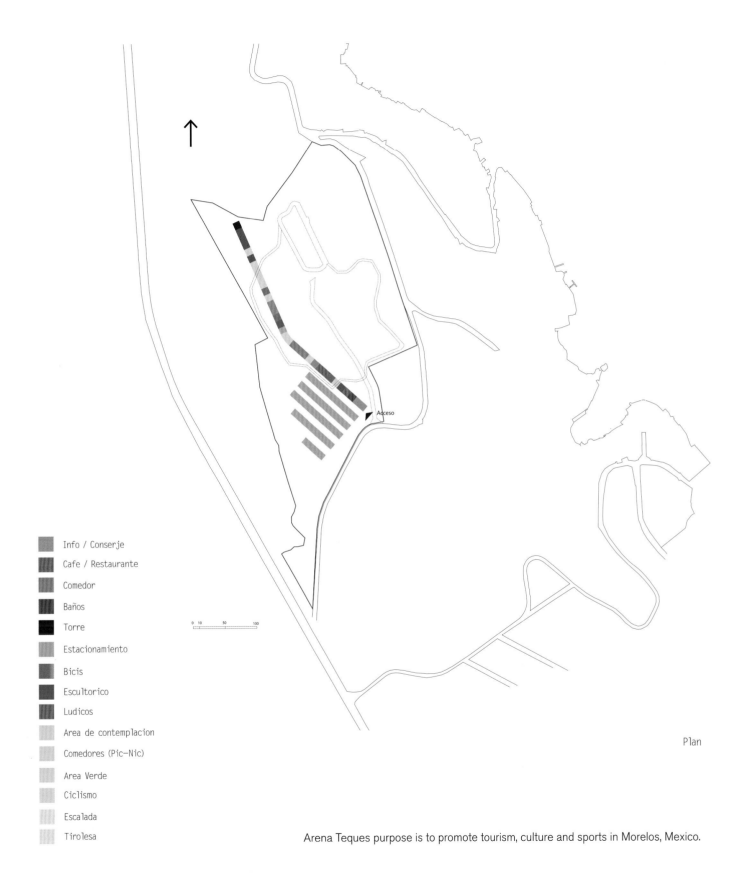

Acceso

Info / Conserje

Cafe / Restaurante

Comedor

Baños

Torre

Estacionamiento

Bicis

Escultorico

Ludicos

Area de contemplacion

Comedores (Pic-Nic)

Area Verde

Ciclismo

Escalada

Tirolesa

0 10 50 100

Plan

Arena Teques purpose is to promote tourism, culture and sports in Morelos, Mexico.

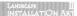

In a 0.1 k m² area, a linear park is proposed to promote recycling and a sustainability culture. Prefabricated elements generate a multifunctional platform, favoring versatility with their module arrangement and quick installation, creating spaces where fairs, festivals, sports and cultural activities can be carried out.

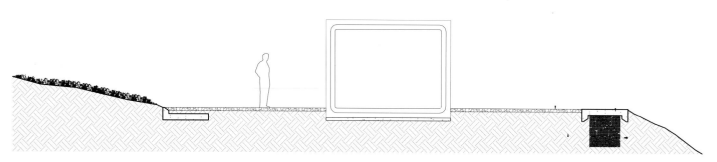

Section 1

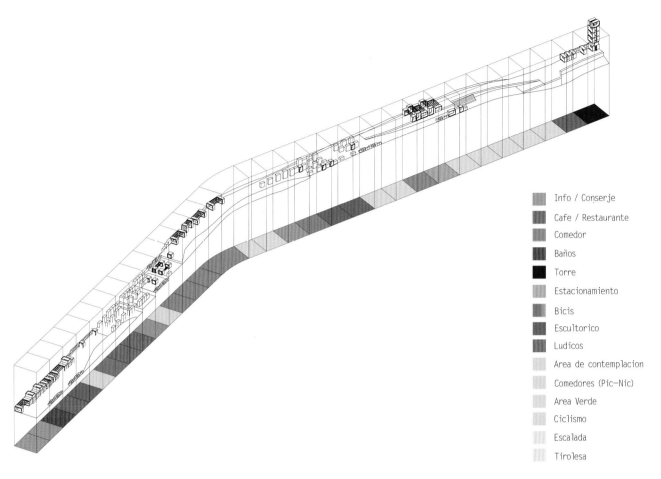

Info / Conserje
Cafe / Restaurante
Comedor
Baños
Torre
Estacionamiento
Bicis
Escultorico
Ludicos
Area de contemplacion
Comedores (Pic–Nic)
Area Verde
Ciclismo
Escalada
Tirolesa

Layout Program

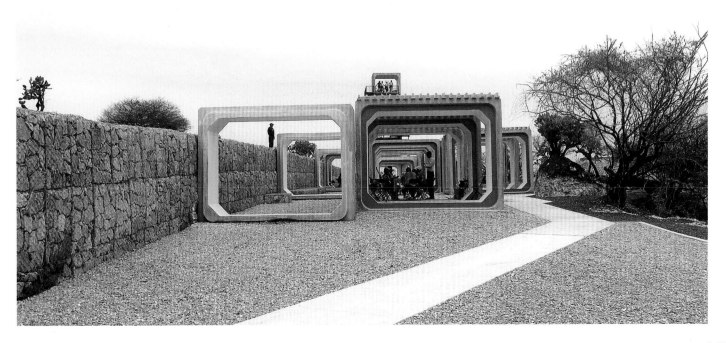

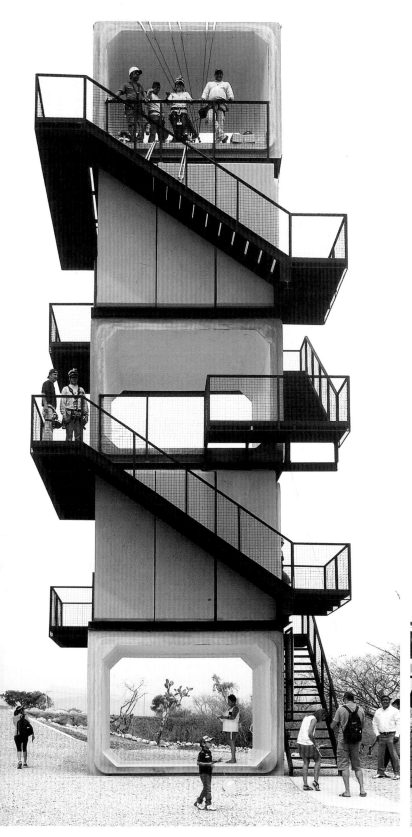
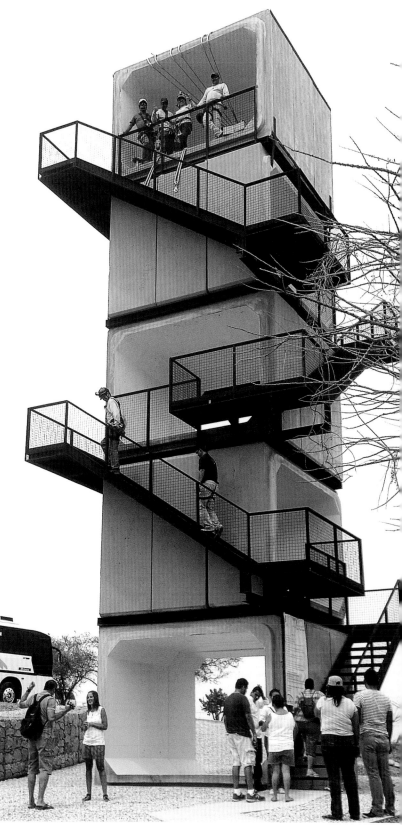

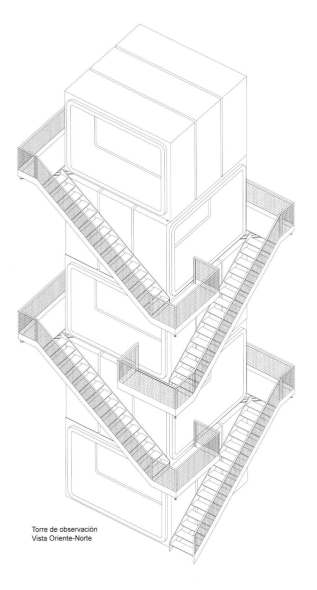

Torre de observación
Vista Oriente-Norte

Torre de observación
Vista Poniente-Sur

The intention of the Government of Morelos is to build spaces that people can occupy and make their own, connectivity spaces where visitors generate the program of each element in the path, with activities like biking and hiking amongst many others.

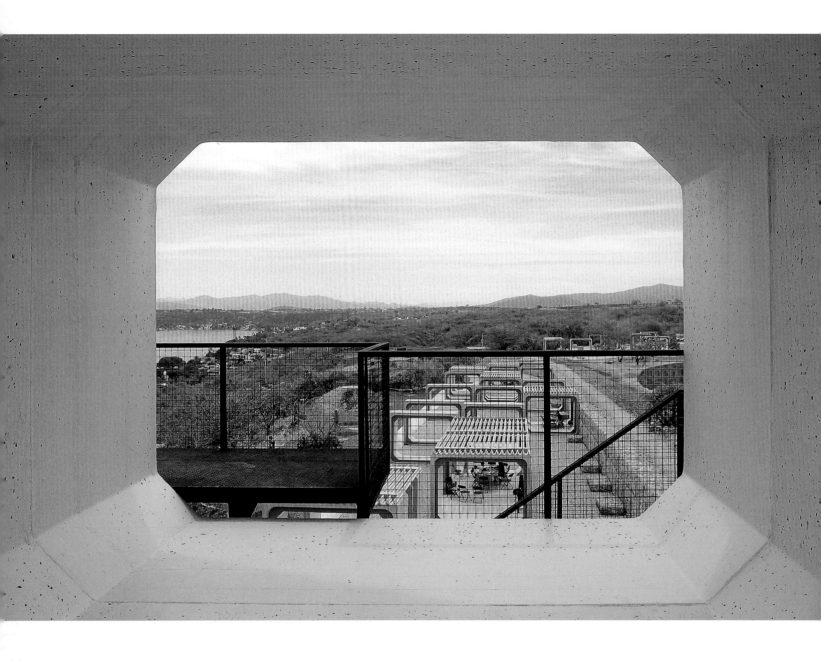

The project ends with a tower/zip line that favors the views of volcanoes and Lake Teques quitengo, as well as being the prelude

to an outdoor auditorium.

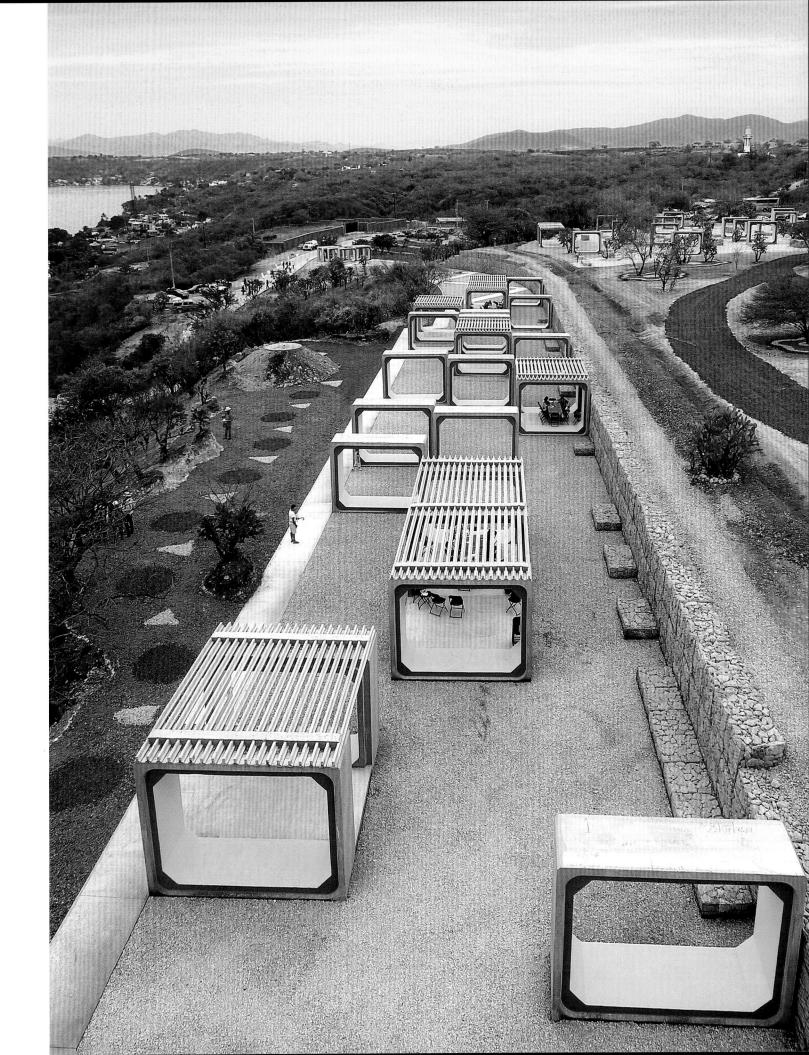

BA_LIK Summer Pavilion for Bratislava

Design Architects: *Vallo Sadovsky Architects*

Costs: *€50,000*

Build Surface: *30.9 m²*

Location: *Franciscan Square, Bratislava, Slovakia*

Photographer: *P.Safko*

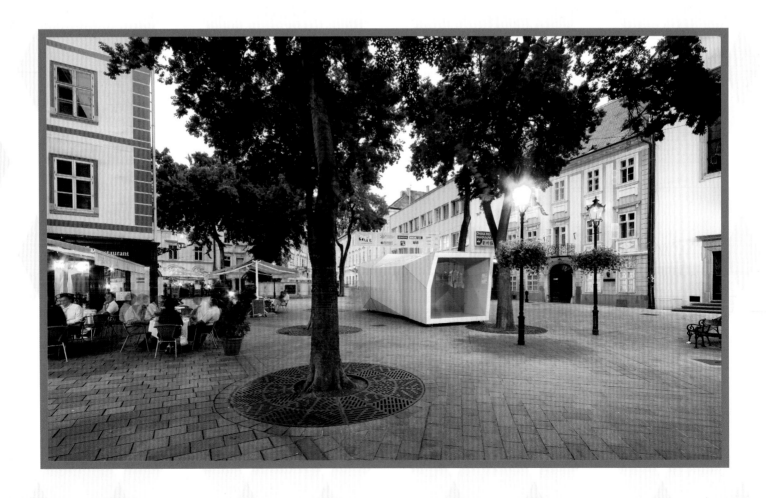

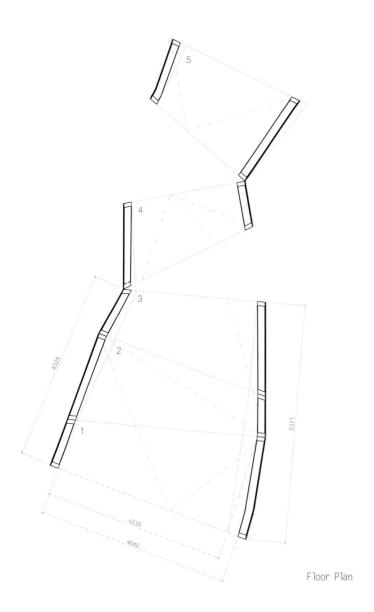

Floor Plan

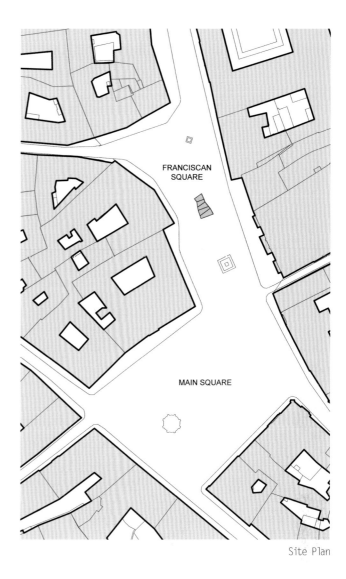

Site Plan

Summer stage and exhibition pavilion BA_LIK for Bratislava City

Project of the pavilion is one of the projects of City Interventions, their long running initiative which invites young architects to propose feasible architectural solutions to various problems and neglected spaces in Bratislava, with the hope that, within an urban context, small changes can create big effects. The project was initiated by Vallo Sadovsky Architects within the long-term project City Interventions.

The architects submitted the idea to the city officers,
found a sponsor for a part of the pavilion and dealt
with a major part of the summer schedule.

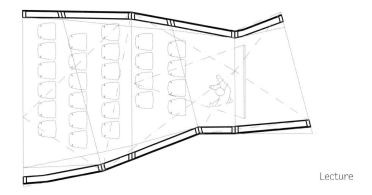

Lecture

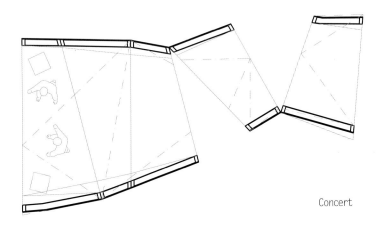

Concert

Exhibition

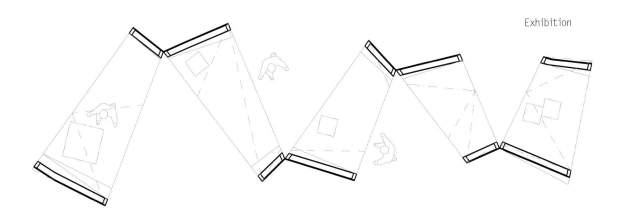

Variable Use

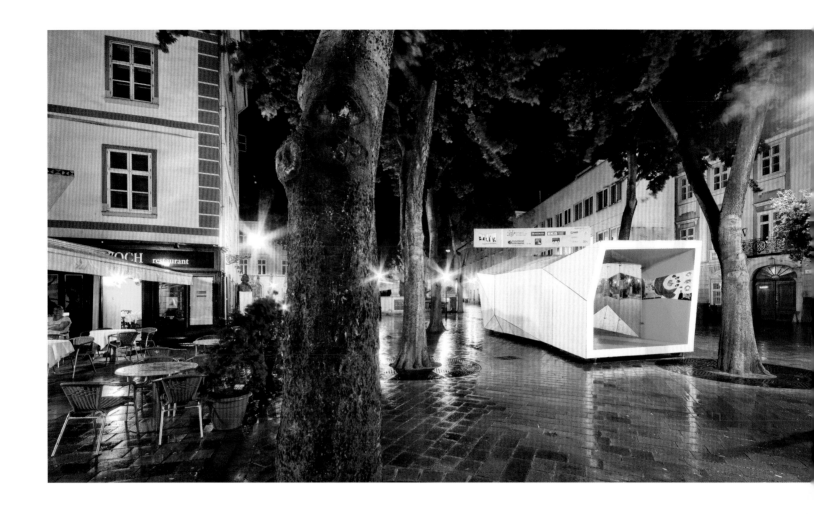

PREVIOUS STATE

BA_LIK pavilion designed by Vallo Sadovsky Architects is set in one of the Bratislava's historical squares. Regardless of the fact that this square is directly connected to the Main Square, which is attractive from the tourism point of view, the Franciscan Square is mainly recognized as a transition point missing a more specific function. Except for summer terraces and a couple of benches, it did not offer any other possibilities of using its premises and did not represent any "destination" for citizens either.

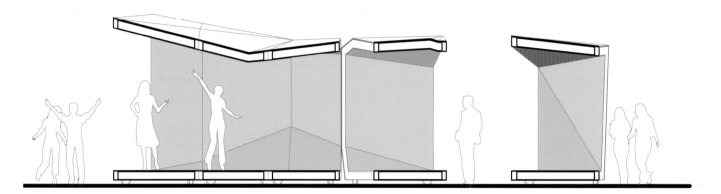

Longitudal Section

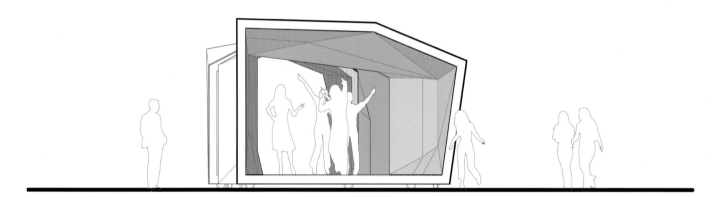

Front View

AIM OF THE INTERVENTION

BThe objective of our intervention can be summarized in three basic issues. Since the central Main Square continuously becomes a certain scene for "one-day" tourists spending their time on their traveling between Prague and Vienna, our intervention was intended on giving the centre back to the citizens. We have evaluated the creation of a multifunctional space as the best way of giving a function to this place, of making it easily modifiable and of making it interesting and usable even in those days, when no event is held thereby, thereon or therein.

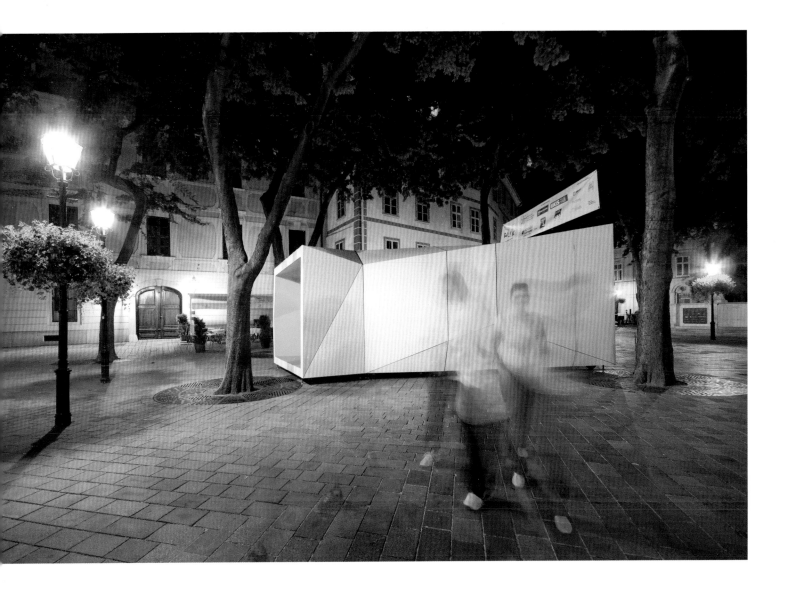

Incorporating features included in BA_LIK into the Franciscan Square gives these premises a new dimension in the city hierarchy. The pavilion is also a part of the Vallo Sadovsky Architects ongoing research focused on the ways, in which people can affect and change city premises through the interaction with a small architecture and movables.

Will the attractiveness of city premises increase, if the people assume the feeling, that the premises are not completely resolved, and a real chance to affect them?

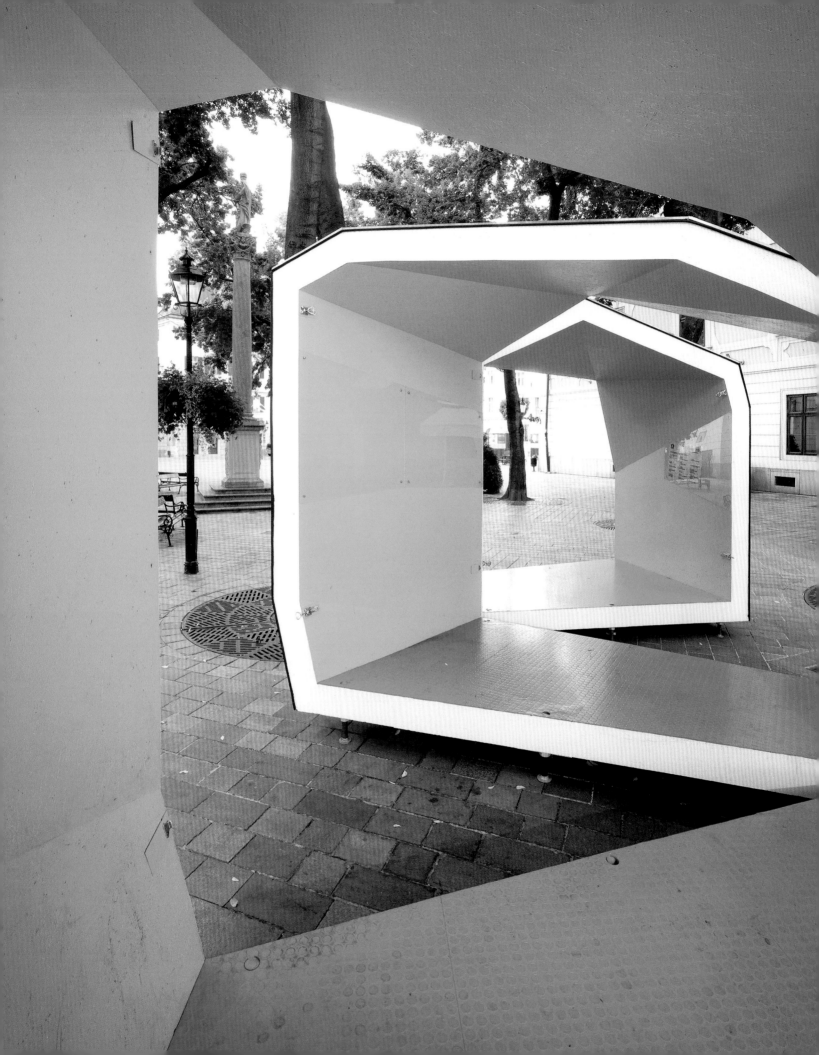

DESCRIPTION OF THE INTERVENTION

Flexibility and mobility are main characteristics of the pavilion. The object itself is composed of 5 elements mounted on wheels that can be moved and connected so it becomes closed and compact or loosely open. We would like to have the pavilion as multifunctional as possible and easily adaptable to the needs of various events. Particular parts can be quickly and simply unlocked or anchored to a required composition via arrestments. During the summer months it can be used for various cultural activities: a theater performance, concert or a photography exposition. Similar to how a concert differs from a theater performance the proposed structure can adapt and change.

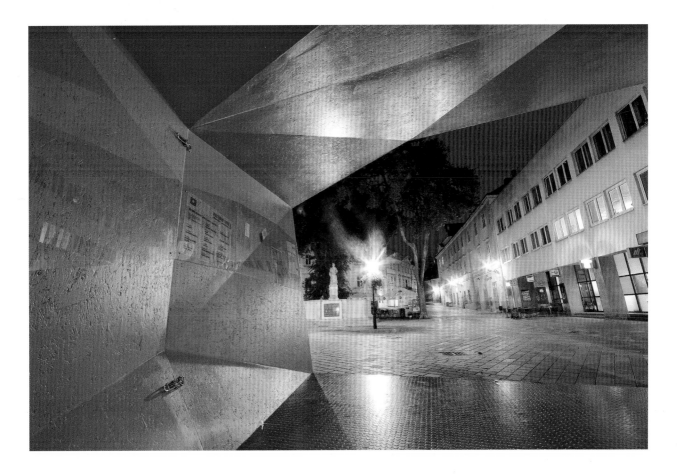

In time when there is no particular event taking place, the pavilion becomes a modern city furniture, giving young contemporary

identity to a square otherwise catering tourists with pseudo-historic "little big city".

EVALUATION

BA_LIK went through its first summer in the city without any negative experience. During this period, a plenty of concerts, two

exhibitions and both a politically and a literally oriented discussion were held there.

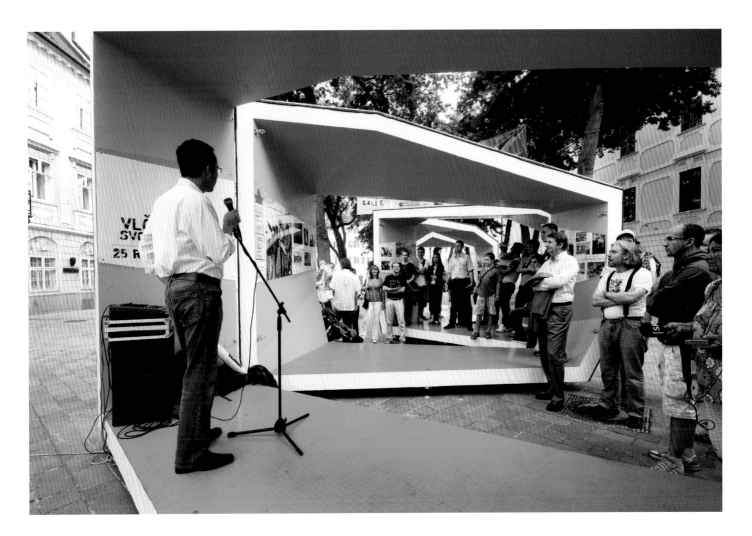

At all of these events, the pavilion was able to create a pleasant environment both for the actors and for the audience res. for

visitors of the exhibitions. The square suddenly came to life in the context of summer Bratislava and, eventually, it became the

"destination". Naturally also various unintended types of interaction occur: the homeless sleep over, young people party inside,

writers spray graphics, however none of them proved disruptive nor destructive. Luckily for Bratislava, our BA_LIK confuted

the need of idiot-proof strategy, under which architects, but also city officers, too frequently face the projects relating to public

premises.

Installation for Festival dell'Innovazione

Design Architects: *LAN Laboratorio Architetture Naturali*

Dimension: *Length x width 15x7.50 m, height 2.50 m*

Location: *Bari, Italy*

Photographer: *Andrea Pizzi Mazzei*

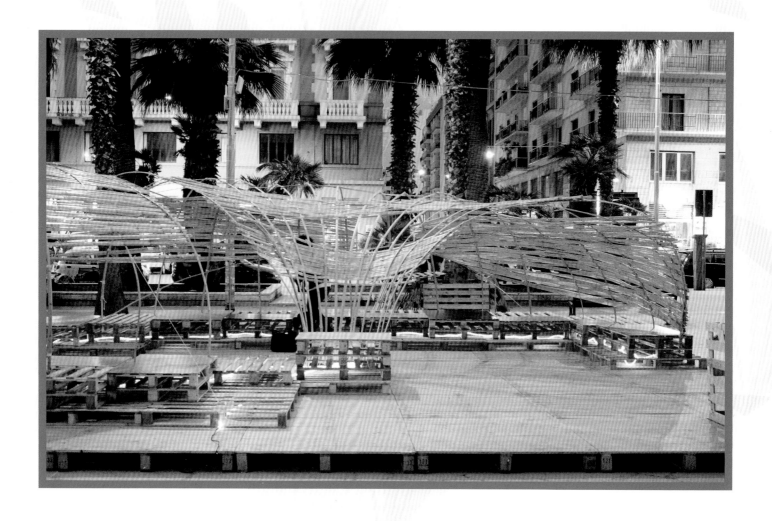

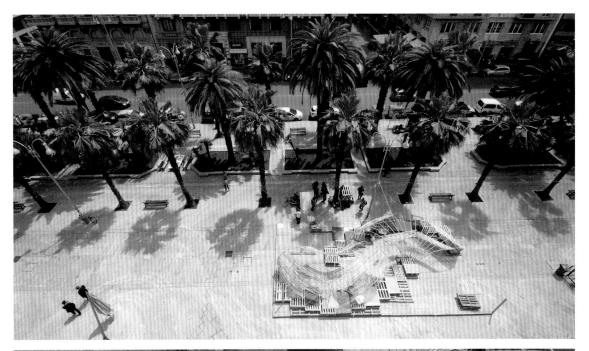

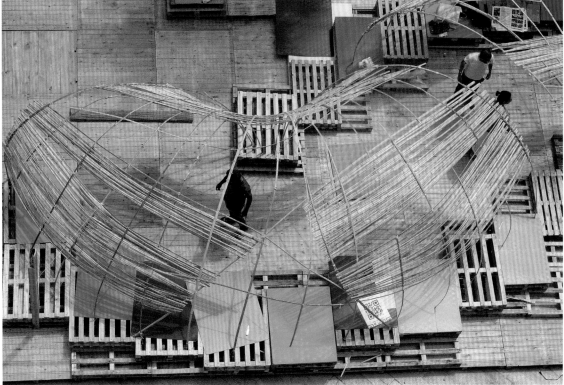

During the Innovation Festival in Bari, in Corso Vittorio Emanuele, Lan has created a bamboo cane and Arundo

Donax installation, promoted by the "smart Citizen" web of Bari.

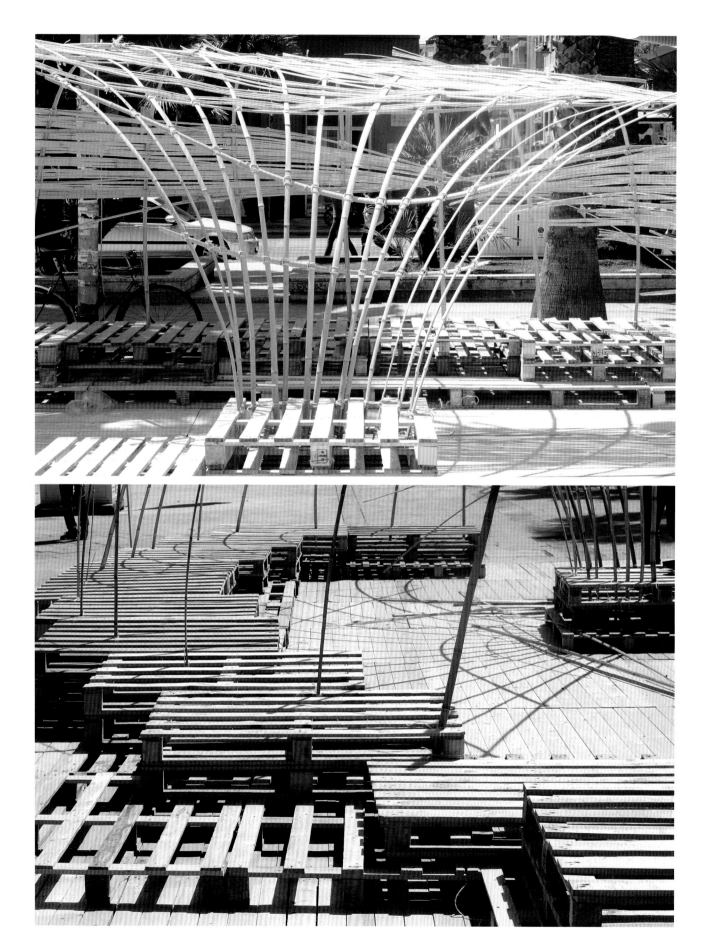

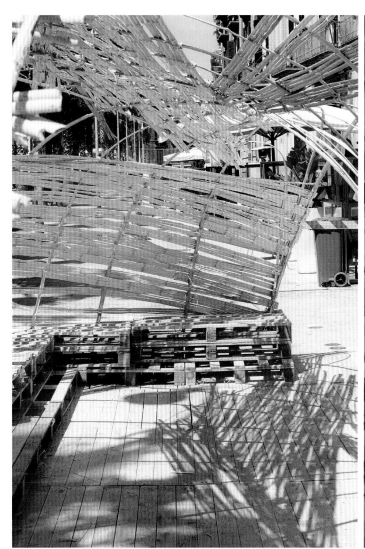

The structure represents a place where to have a break, where to pop in or simply have a rest. It is totally natural and its purpose is to shatter gently the urban weaving with its organic shape. It rises on a pallet basement that is aimed to secure the main structure with the bamboo arches and in the meantime it is also useful to sit down on it. The installation is partly covered with a weave of Arundo Donax and this gives you the possibility to live meanwhile all the space, exchanging the inside and the outside as it is a game.

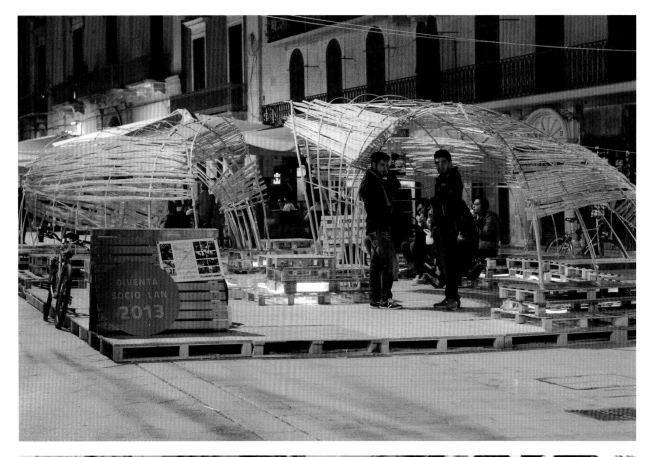

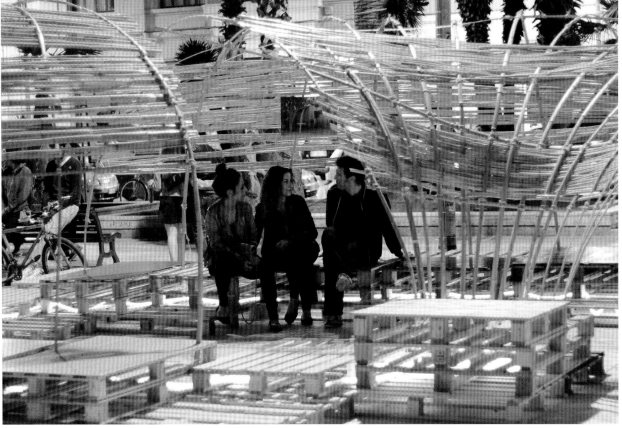

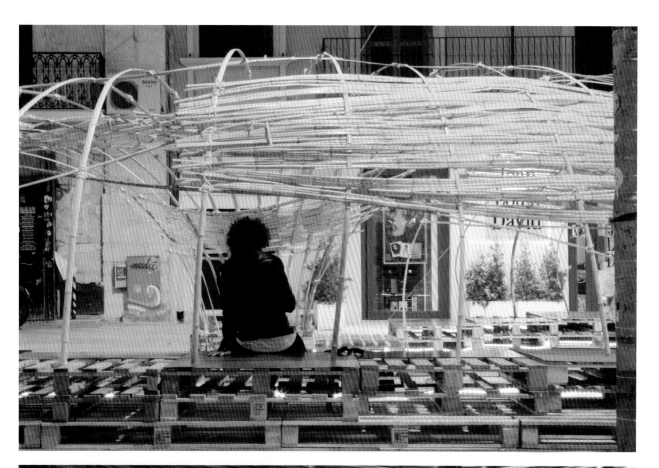

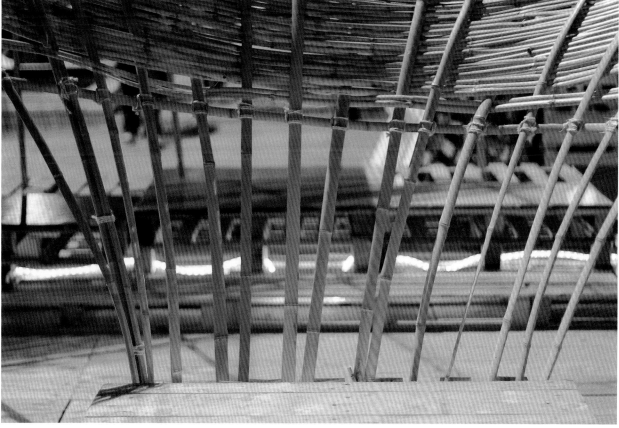

Fresh Flower

Design Architects: *Tonkin Liu*

Project Budget: *£ 80,000*

Gross Footprint: *Measures 100 square meters covered area*

Brief Description: *A pavilion that moved around between four different sites in central London*

Location: *St Paul's Cathedral, Bedford Square, Canary Wharf, Princess Garden in Kensington, the United Kingdom*

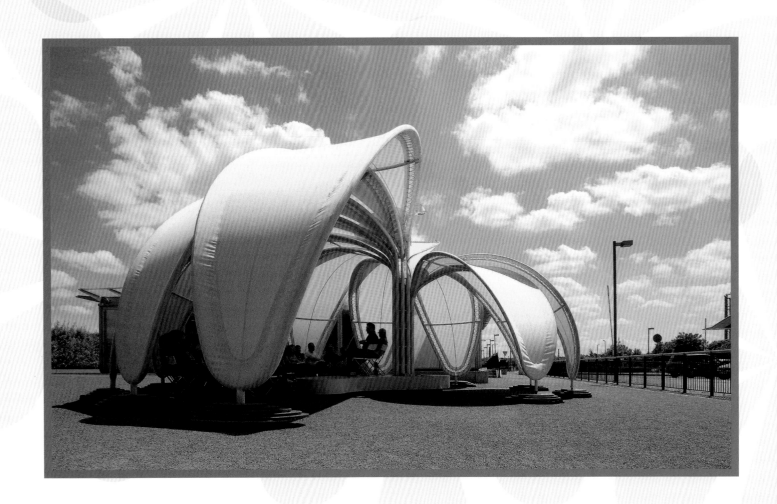

A pavilion that travels to four different hubs in central London hosts events for the London Festival of Architecture. Eleven petals arch to create shelter beneath, gathered at the centre around which a stage is set. Visitors enter the pavilion between the petals from every direction, the spaces increasing in size around the structure. Rain falls with the curves of the petals and is gathered by the central flue to the void inside the columns.

Axo

Elevation

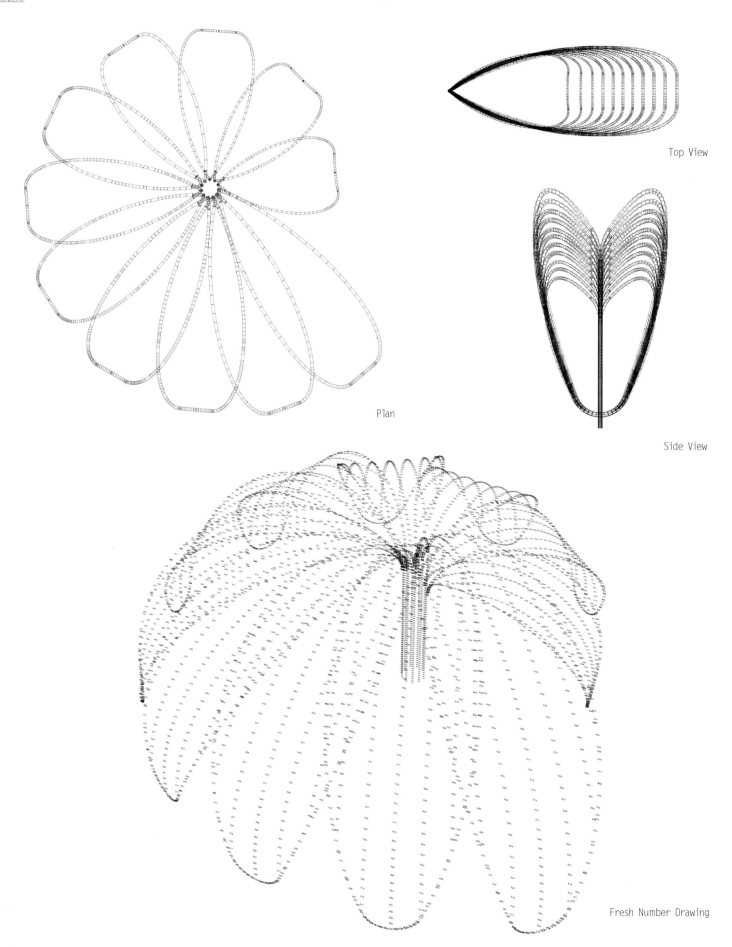

Top View

Plan

Side View

Fresh Number Drawing

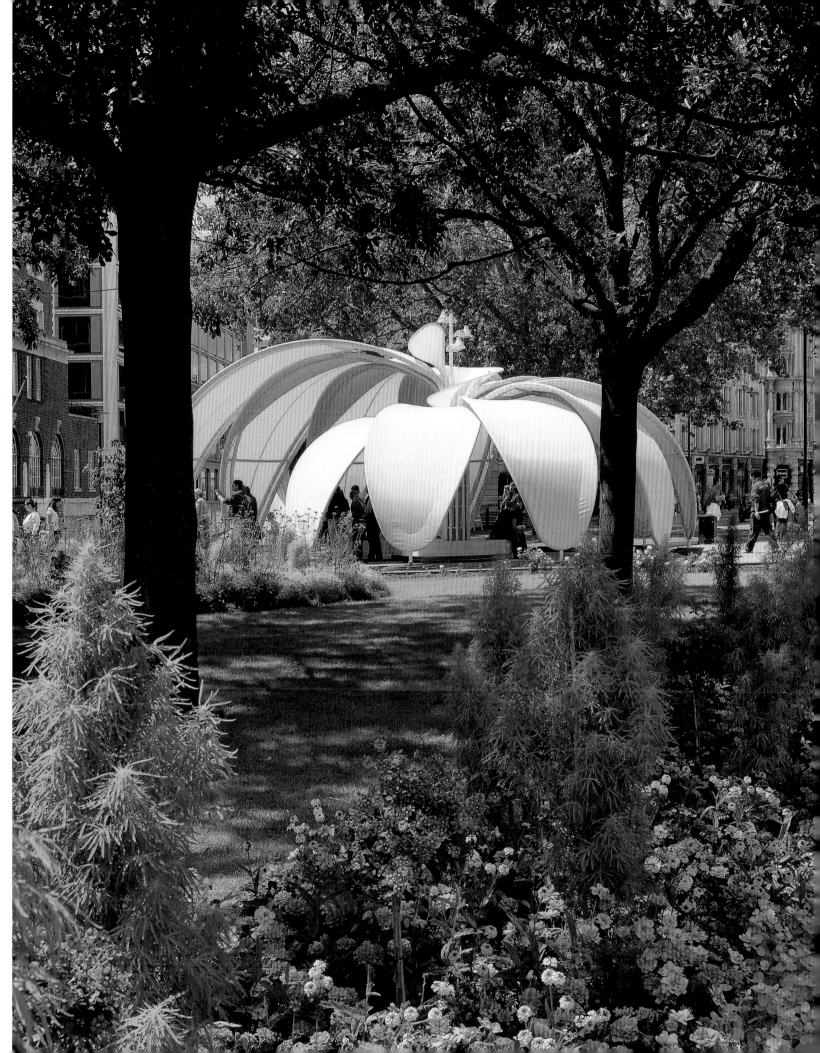

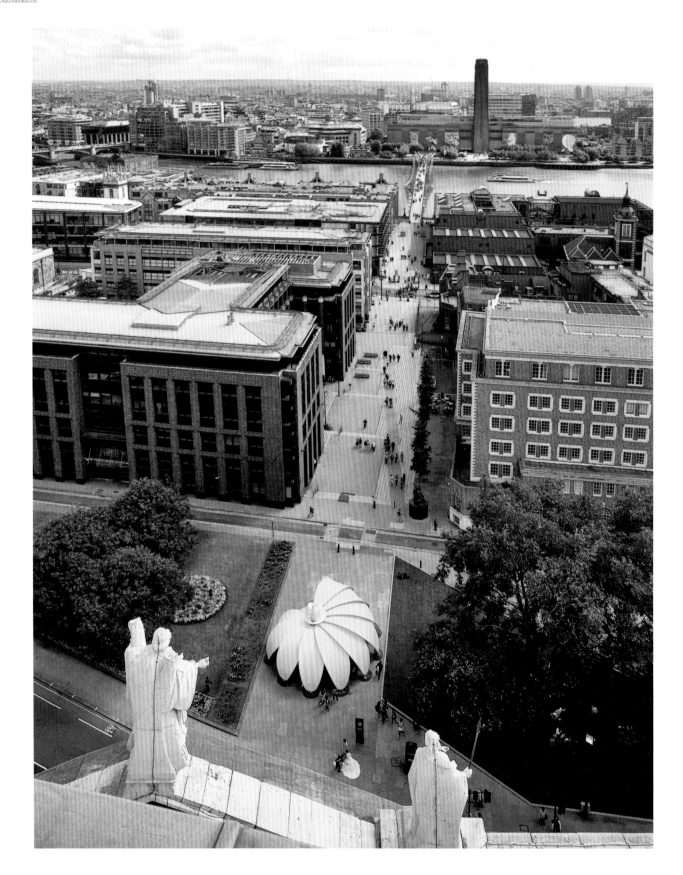

Sunlight makes the petals glow. Lights rising from the central stalk illuminate the pavilion. At each hub the stacked petals

arrive, unfurl, and are erected creating an architectural event.

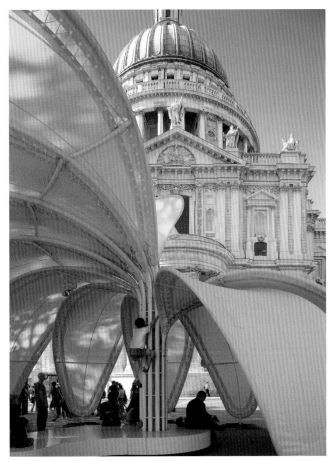

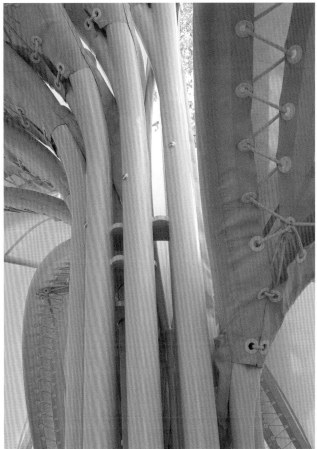

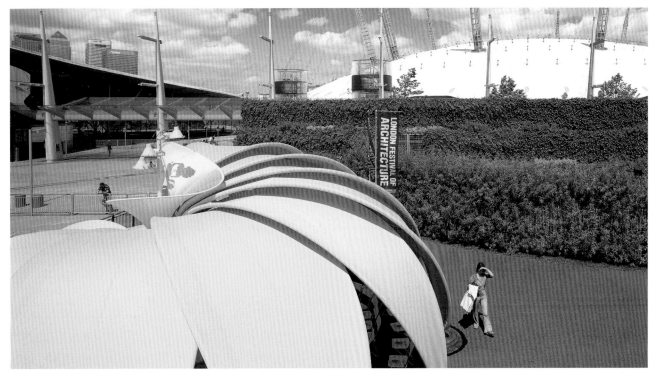

Heartwalk

Design Architects: *SITU Studio*

Project Size: *9.7 m x 8.92 m x 1.78 m*

Materials: *Salvaged wooden planks from New York and New Jersey boardwalks*

Location: *Atlantic City, New Jersey, USA*

Photographer: *Ka Man, Keith Sirchio*

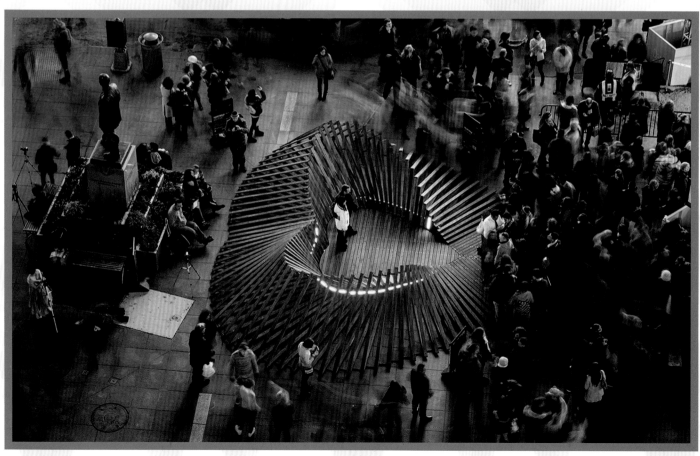

Keith Sirchio

Heartwalk was the winner of the fifth annual Times Square Valentine's Day Heart Design Competition that invites emerging architecture and design firms to submit proposals for a public art installation. The 2013 competition was organized by Times Square Arts, the public art program of the Times Square Alliance, and the Design Trust for Public Space.

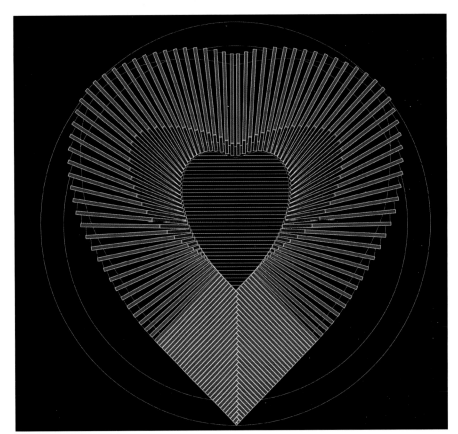

Plan

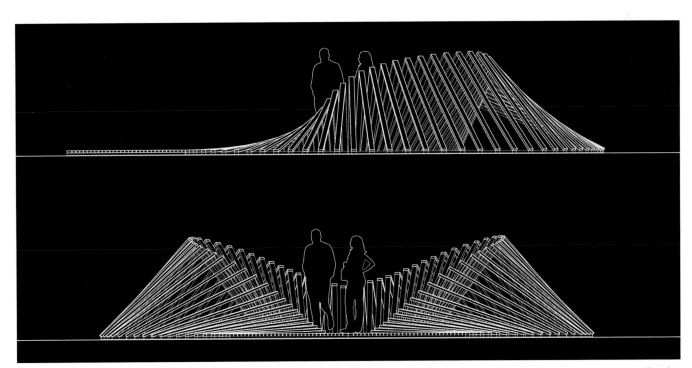

Drawing

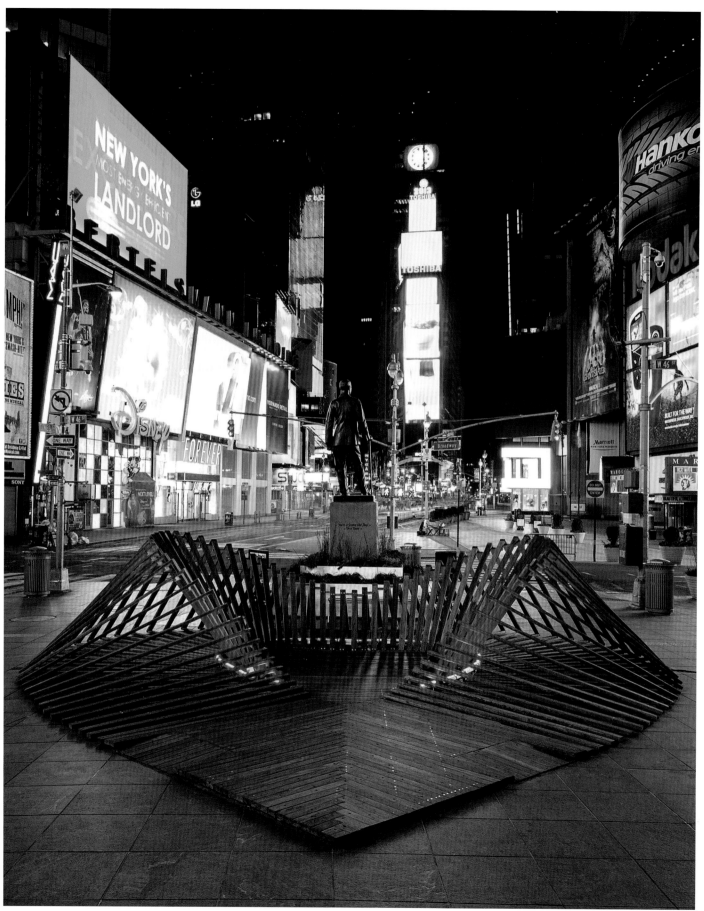

Keith Sirchio

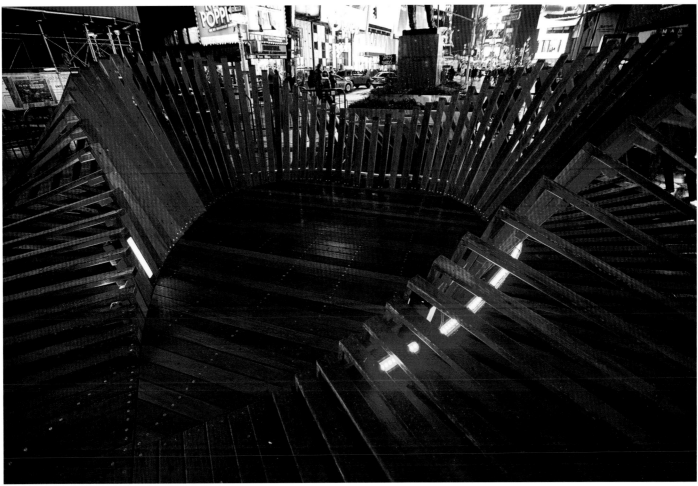

Ku Man

Heartwalk draws inspiration from the collective experience of Hurricane Sandy and the love that binds the City's citizens together during trying times. Built entirely from wooden planks salvaged from New York and New Jersey boardwalks that were severely damaged by Hurricane, the installation wraps around the visitors, providing a moment of pause amidst one of the country's busiest public spaces.

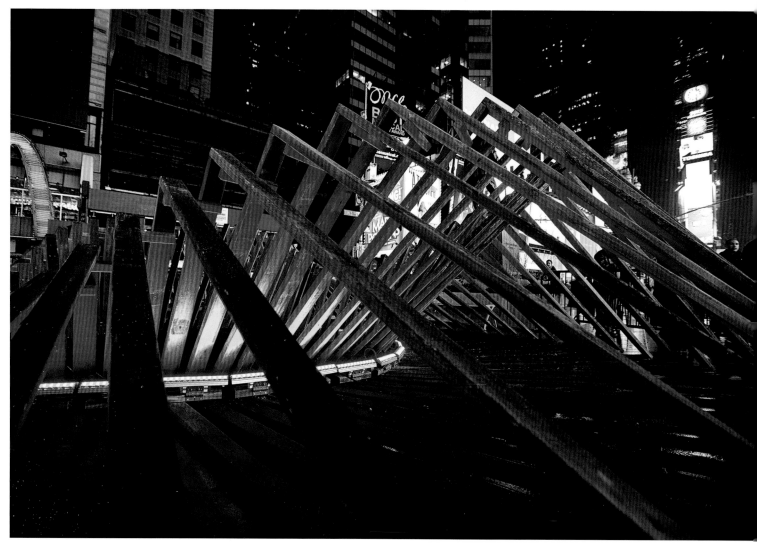

Ku Man

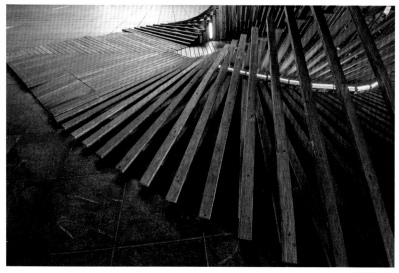

Keith Sirchio

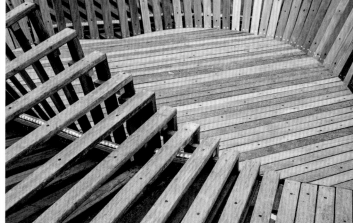

Situ Studio

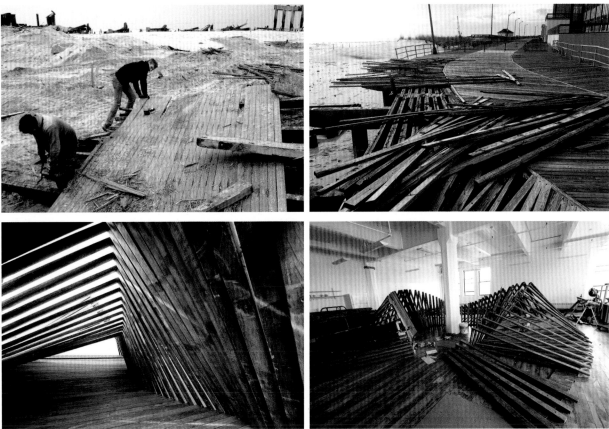

Situ Studio

The salvaging process entailed working with city officials to identify sections of boardwalk that would need to be rebuilt so damaged material could be repurposed. Boards were then gathered from four locations and transported to SITU Studio's workshop in Dumbo, Brooklyn. Screws and nails were removed, salt and sand was washed away, splintered sections were trimmed off and the boards were cut to size. A number of the boards that make up the interior of the heart were planed on one side to expose the beautiful red grain of the Ipe timber that lies under the weathered gray patina. Finally the boards were assembled into triangular sections of varying size and installed in Times Square.

Sky Spotting Stop

Design Architects: *SO? Architecture and Ideas*

Project Size: *1,100 m²*

Location: *İstanbul, Turkey*

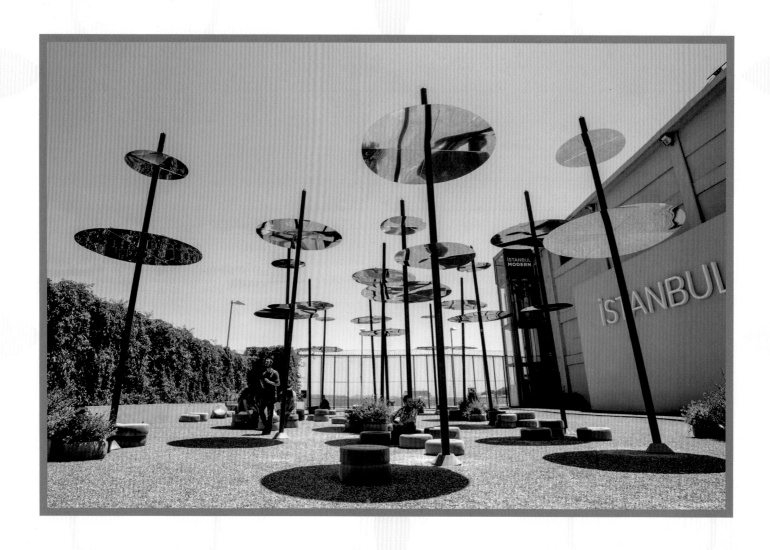

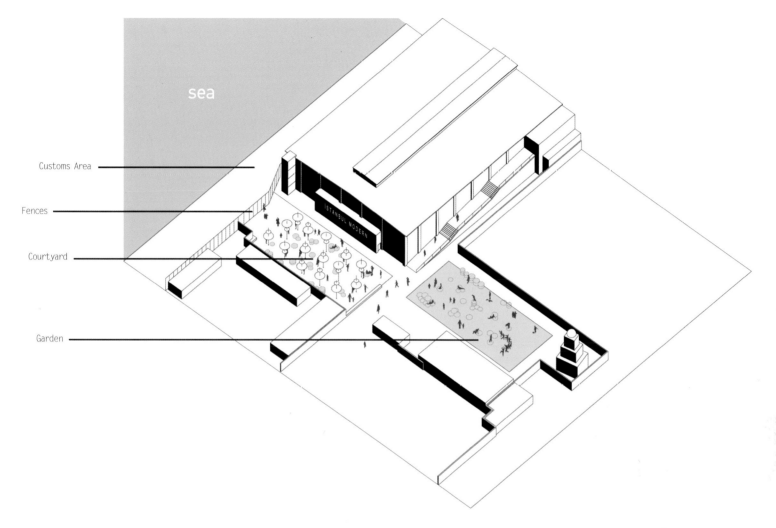

sea

Customs Area

Fences

Courtyard

Garden

ISTANBUL MODERN

Site Plan

Sky Spotting Stop is an installation by SO? Architecture and Ideas that shades the courtyard of Istanbul Modern while floating gently on the hidden waters of the Bosphorus. While the illuminated mirror plates create an invariably changing background for night events, they provide constantly swinging shadows during the day.

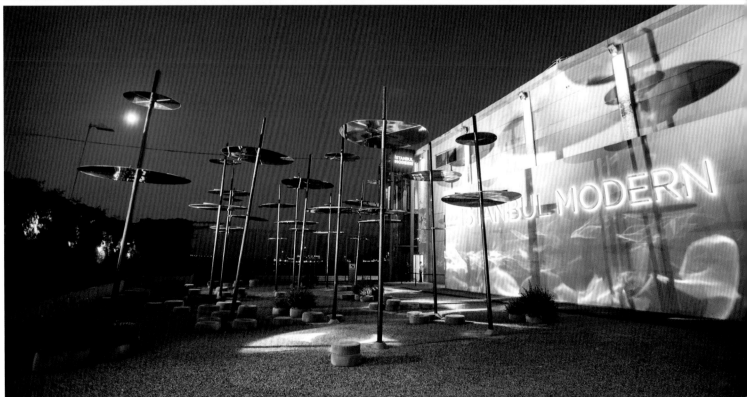

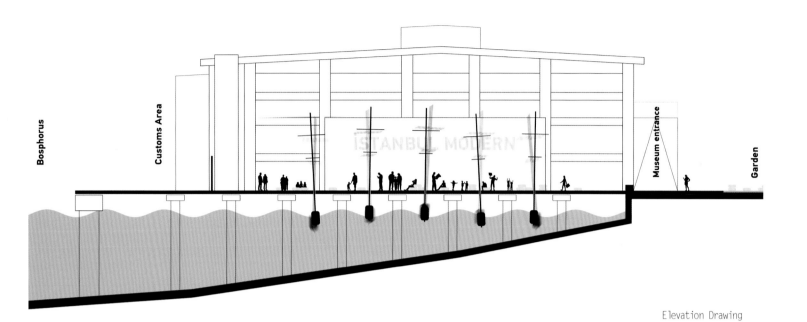

Elevation Drawing

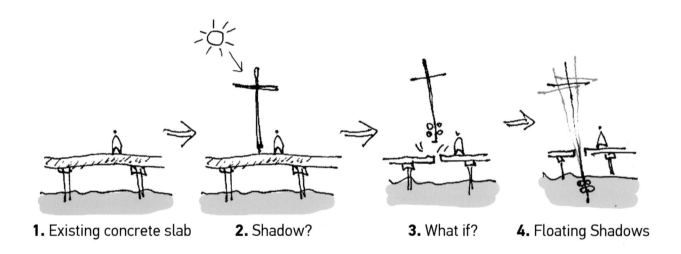

1. Existing concrete slab **2.** Shadow? **3.** What if? **4.** Floating Shadows

Design Drawing

On the ground, an altering landscape made of reused vehicle tires which are covered by fishnets transforms the courtyard to a new stop for sitting, resting, gathering, playing, or sky spotting.

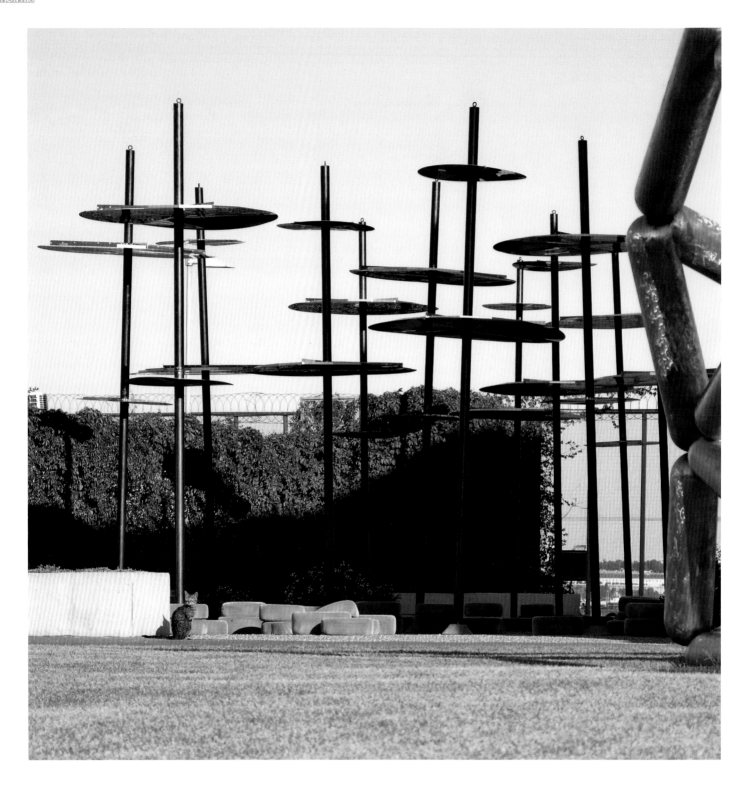

The courtyard of Istanbul Modern was built in the 50s as a wharf on the Bosphorus, where huge fight ships dock. The project site, though located

by the Bosphorus, is now disconnected from the coastline by a customs zone fence.

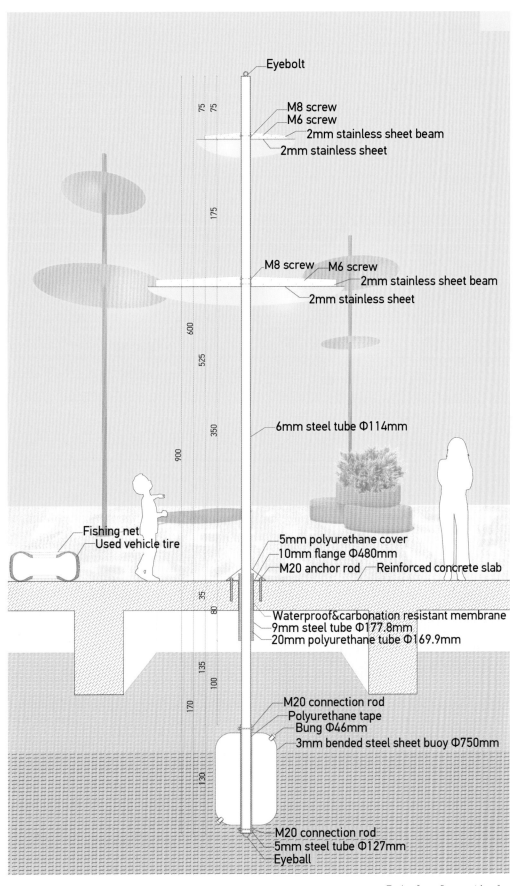

Eyebolt

M8 screw
M6 screw
2mm stainless sheet beam
2mm stainless sheet

75
75
175

M8 screw M6 screw
2mm stainless sheet beam
2mm stainless sheet

600
525

6mm steel tube Φ114mm

350
900

Fishing net
Used vehicle tire

5mm polyurethane cover
10mm flange Φ480mm
M20 anchor rod Reinforced concrete slab

35
80

Waterproof&carbonation resistant membrane
9mm steel tube Φ177.8mm
20mm polyurethane tube Φ169.9mm

135
100
170

M20 connection rod
Polyurethane tape
Bung Φ46mm
3mm bended steel sheet buoy Φ750mm

130

M20 connection rod
5mm steel tube Φ127mm
Eyeball

Technology Perspective 1

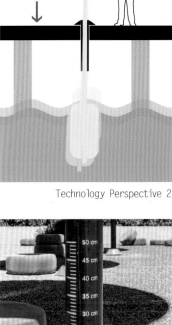

← HORIZONTAL MOVEMENT →

↻ AXIAL MOVEMENT ↺

VERTICAL MOVEMENT

Technology Perspective 2

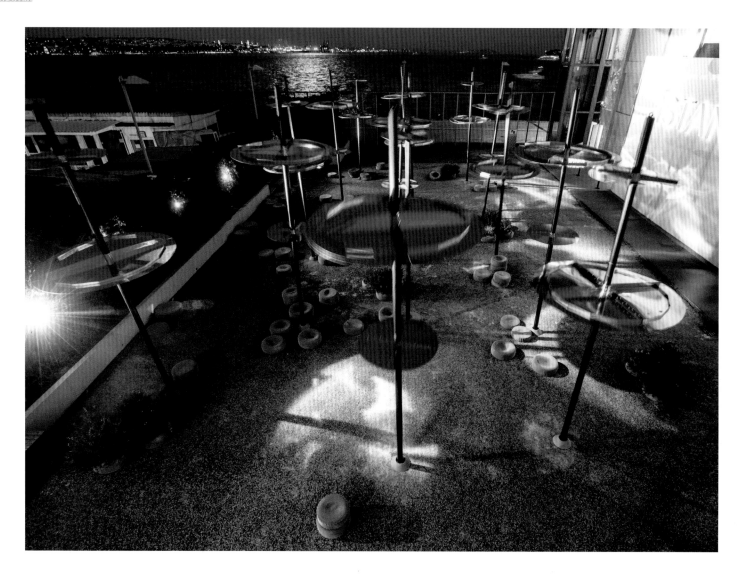

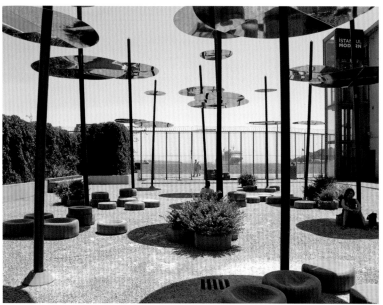

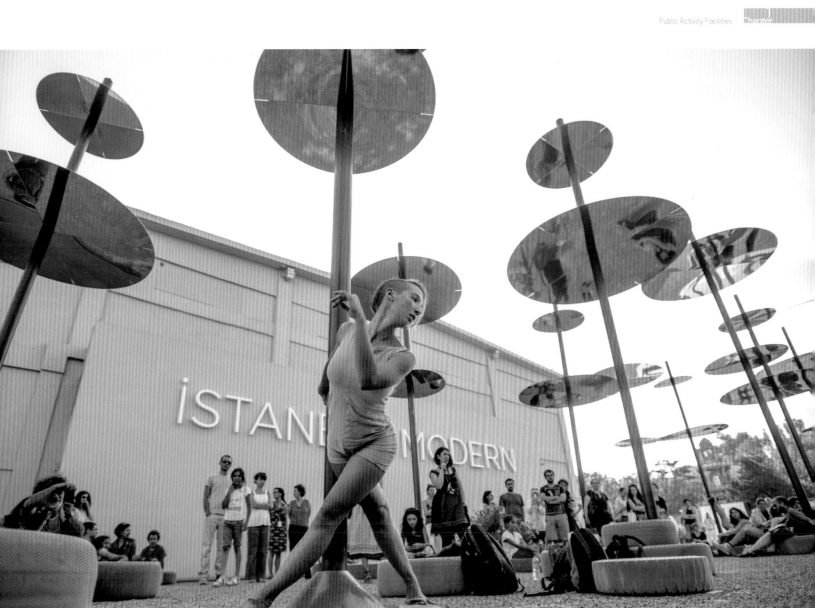

One of the objectives of the project is to create a physical connection with the sea by using the structural characteristic of the site. The movement of the water under the existing slab will be the generator of the movement in the courtyard throughout summer 2013. Besides, water will act as a structural element since the shading elements are not anchored to the existing slab, instead floating on the water with the support of buoys.

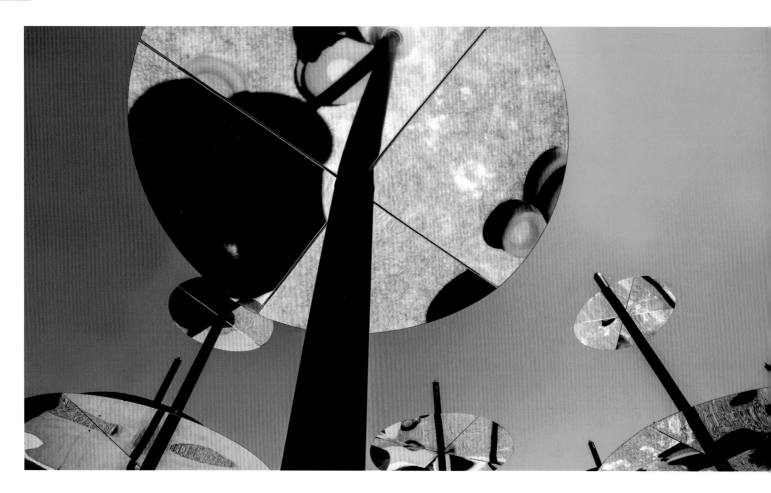

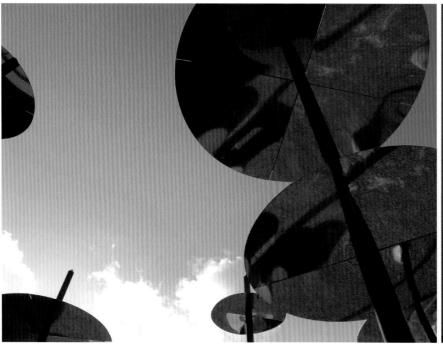

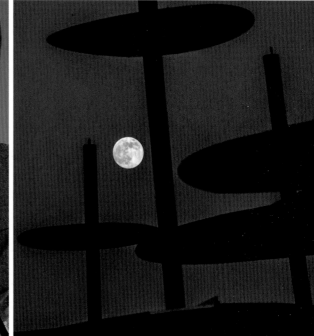

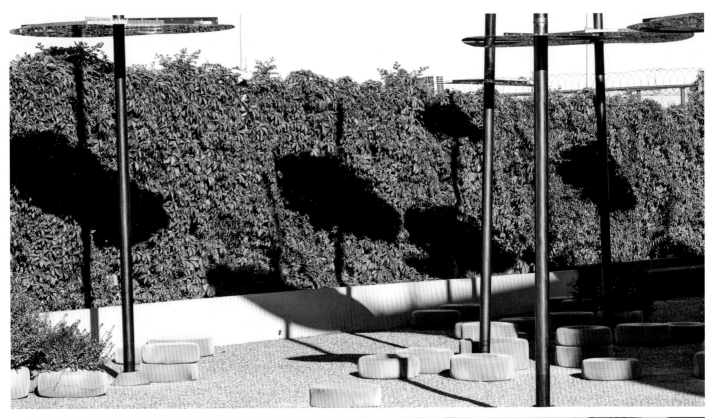

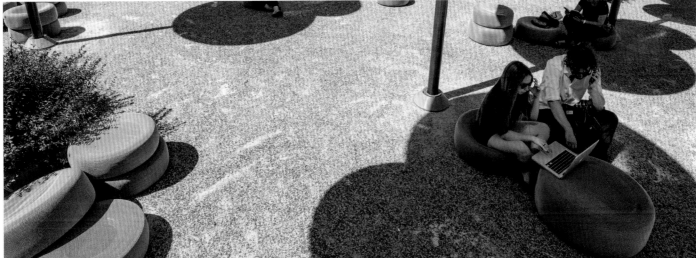

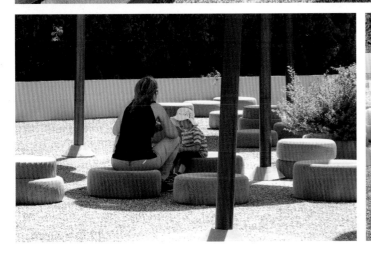

Swing

Design Architects: *Moradavaga*

Project Size: *Max of 15.10 x 4.80 m, Height of 2.20 m*

Materials: *Wooden Beams, Hemp Rope, Bicycle Chains, Wheels, Dynamos, Lights*

Location: *Plataforma das Artes, Guimarães, Portugal*

Photographer: *Moradavaga*

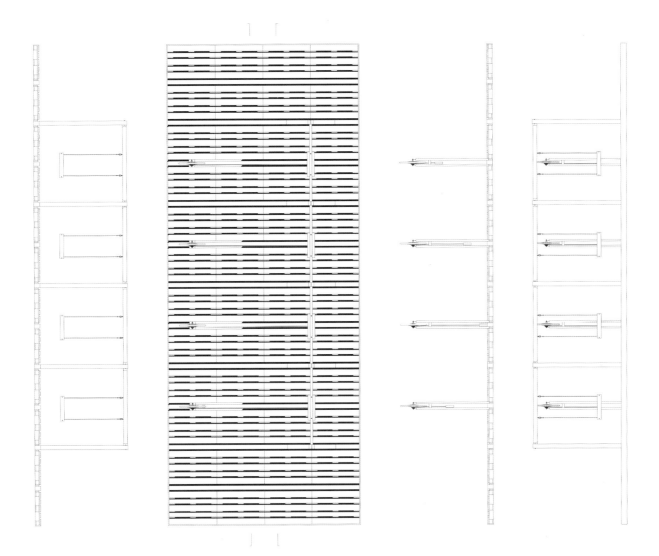

SWING is the title of an experimental work conceived by the collective Moradavaga for the Pop Up Culture program which was promoted by the European Capital of Culture - Guimarães 2012. The main goal of the installation is to produce light by swinging.

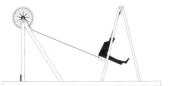

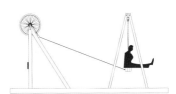

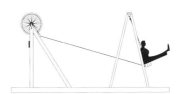

Ground Plan

091

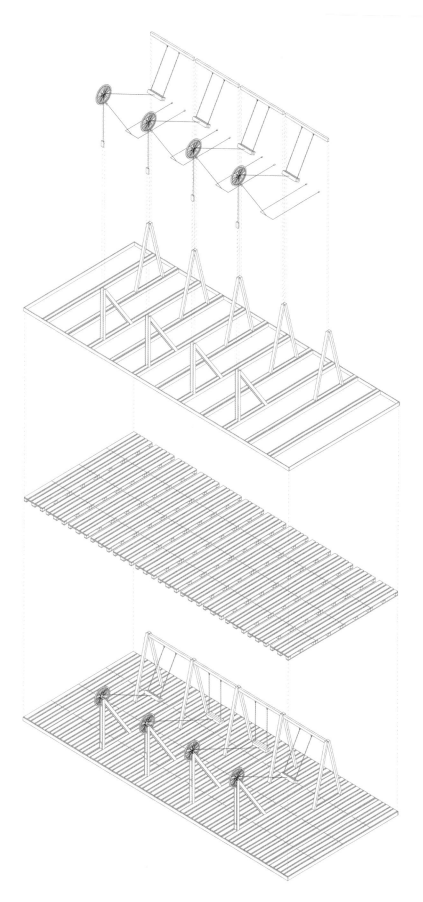

In the context of the city of Guimarães in Portugal SWING is also an ode to the rich industrial heritage of Guimarães, reflected in its mechanical devices and sounds evocative of the ones once produced in the factories of the city.

At the intersection between architecture, art and design SWING was planned to adapt the simple, familiar and approachable idea of a swing into a thought-provoking interactive work that started conversations and asked visitors to re-think how modest engineering can create sustainable energy. Doing that, it raises the question about how can we use public space and common tools in different ways and are there different means for creating and using energy?

Axonometric View

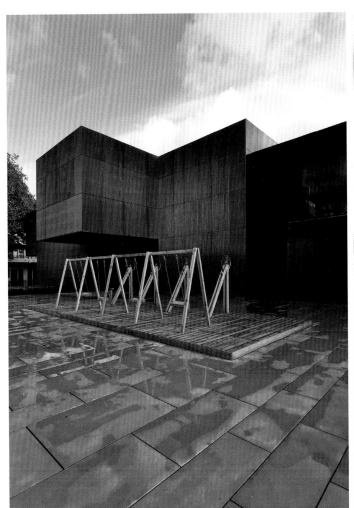

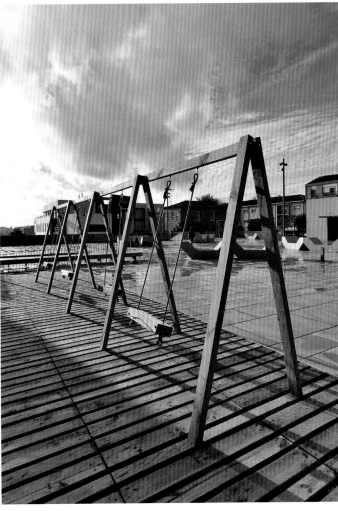

The developing of the project went through different stages regarding its construction techniques and appearance. From the first prototype built in Tramin, Italy, to the second one built in Brussels, Belgium, through to the final version in Guimarães, there was an evolution of the design towards a more down to earth solution.

Benefiting the logistical support by the company Palsystems - Pallets and Packaging Ltd. the installation was set up by the two members of Moradavaga in one week.

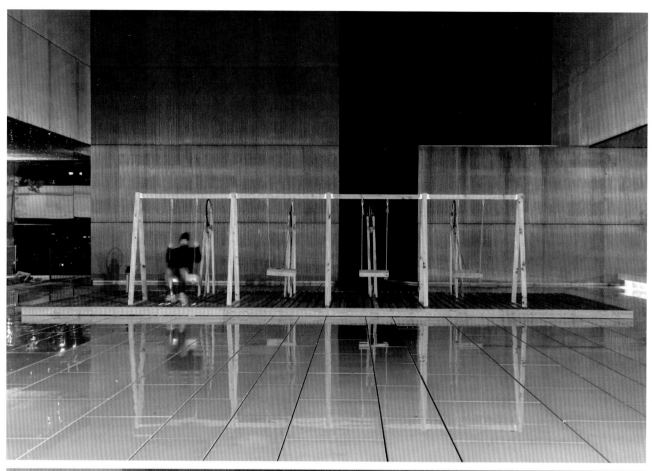

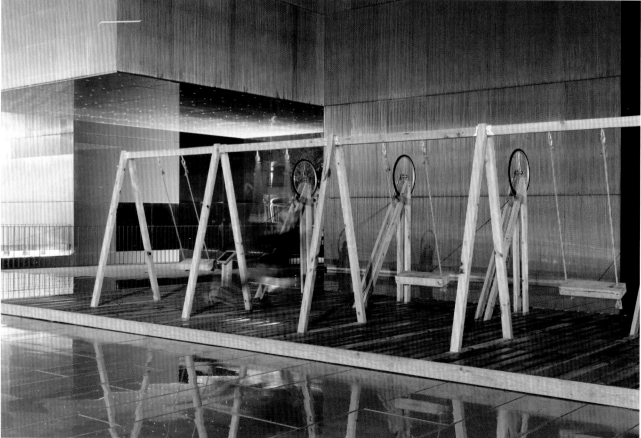

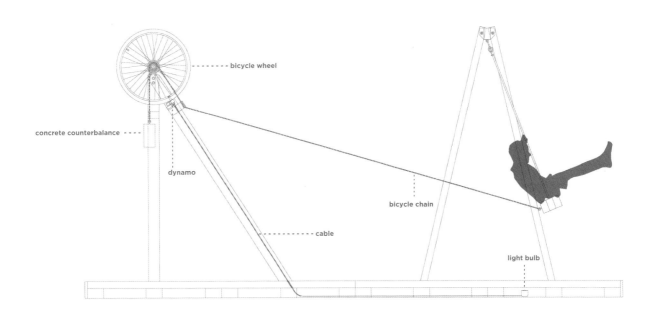

bicycle wheel

concrete counterbalance

dynamo

bicycle chain

cable

light bulb

Section Drawing

The base platform (4,844 mm x 11,230 mm) with the Euro-pallet as the main construction element, consist almost entirely of wood, to serve as a podium structure of the swing and to contain the hidden electrical system. Traditional hemp rope, chains, wheels, dynamos and bicycle lights, concrete counterweights, metal fittings and screws complete the palette of materials used in the construction of SWING.

As a kind of a low-tech construction SWING was able to establish, during his short two weeks long stay at the Plataforma das Artes in Guimarães, an interesting contrasting dialogue with the square facing hi-tech metal and glass building designed by the atelier Pitágoras Arquitectos.

Since it was an ephemeral work, the factor of sustainability was an important aspect in the choice of materials and construction. So, all used materials can be reused or recycled and reintegrated in the circuit.

The Reading Nest

Design Architects: *Mark Reigelman*

Location: *Cleveland, Ohio, USA*

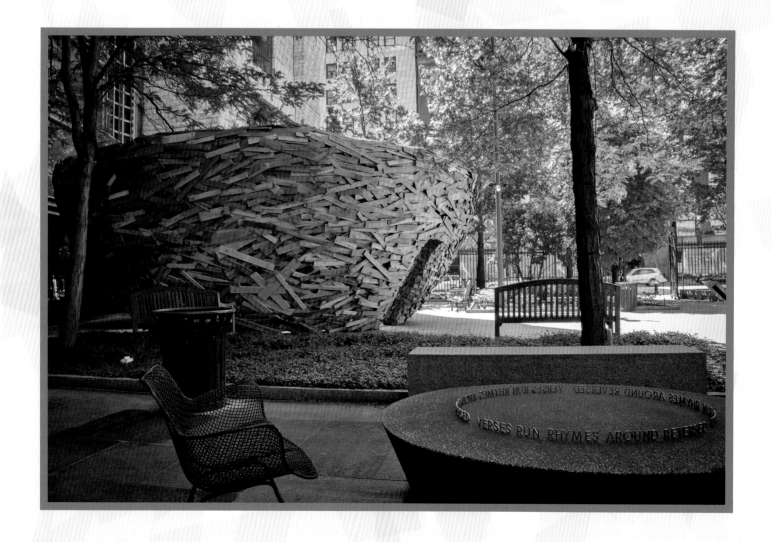

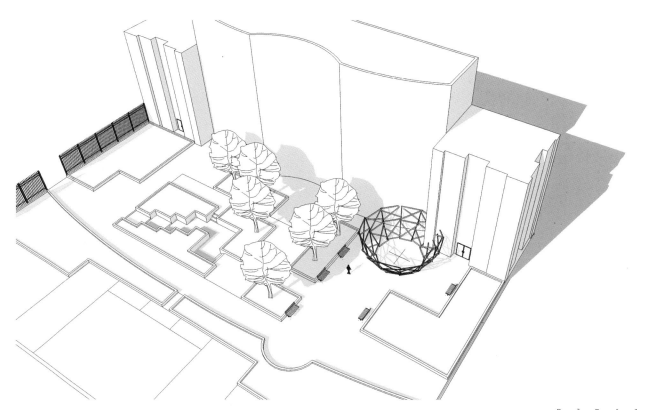

Develop Drawing 1

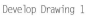

Develop Drawing 21

Overall

The Reading Nest is a temporary site specific installation by Mark Reigelman inspired by mythical objects and symbols of knowledge.

097

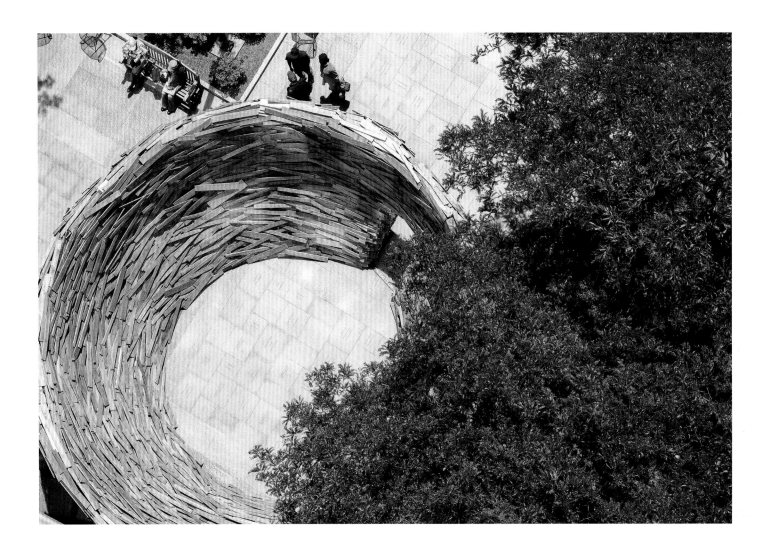

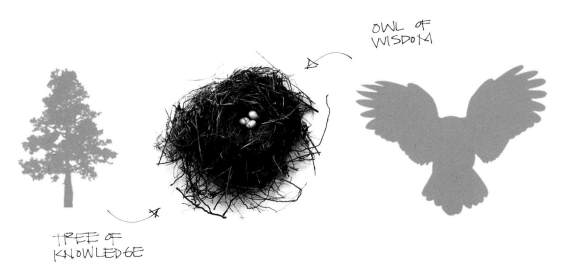

OWL OF
WISDOM

TREE OF
KNOWLEDGE

Develop Drawing 3

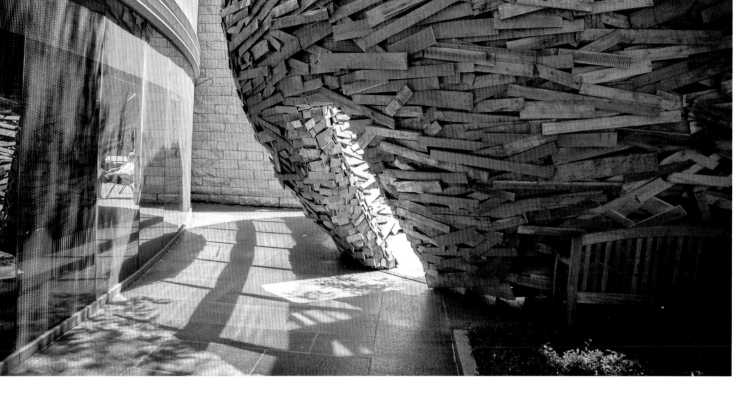

Concept

For centuries objects in nature have been associated with knowledge and wisdom. Trees of enlightenment and scholarly owls have been particularly prominent in this history of mythological objects of knowledge. The Reading Nest is a visual intermediary between forest and fowl. It symbolizes growth, community and knowledge while continuing to embody mythical roots.

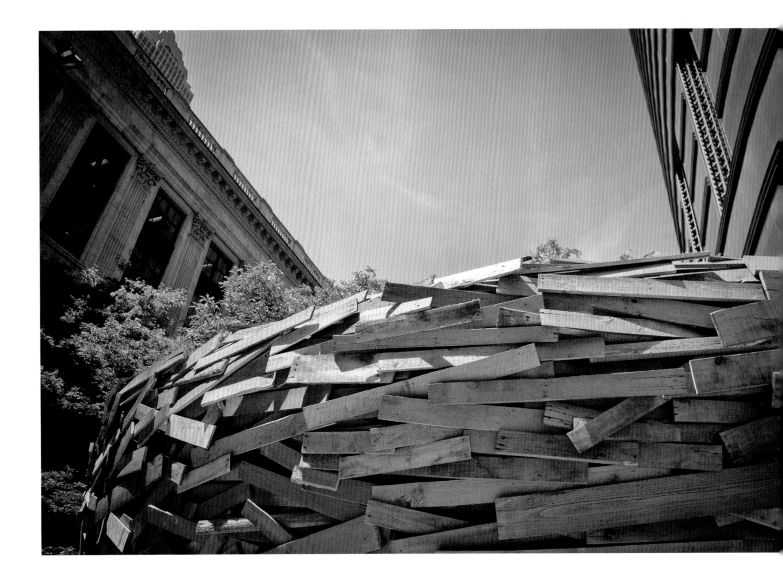

Process and Specs

The Reading Nest was created with discarded wood boards that were obtained through local Cleveland industrial and manufacturing sources. A basic wooden 5 × 10 cm armature was built and reinforced with 61 m of steel cable. The armature was cladded with over 10,000 discarded palette boards which were held in place by approximately 40,000 nails. It took a team of 5 guys 10 full days to complete the installation. The final work stands approximately 4 m tall and 11 m wide.

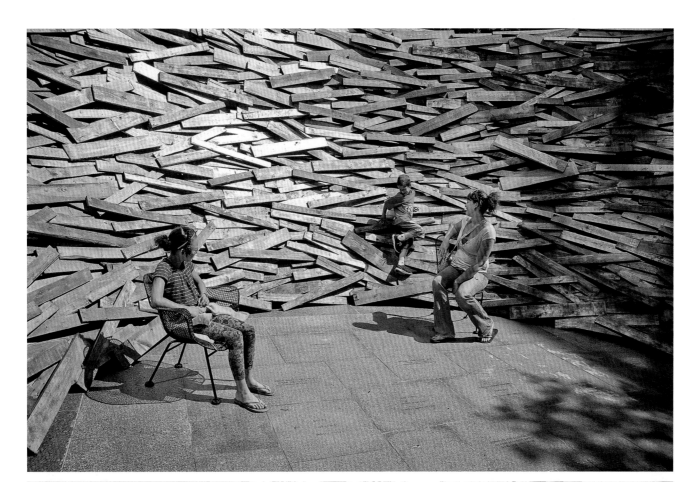

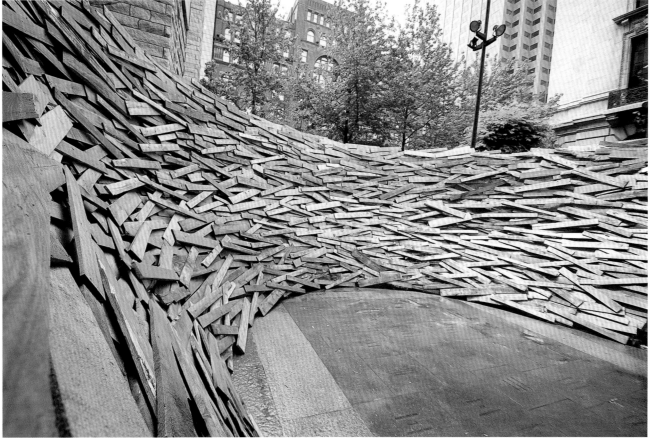

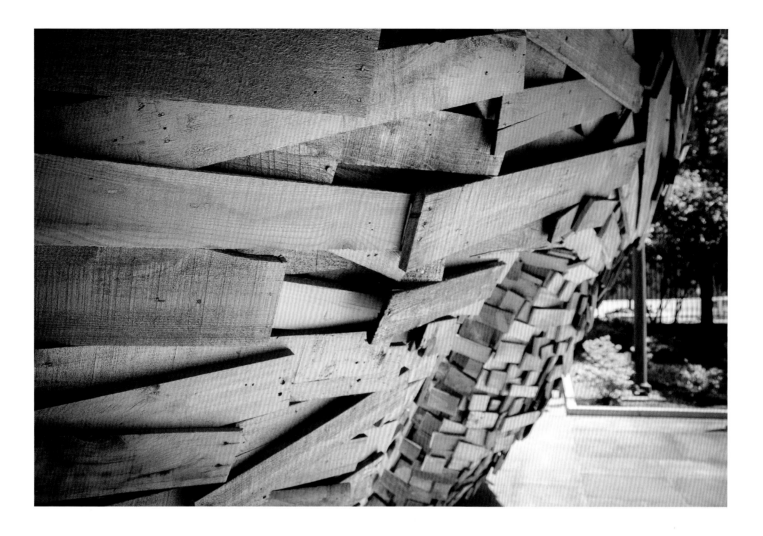

Color

The Reading Nest is comprised of 10,000 reclaimed boards. 4,000 of these boards were left raw and weathered while 6,000 were painted with a gold exterior paint. The exterior of the nest is a combination of raw boards and golden boards while the interior is completely covered in golden boards. During the day the installation offers a powerful glow and an intense experience for visitors. This color choice was inspired by the legendary Griffin. This king of beasts, with the rear body of a lion and the head and wings of an eagle, is said to have made its nest of pure gold and, as such, protected it ferociously. The Griffin is regularly seen sculpted from stone and standing guard at the entrances of civic buildings across the country including The Cleveland Public Library.

Lightscape Pavilion

Design Architects: *Miso Soup Design*

Project Size: *21.2 m²*

Materials: *Bamboo Dowel, Laser Computer-numerical-controlled Acrylics*

Location: *Taipei Treasure Hill Artist Village, China*

Photographer: *Miso Soup Design, Daisuke Nagatomo*

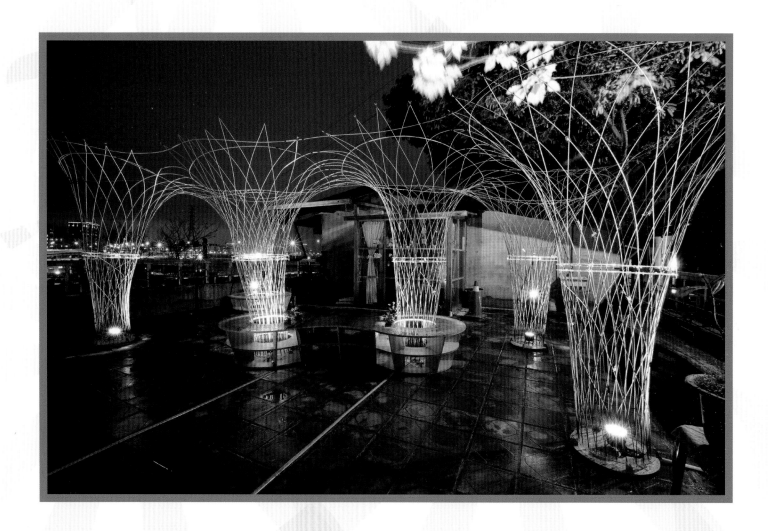

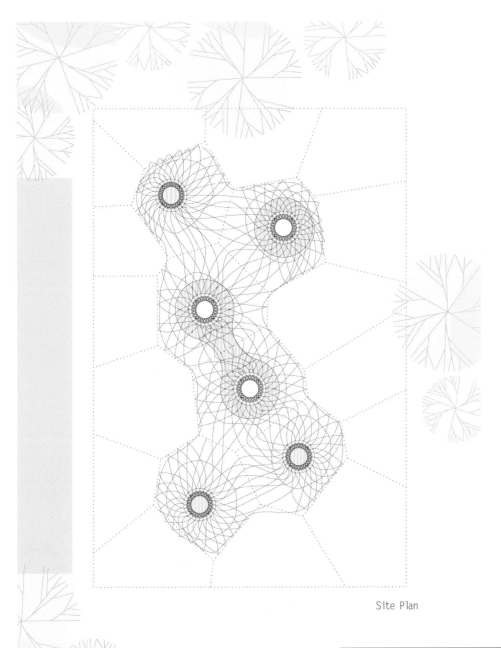

Treasure Hill in Taipei is an old settlement with a vision of an artist compound. The contrast between the new and the old, villagers and the artists, creates an interesting dialogue, which can be experience by the visitors.

Site Plan

Conceptual Sketch

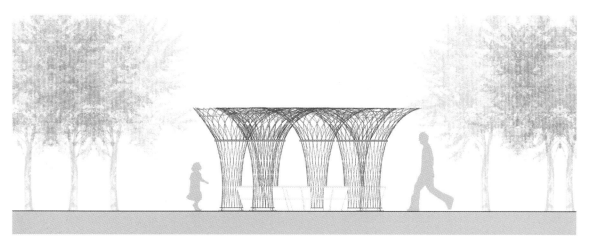

Elevation Drawing 1

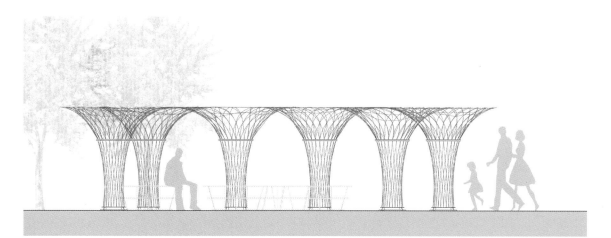

Elevation Drawing 2

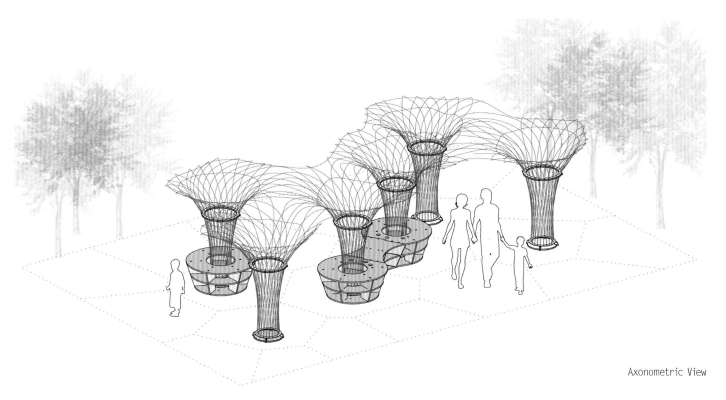

Axonometric View

 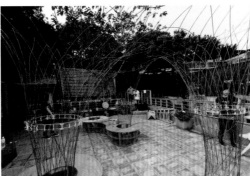 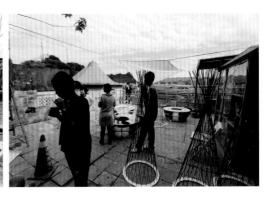

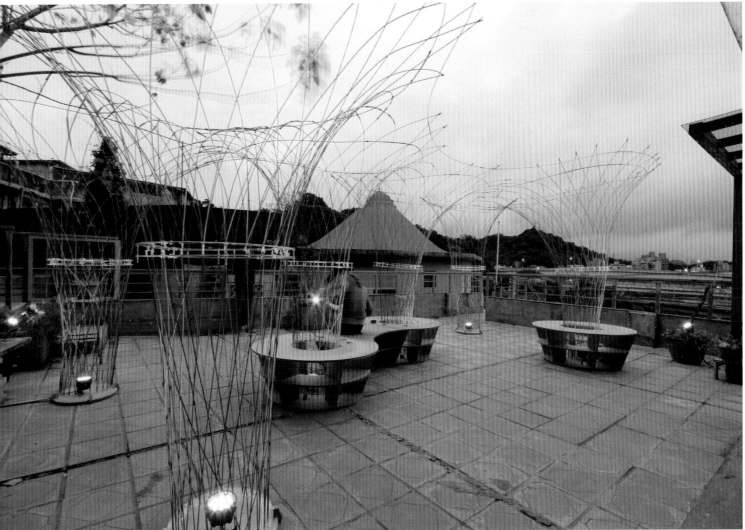

To echo Treasure Hill's spirit, Miso Soup Design's founder Daisuke Nagatomo and Minnie Jan believes it is important to inherit the old to innovate the new. Situated at the highest point of Treasure Hill, the Lightscape Pavilion becomes a focal point that can be seen from far away.

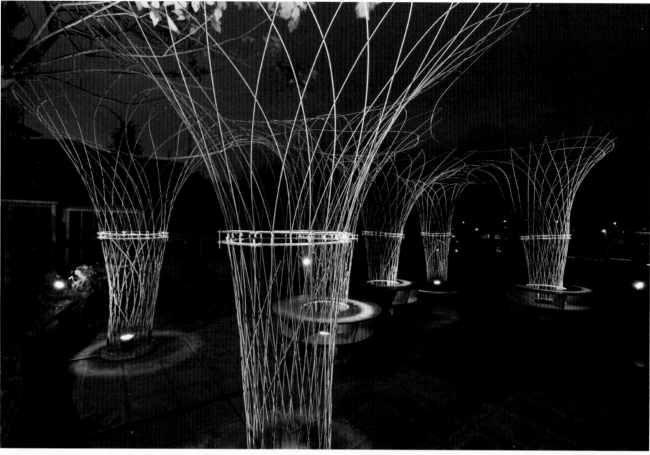

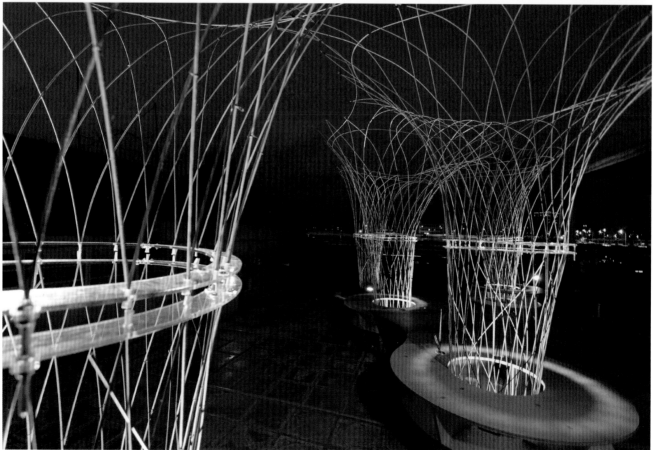

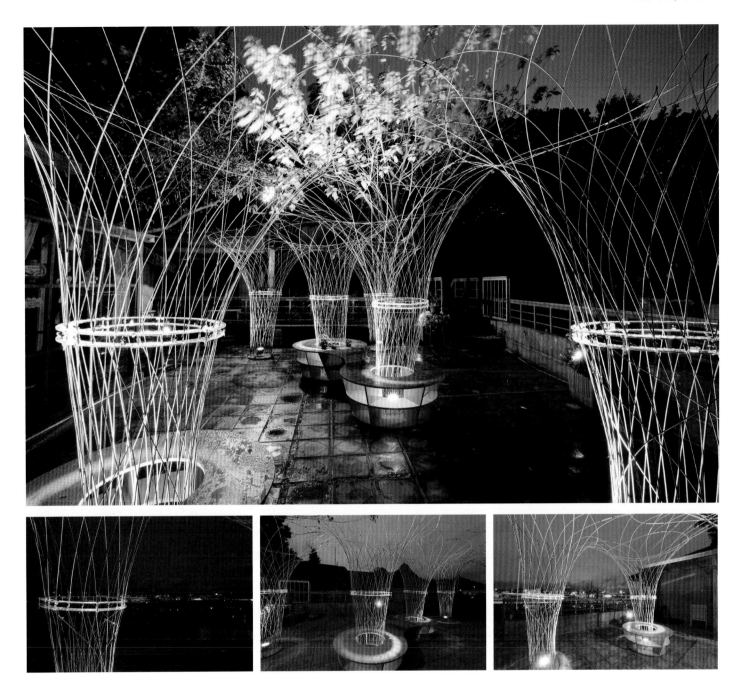

The design concept is inspired by the traditional Chinese lantern, which is made with bamboo and paper. This pavilion is a lightweight structure, accompanied with curved resting benches and lighting. In the evening, the lights gently pass through thin bamboo dowels and create a soft, delicate atmosphere.

Trylletromler

Design Architects: *FABRIC (Amsterdam)*

Location: *Kongens Have, Copenhagen, Denmark*

Photographer: *Walter Herfst*

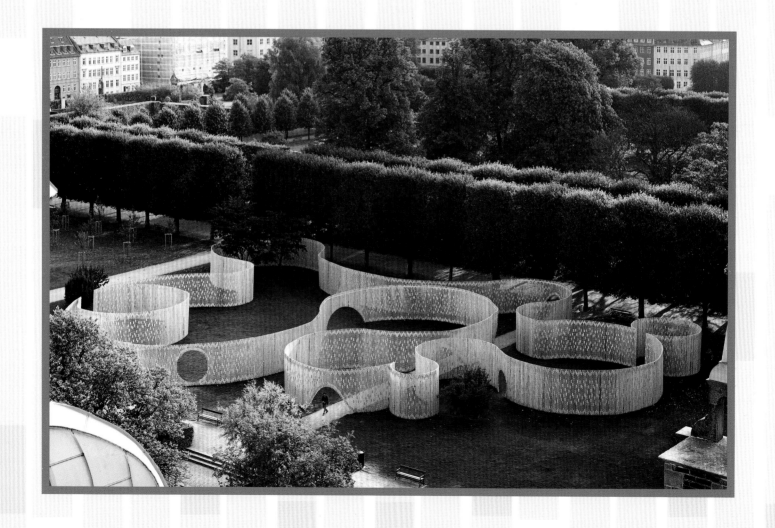

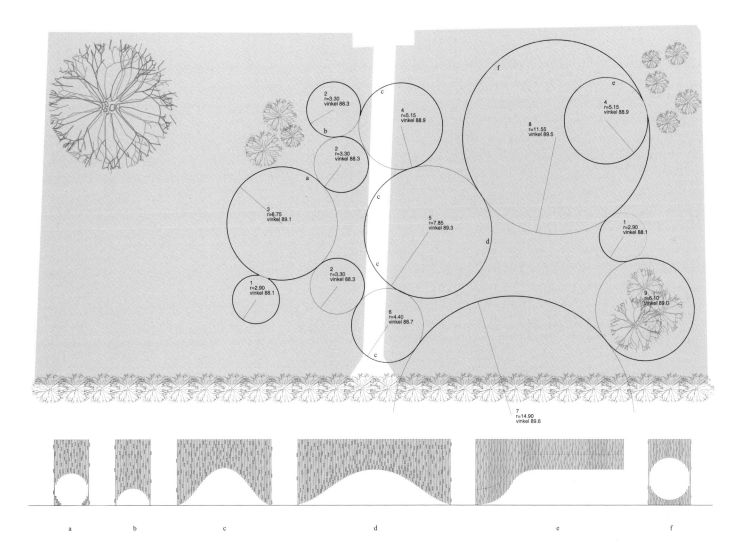

Site Plan and Facade Details

The Dutch design firm FABRIC (Amsterdam) has built a pavilion in the Kongens Have (ed. King's Garden) in Copenhagen. The design is named 'Trylletromler', the Danish word for zoetrope. This 19th century device activates an impression of movement within a still image. The pavilion is a result of international design competition issued by the Danish Akademisk Arkitektforening early this year, which was won by FABRIC.

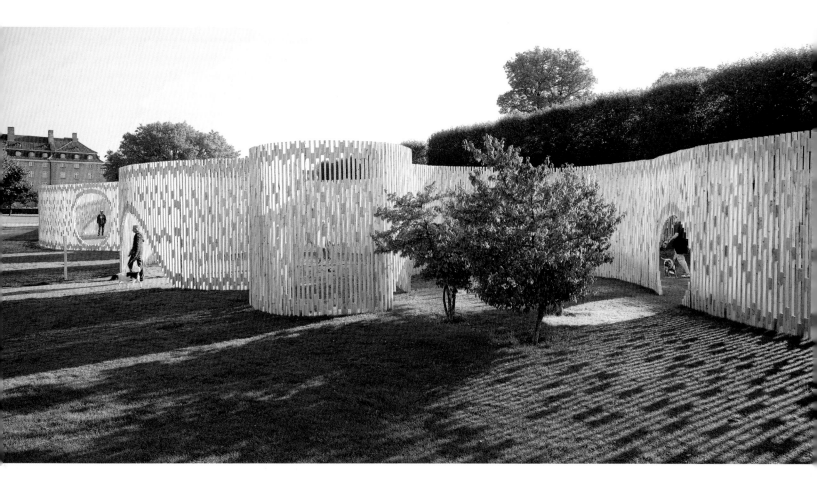

The Renaissance garden design of Rosenborg Castle is the oldest known example of garden design in Denmark. The design draws heavily on principles of Euclidean geometry. This language of absolute space was long regarded as the construction principle of the world. The architecture, urbanism and landscape design that were derived from it, were essentially aiming to create order out of chaos using absolute shapes: line, square, triangle, sphere and cone. In a later stage baroque elements were added, such as mazes and diagonal paths. Also Kavalergangen and Damegangen, two tree-lined avenues, were introduced. After these alterations the garden was never drastically changed. This classical representation of space was meticulously maintained until today.

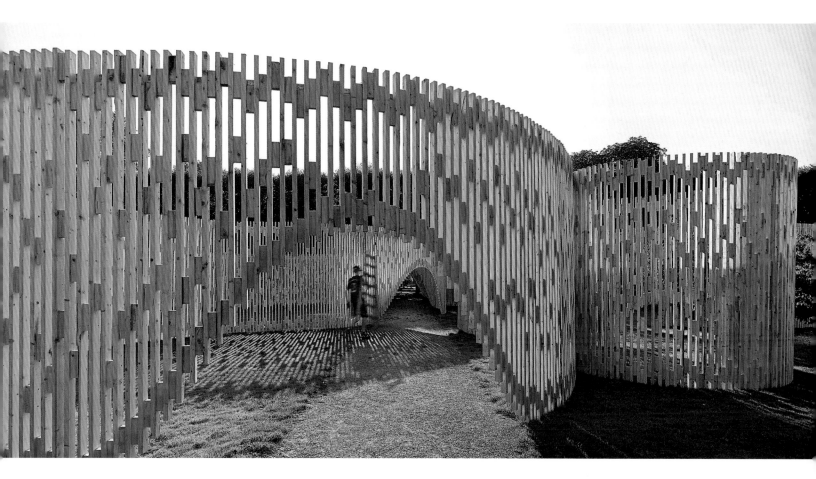

This is the context for the question to design a pavilion, which is accessible to all public, appears innovative in its spatial expression and is challenging by its idiom. While remaining removable the design had to be realized within a very limited budget. FABRIC therefore introduced a new spatial concept in the royal garden in Copenhagen by stretching the understanding of the 'pavilion' towards the most elementary architectural element in garden design: the fence. This new understanding of space provided by questioning strict order in the garden design and give way to ambivalence and hybridity is a ' blurring strategy' . This strategy addresses three independent paradoxes by provoking the notions inside and outside, by introducing a maze that is paradoxically transparent and by creating an illusion of motion.

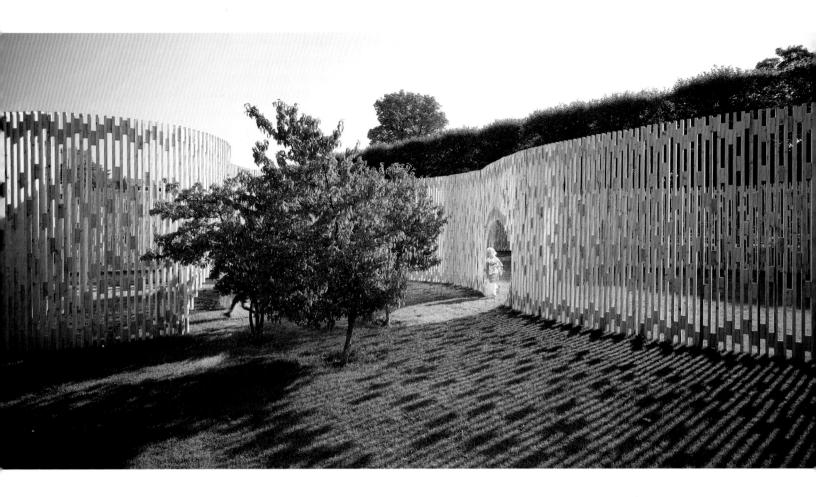

First of all, the fence as a freestanding structure is designed to restrict movement across a boundary. By folding and wrinkling the fence on the location, it produces new meanings of being spatially included or excluded.

Secondly, openings in the fence create routes through the pavilion. Most openings in their appearance resemble a partly raised curtain, making the fence look very light. By avoiding openings on obvious routes on sightlines, visitors are forced to find their way through the sequence of circle shaped spaces. And not all the openings are accessible to everybody. Some openings only allow kids into the pavilion, escaping their parents gaze as they explore the pavilion. The fence so to say acts like a see through maze.

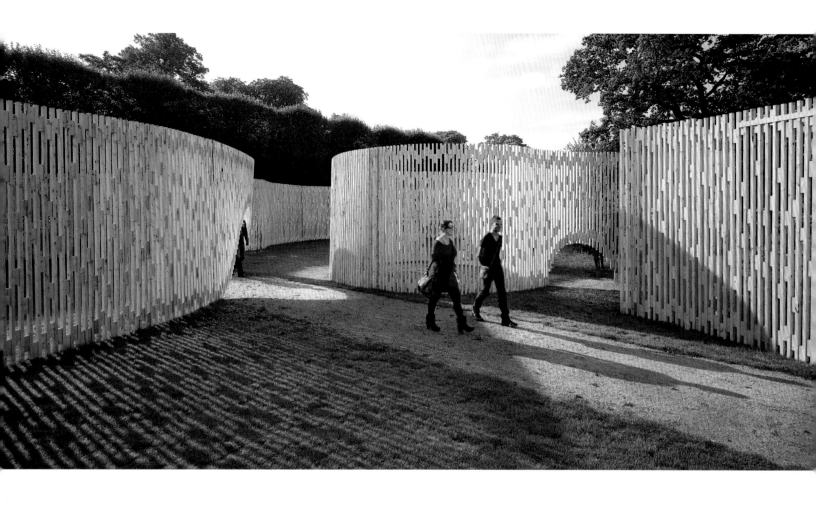

Thirdly, the fence gives new meaning by its potential to create the illusion of motion via the so called moiré patterns while moving along the fence. The fence is made out of three thousand standard pieces of Nordic timber, which are joined using an irregular pattern of wedges. The repetitive openings between the bars of the fence and their connections create a continuous moving image. When one thinks of a fence made out of sticks with narrow vertical slits arranged on a circular layout the image of a Zoetrope - or 'wheel of life' - jumps to mind. This 19th century device triggers an impression of movement within a still image.

Based on these three principles an intriguing floor plan was designed using a composition of ten perfect circles. The plan design reacts to given circumstances such as the exit of the rose garden, the statue by the water, sightlines towards the castle, existing tree lines and the position of solitary trees.

The maze like structure has in fact only one detail for all its connections. The entire structure built with 2,967 standard pieces spruce of 38 millimeters thick and 68 millimeters wide. The narrow side of the uprights is placed forwards, while the cross-links are made of the same wood rotated ninety degrees. Each cross-link has a height of 200 millimeters and is planed under an angle on one side, so a circular structure arises. The fence is prefabricated in segments of one meter, which are screwed together at the site and anchored into the ground. The result is a 308 meter long winding wooden sculpture. Because the spruce is used untreated, all the material can be fully reused after the deconstruction of the pavilion.

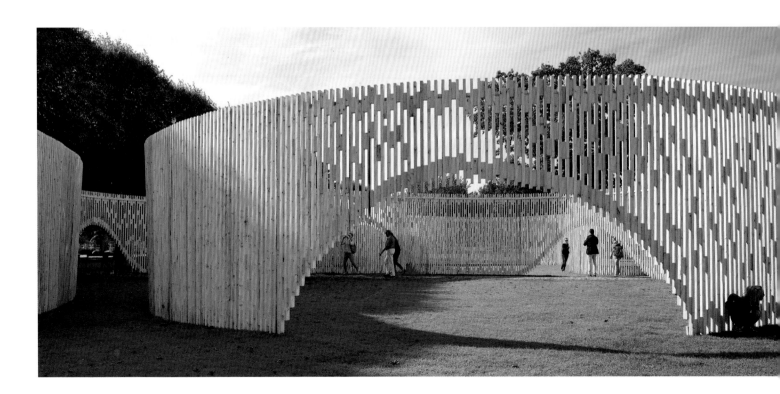

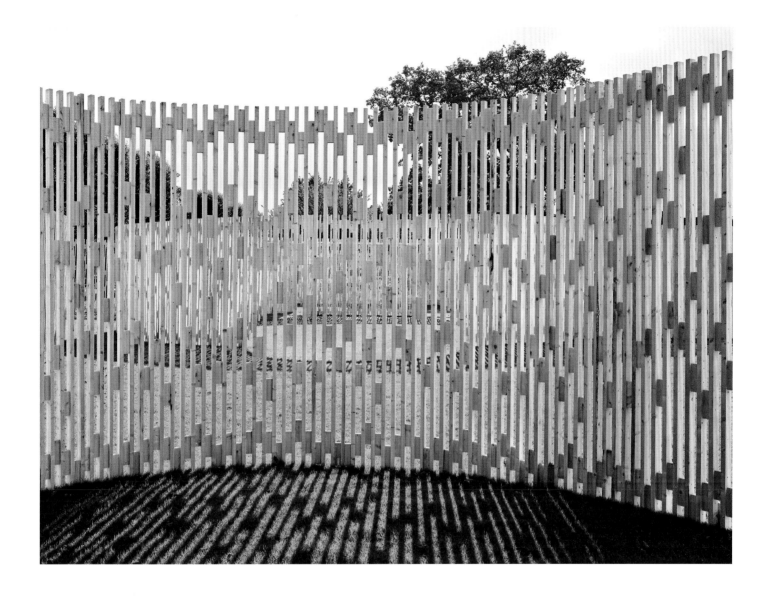

The spatial quality offered by the pavilion is supported by the many rooms and directions users can explore. According to the jury the project therefore demonstrates the best desire and ability of architects to challenge and give new meaning to the concept of the pavilion. "We are very pleased that we can support this initiative to have a pavilion - after international model – build here in Denmark for the very first time. Both the Danish and international public will have the opportunity to see alternative and innovative solutions for the construction industry. This is fully in line with our aim to support projects that promote the architectural profession from development and interaction with the community", says Bo Rygaard, CEO of The Dreyer Foundation, which has supported the competition.

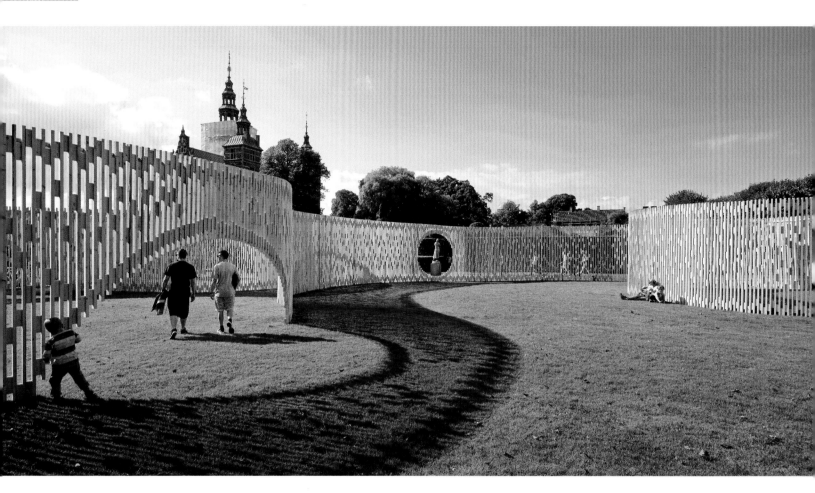

The use of the pavilion by the visitors confirms the jury in its judgment. King's Garden is opened daily from sunrise till sunset. During that time there appears to be no moment when people are not using the pavilion. The fence proves to have a great attractive effect. People wonder amazed through the winding structure. Kids immediately recognize the potential of this enormous playset, but also adults take full possession. Whether it's romantic couples, a club of bike messengers, runners, people walking their dogs or people who enjoy their lunch outside everyone finds a place in this endless fence. A fence thus that no longer separates but also connects unites and astounds people. A fence that stretches the concept of a pavilion and above all marks the launch of a new ambition to organize this yearly event in Danish architecture.

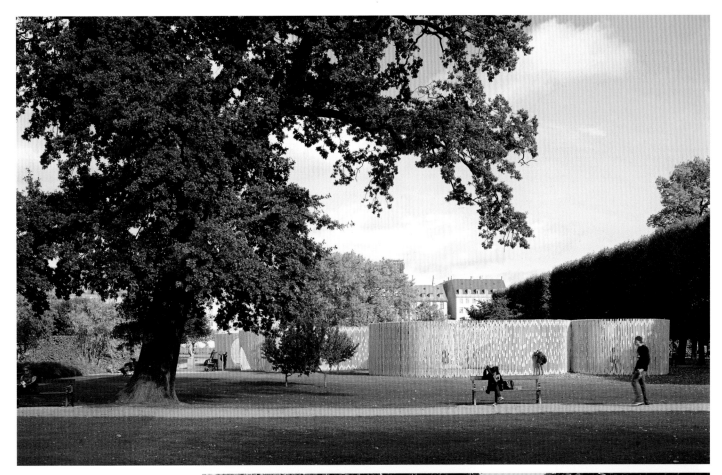

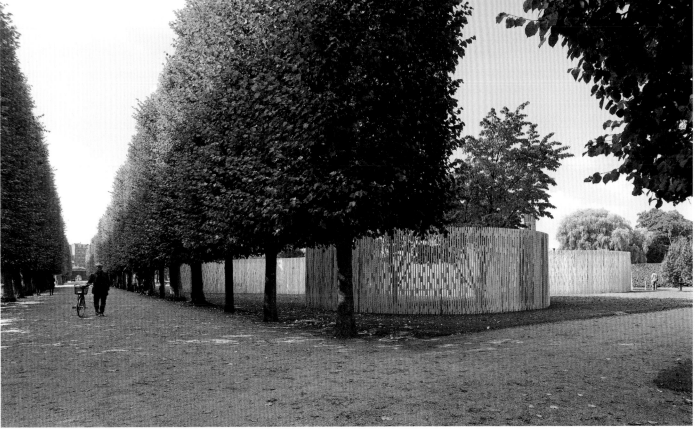

Yoshi Bar

Design Architects: *Naoya Matsumoto Design*

Location: *Seian University of Arts and Design, Shiga, Japan*

Photographer: *Takeshi Asano*

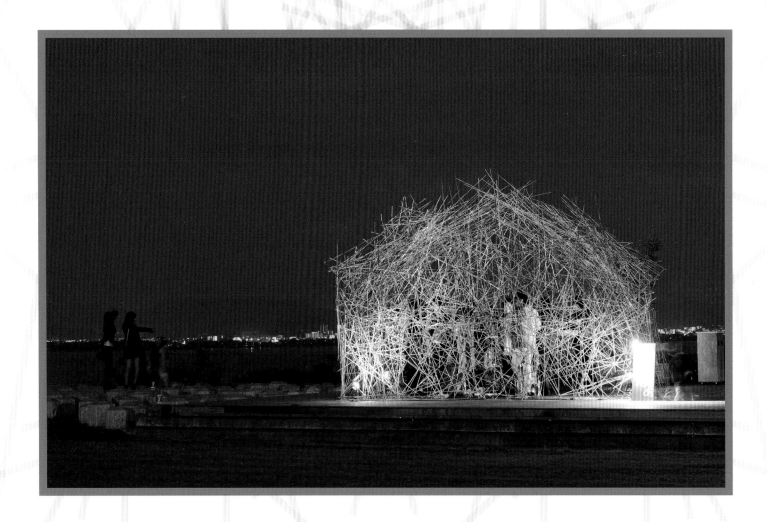

This is the second time I used reed which is grown in Biwako Shiga, as a material for a stall (a food wagon?) for school festival. Though last time 1 used it simply for a place to sell Oden, one of the Japanese traditional food this time I added the idea of 'systematic' (there is a certain rule exists where I found interesting.) First of all I prepared six panels of reeds and put them (the front, back, left, right and the tops for the roof parts) together with reeds. As a panel it doesn't stand itself yet but putting them together and building them makes it possible to stand and gives us some space inside.

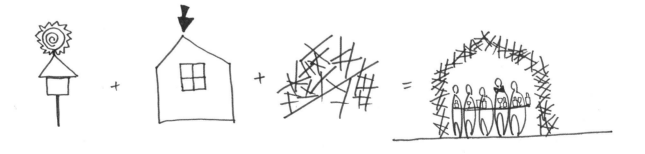

Design Sketch

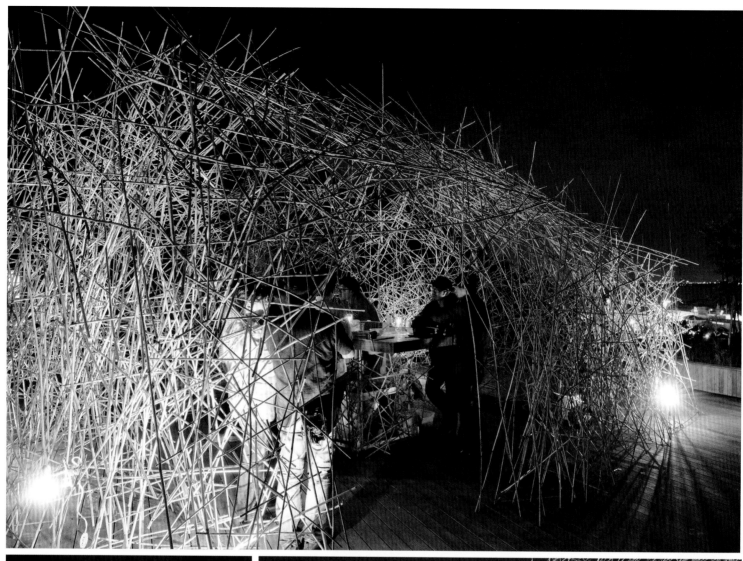

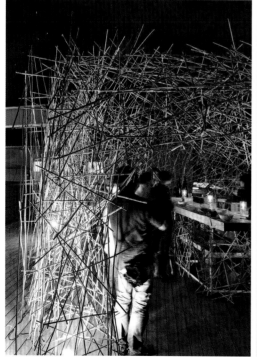

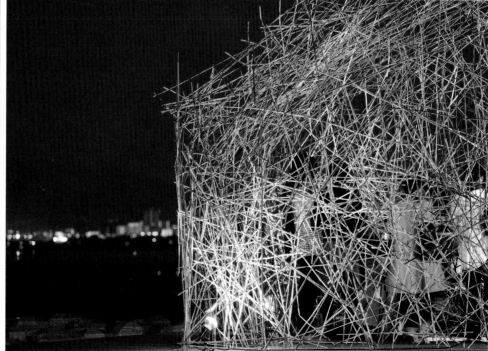

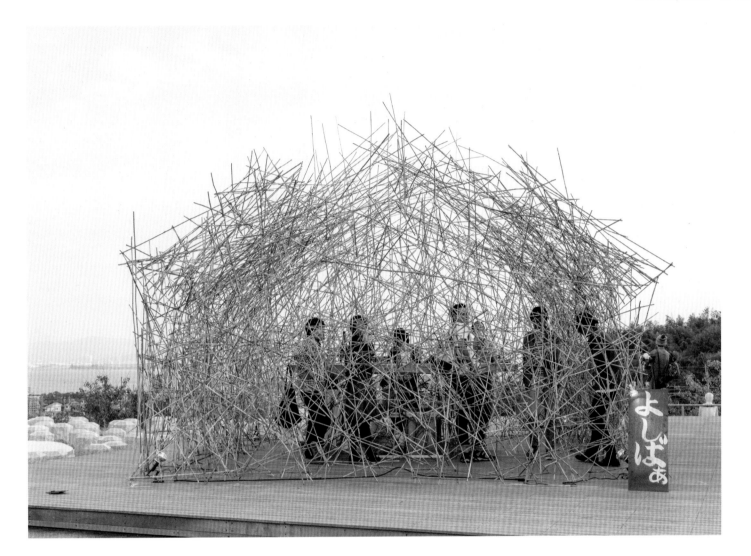

Seen from the front of the stall structured randomly but systematically, the stall looks like a gabled roof which is familiar to the Japanese Oden also is familiar and usually reminds us of our mom's cooking. A small discovery of a roof and a memory of their mom's cooking (taste of our mom) made the people feel relaxed and came to buy food with a warm feeling when a chilly day. It takes only a couple of days to build this type of stall and it can be built easily. I would like to have more opportunities to provide some spaces like this kind of temporary stall for the future project.

Chapter

2

Public Application **Facilities**

Gordon Square Bus Shelters

Design Architects: *robert maschke ARCHITECTS inc.*

Project Size: *2.4 m Tall, 3.4 m Wide, 1.1 m Deep*

Materials: *Perforated Stainless Steel*

Location: *Detroit Avenue at West 65th Street, Cleveland, Ohio, US*

Photographer: *Eric Hanson, Hanson Photo Graphic*

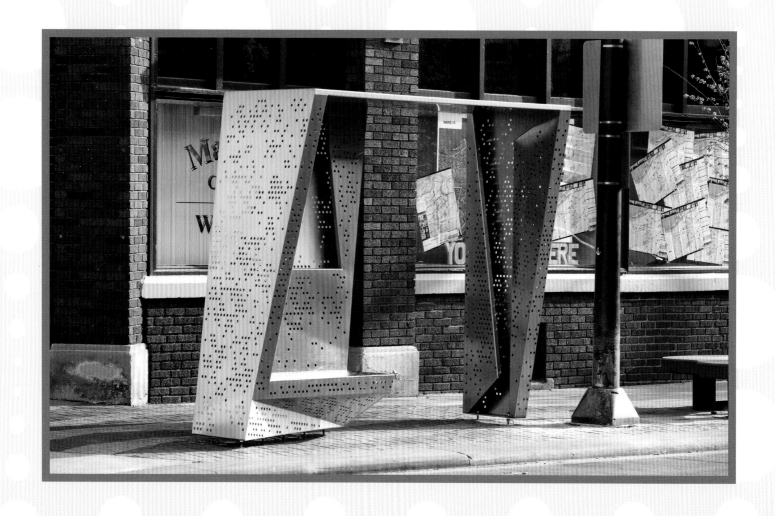

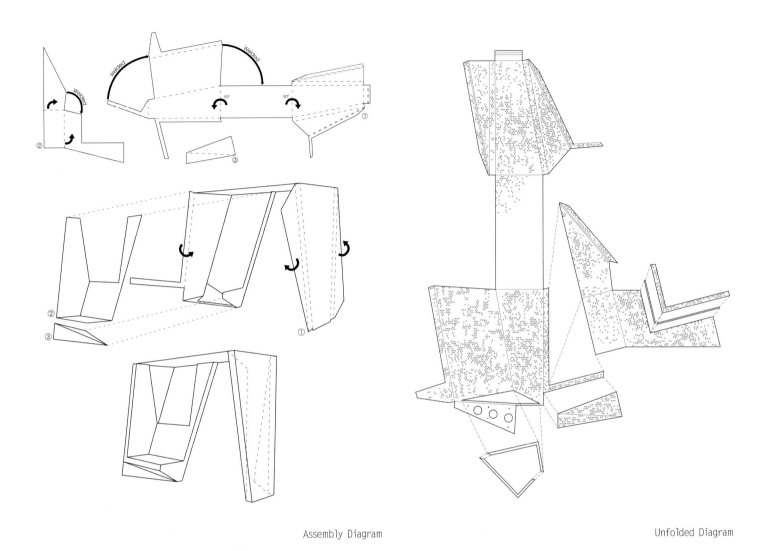

Assembly Diagram Unfolded Diagram

The project consists of two bus shelters designed for the Gordon Square Arts District within Cleveland's Detroit Shoreway neighborhood. The brief called for the creation of functional and iconic elements to be incorporated as a part of an ensemble of new pieces of public art slated for the highly anticipated Detroit Avenue Streetscape project.

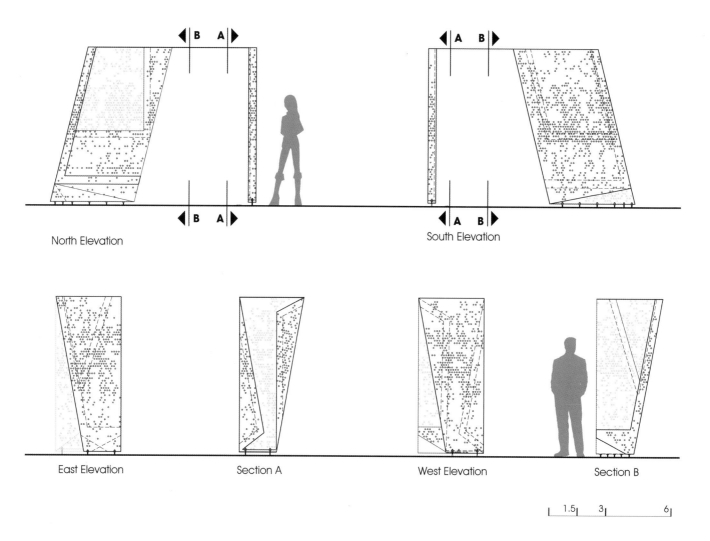

North Elevation

South Elevation

East Elevation

Section A

West Elevation

Section B

1.5 3 6

Elevation Drawing

Conceptually, the design is conceived as a single stainless steel surface which wraps and folds to create the shelter. The singular material enhances the sculptural quality of the modestly scaled shelters. Folds in the surface are determined by the accommodation of functional, contextual, and structural variables, which merge to generate the shelter's shape. A pattern of perforations moves across the surface of the shelter which responds to localized conditions of sun, wind and view.

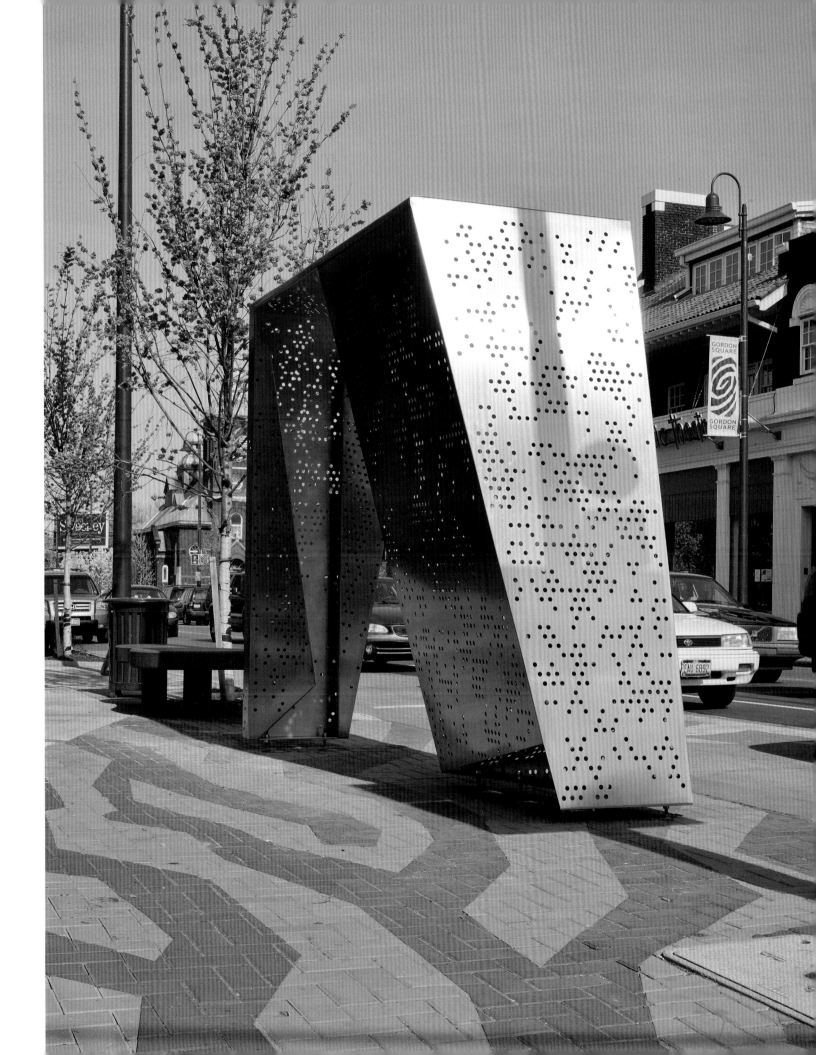

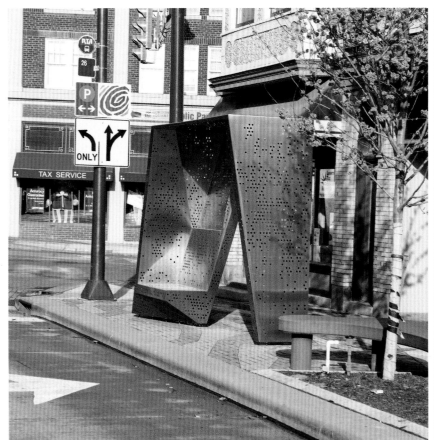
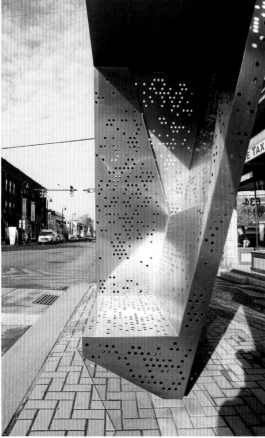
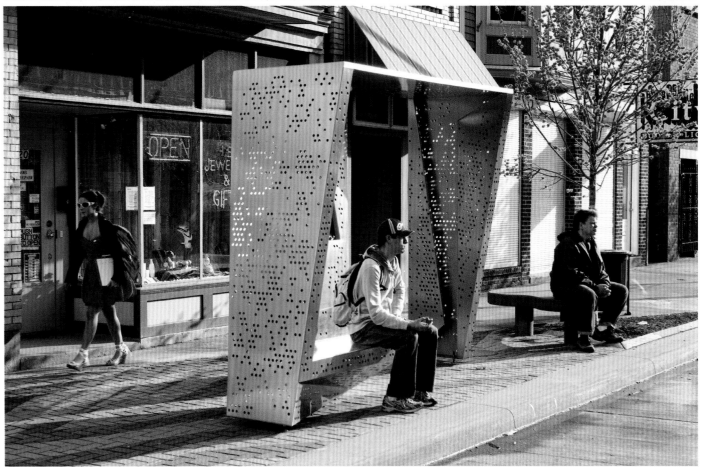

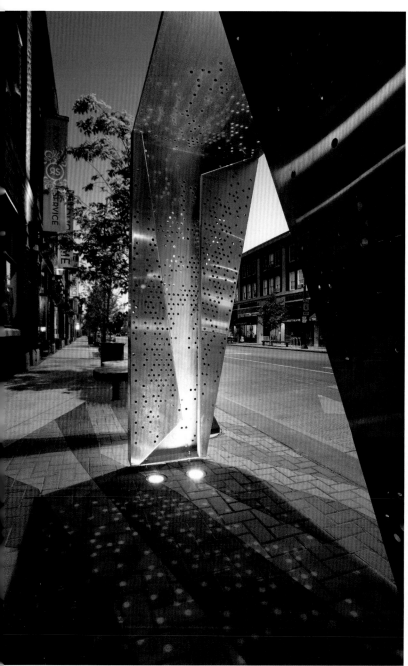

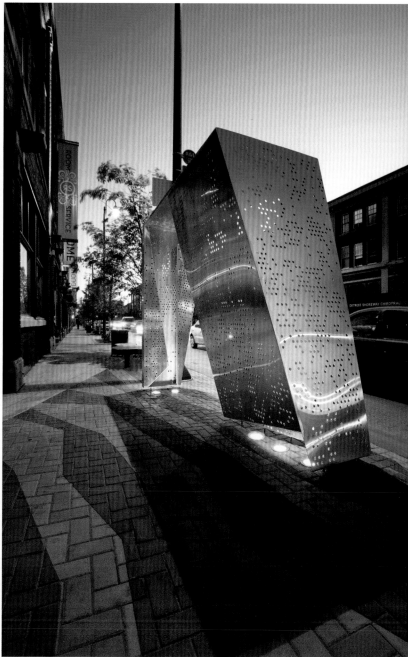

In the evening the shelters are internally illuminated, projecting a subtle dithered pattern on the surrounding buildings and surfaces transforming the existing context and incorporating it as a part of this new vibrant installation.

Embrace

Design Architects: *Design Systems Ltd (in collaboration with Studio Zhai)*

Materials: *Custom-made mild steel structures with epoxy paint finish*

Project Area: *400 m²*

Location: *Tsim Sha Tsui Kaifong Welfare Association, Hong Kong, China*

Design Concept

With its humane concern about the Tsim Sha Tsui precinct, the community-oriented Tsim Sha Tsui Kaifong Welfare Association has been dedicated to nurturing community lives, particularly those of minors and seniors, for over 50 years in Hong Kong, bearing at heart the principle of "embracing the society".

Paying special attention to the needs of the elderly and the disadvantaged, the renovation project managed to re-create a more user-friendly pedestrian path leading to the association. It includes reworking the path into sections of ramps and constructing a series of custom-designed street furniture like feature lamp posts, handrails and seats.

Drawing Sketch

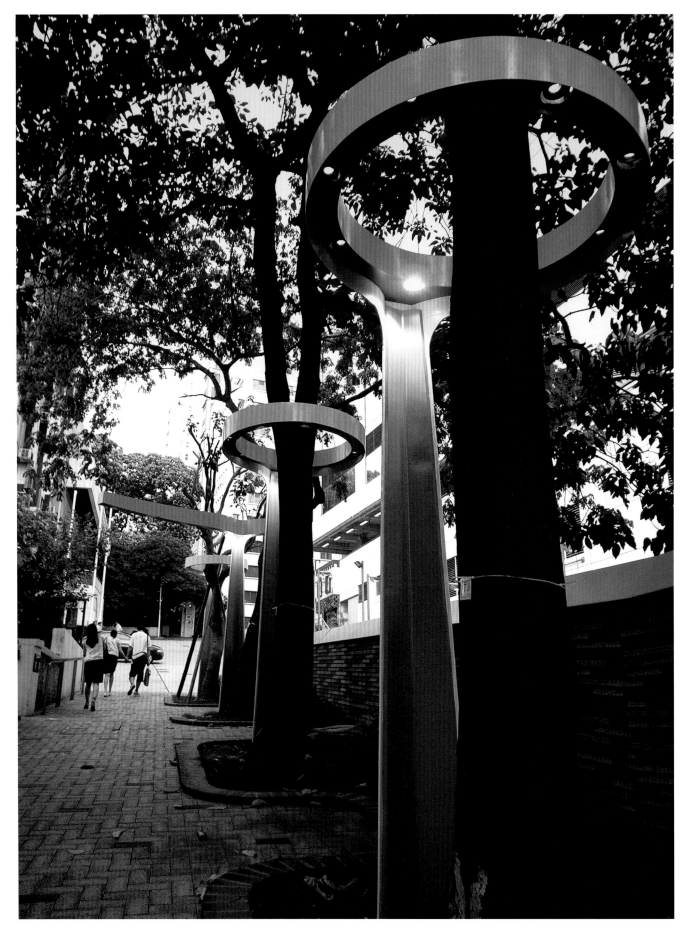

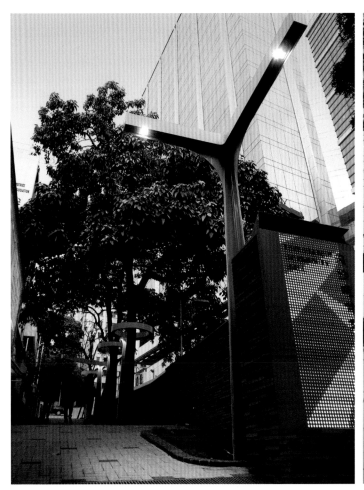

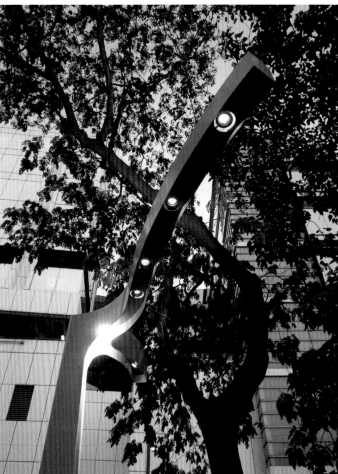

The set of five feature lamp posts represents the welcoming warmth to visitors, all-round protection and stern support for the district's residents. Each of three of them surrounds a decade-aged tree, while the other two are crotched to symbolize the association's pair of open arms, giving the most caring and inviting gestures to the public, especially the youngsters and the elderly. All lampposts are made of mild steel with epoxy paint finish.

Generating soft yet plentiful light, the feature lamp posts perform the basic illuminating function for the public, at the same time project the organization's vision: to embrace the community.

Fence for Sport Complex of Durazno

Design Architects: *jaf architecture + design*

Project Client: *Municipality of Durazno*

Materials: *Colored Steel*

Length: *600 m*

Location: *Durazno, Uruguay*

Photographer: *Javier Villasuso, Juan Andrés Fernández*

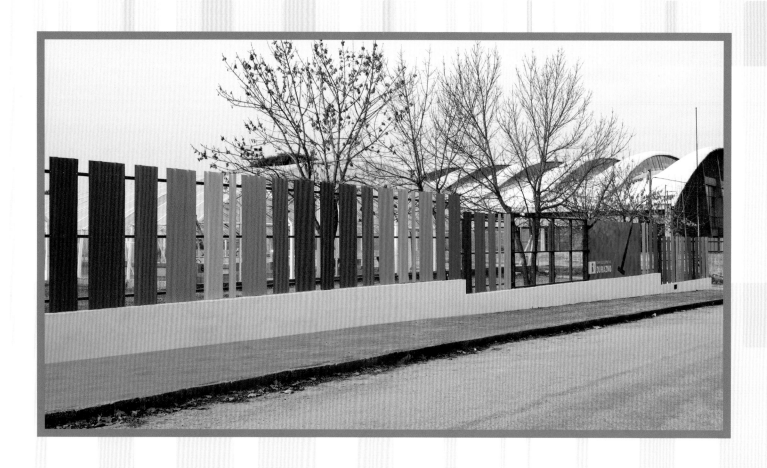

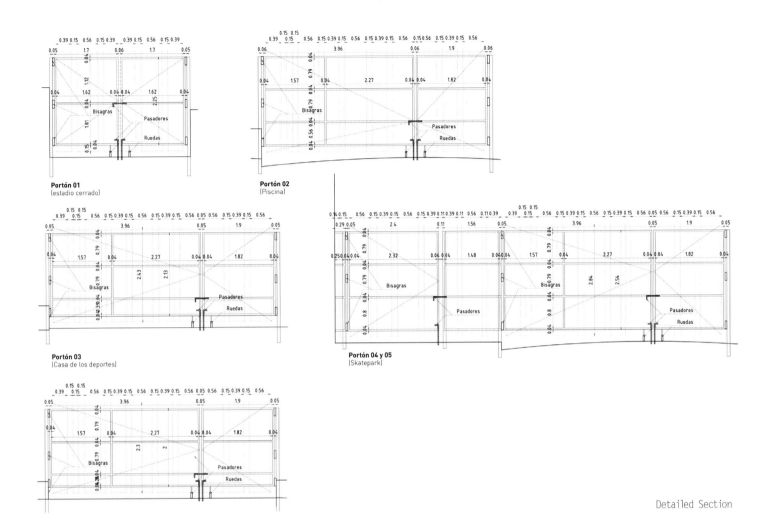

Portón 01
(estadio cerrado)

Portón 02
(Piscina)

Portón 03
(Casa de los deportes)

Portón 04 y 05
(Skatepark)

Detailed Section

The sports complex of Durazno is the main sporting and social center of the city. At the request of the municipality of Durazno, an enclosure is proposed that, in the 600 m. of length, in addition to providing security for users, creates a strong visual identity and intensifies the inclusive nature of the complex.

SECTOR 2 (tramos A y B)
Calle Leandro Gomez

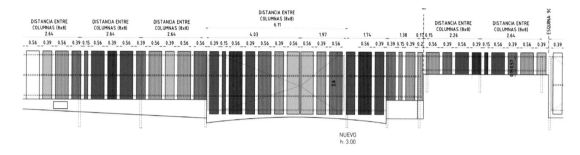

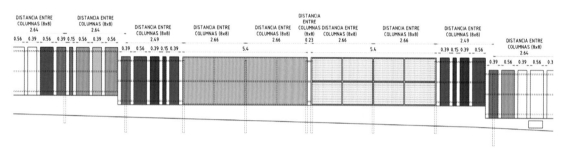

Design Sketch 1

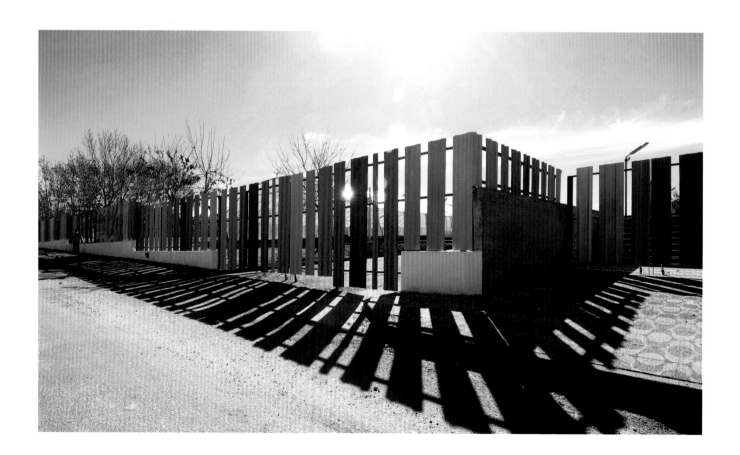

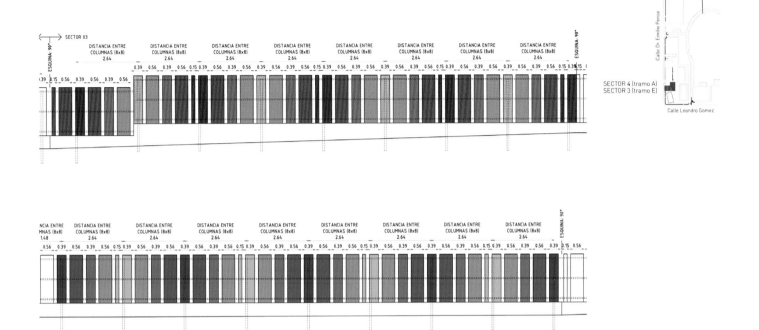

SECTOR 4 (tramo A)
SECTOR 3 (tramo E)

Design Sketch 2

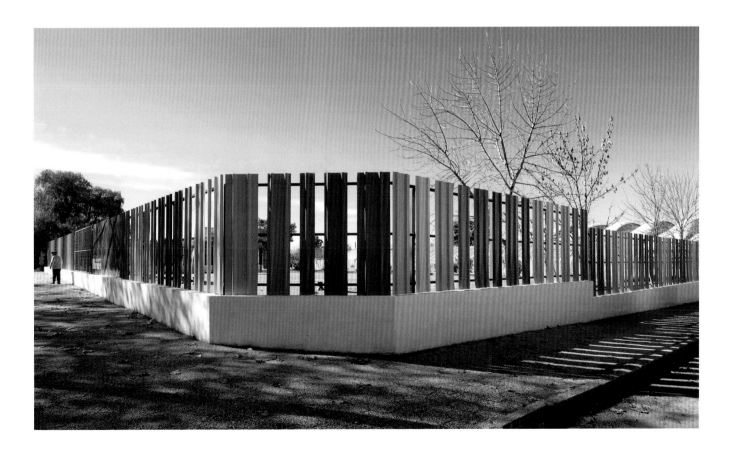

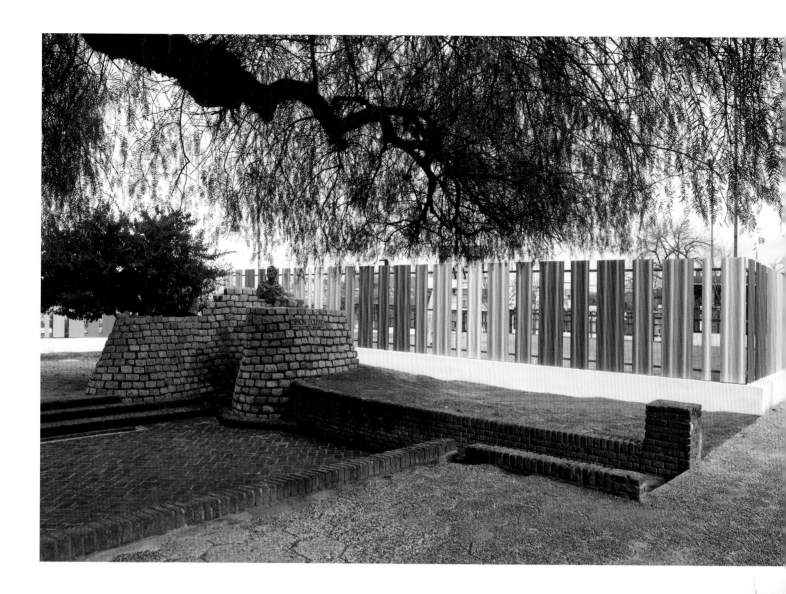

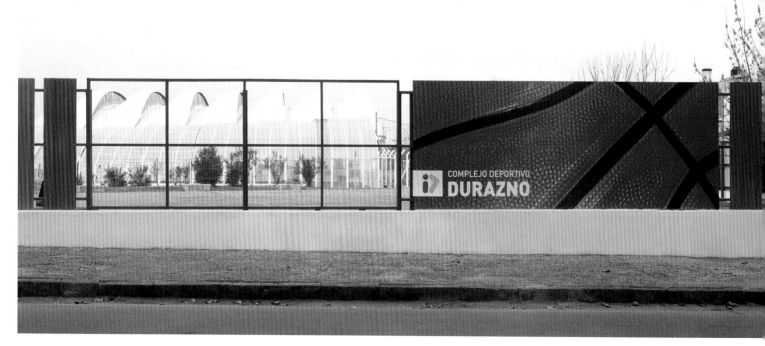

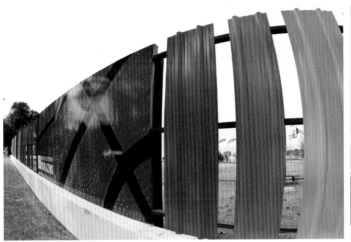
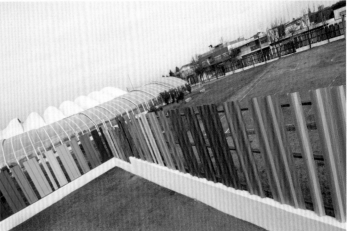

A set of multicolored strips are articulated varying width and color to achieve a composition playing with sports that take place in the complex

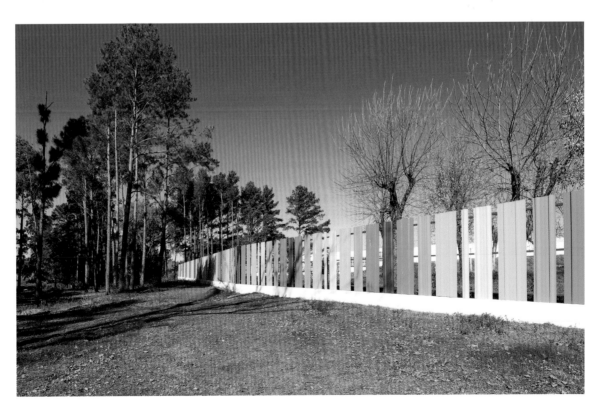

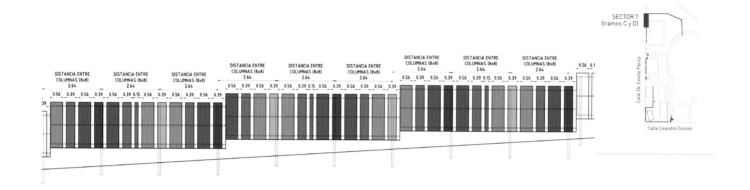

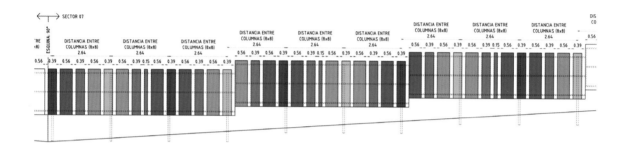

Design Sketch 3

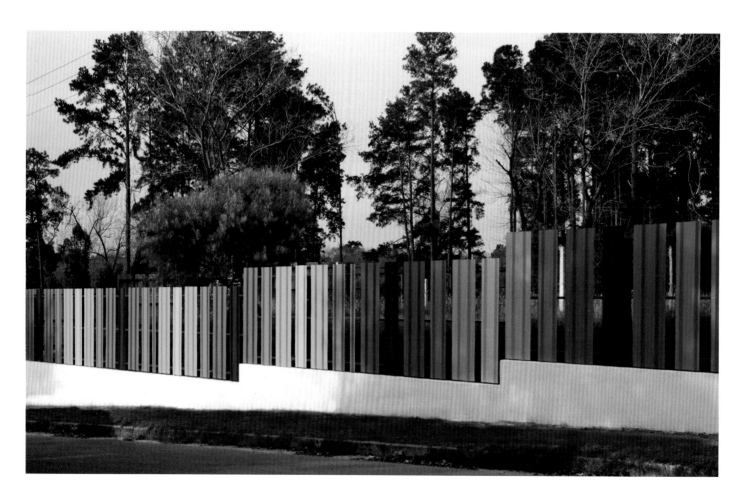

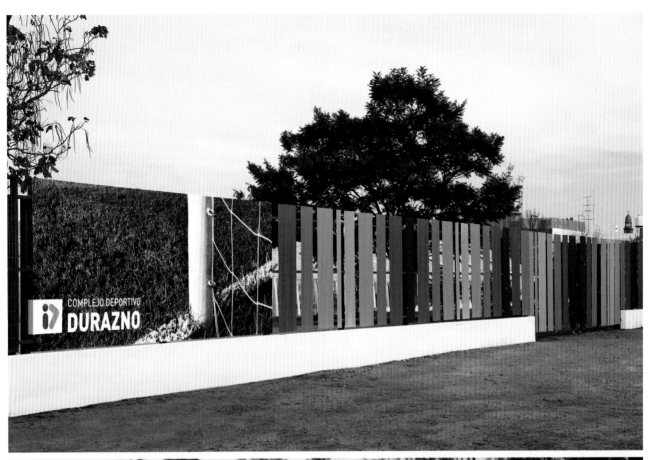

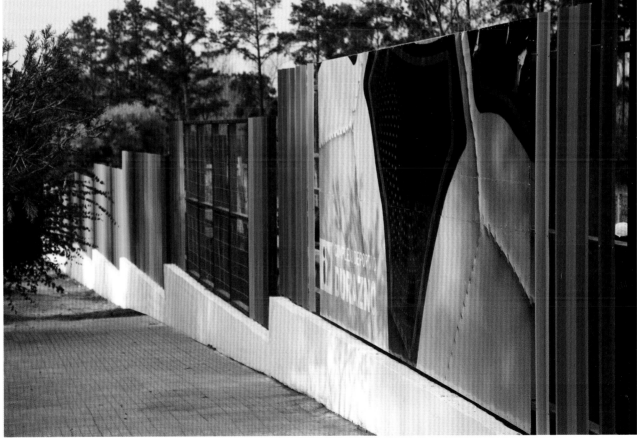

Light Sails

Design Architects: *Söhne & Partner Architekten*

Location: *Millstaetter Lake, Carinthia, Austria*

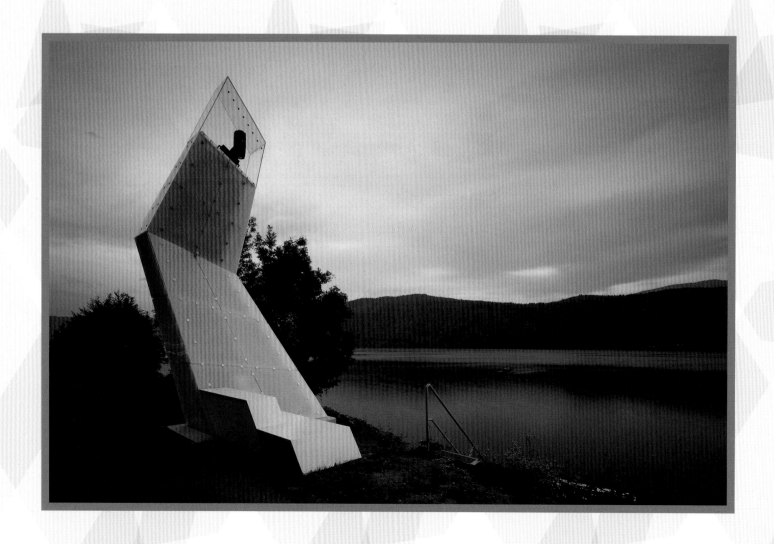

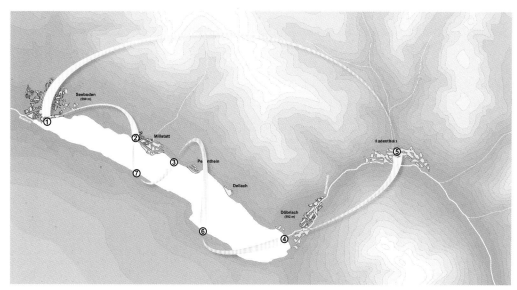

Move Scene

Light Sails are used as guiding symbols for the state exhibition around the Millstaetter Lake, Austria. In the 90's the lighthouse, one of the oldest communication systems, was used as a metaphor for orientation through the World Wide Web by the internet browser "Netscape Navigator". The lighthouse - a point of orientation, to be seen from far, was long time used for shipping throughout day and night. Nowadays the lighthouse is used as a symbol for holidays, for the sea, for adventures and water.

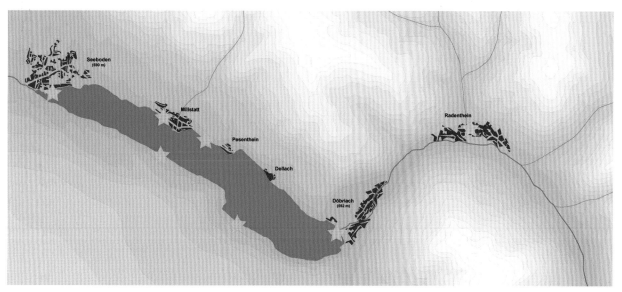

Topograph Drawing 1

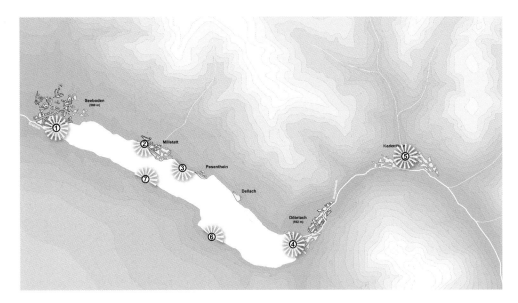

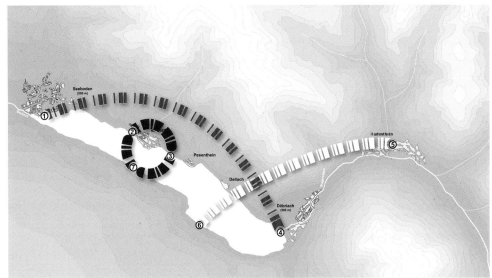

Topograph Drawing 2 Design Sketch

The idea to design the 7 light sails comes out of that old and very well known lighthouses. As lighthouses, the light sails, are used to guide the visitors around the different exhibitions.

The objects are abstract sails, as a "light-space-installation". The objects are orientated to the lake. The lake Millstaetter is getting a tribune out of water, because the energy of the lake is trapped, converted and reflected as light. So the sails are working as a transmitter and receiver at the same time.

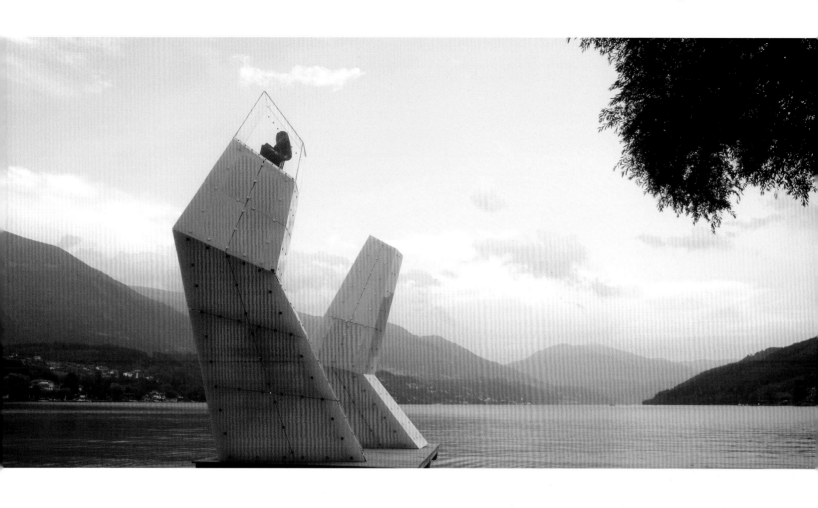

The illumination of the light sails itself is reacting to the surrounding - the more people approaching the sails the more vibrate light. The illumination is also reacting to the temperature - they are constantly changing their color. The colder the temperature the warmer the color of light is getting and inverse.

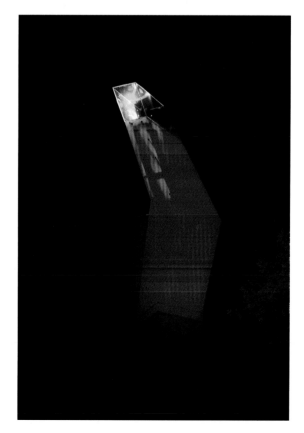

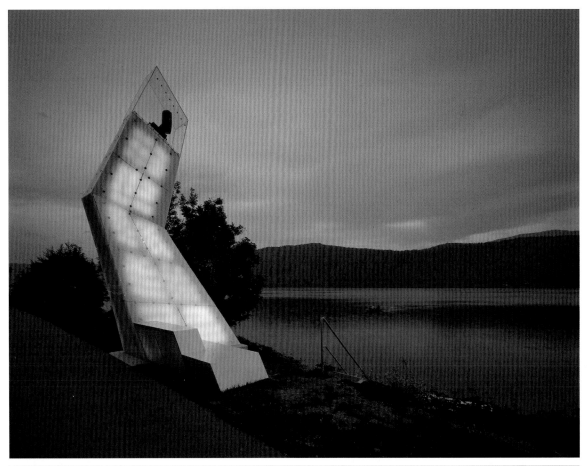

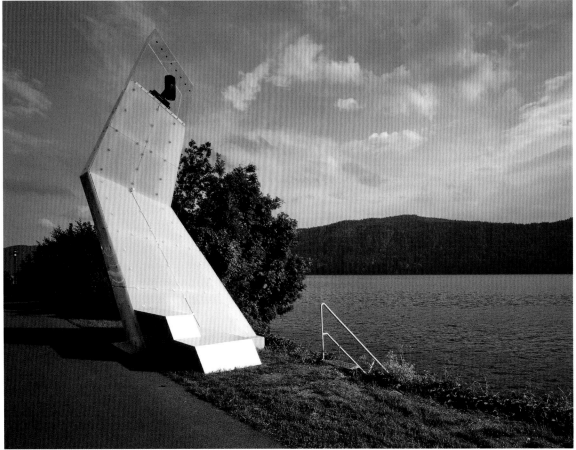

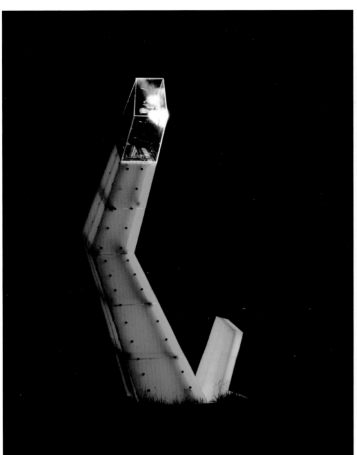

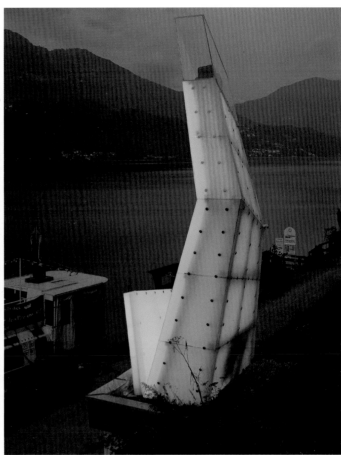

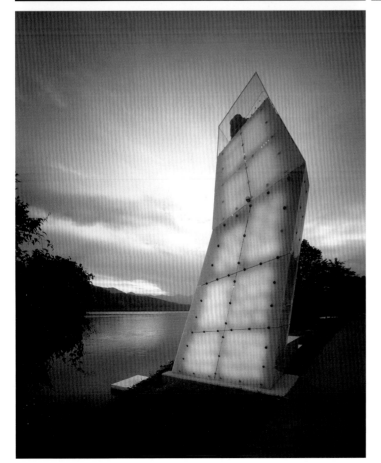

In the dawn the integrated moving heads start their show. They elevate from water surface of the lake. The cone of lights raise and drop, they pulsate, they are reflected by the water. They connect and show the way from one light sail to another one.

Main Street and Square. Pilar de la Horadada

Design Architects: *Joaquín Alvado Bañón*

Location: *Pilar de la Horadada, Alicante, Spain*

Photographer: *David Frutos*

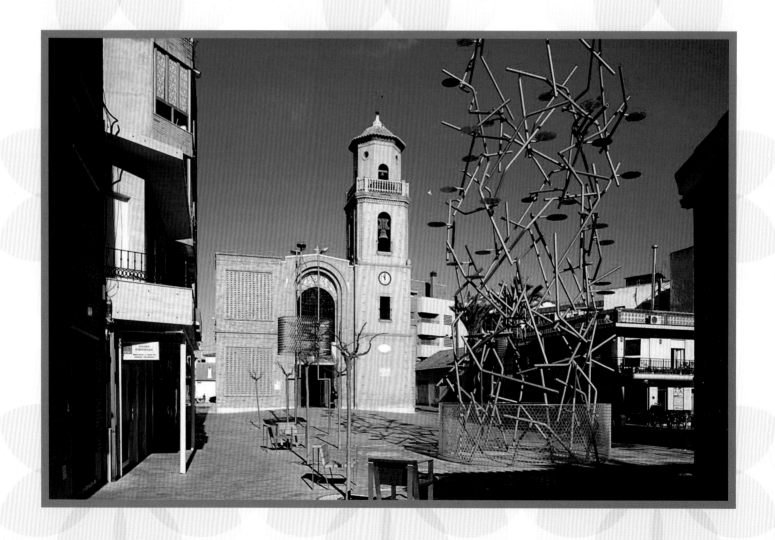

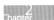

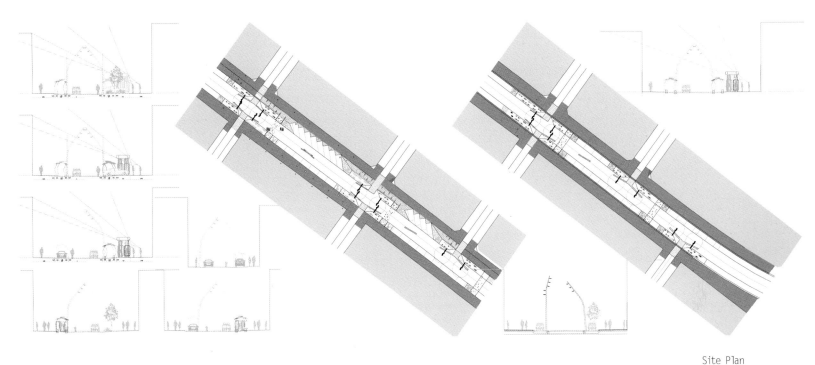

Site Plan

The shape of the main street and the square in "Pilar de la Horadada" were very irregular, with a lot of sharecropping walls, patched parking and twisted lines of trees. We thought about a walk besides the sea, a pedestrian path between sand, palms and coconuts.

The town is a Mediterranean village no more than one Kilometer far from the coast and the beach. The main road divides the landscape and disconnects the sea and promenade from the citizens. Our first decision was to create a promenade working with the sensations you have when you walk along the sea. The sun, the sand, brightness, humidity, colors, trembling shadows, hotness… we wanted to bring to the village all this kind of sensations.

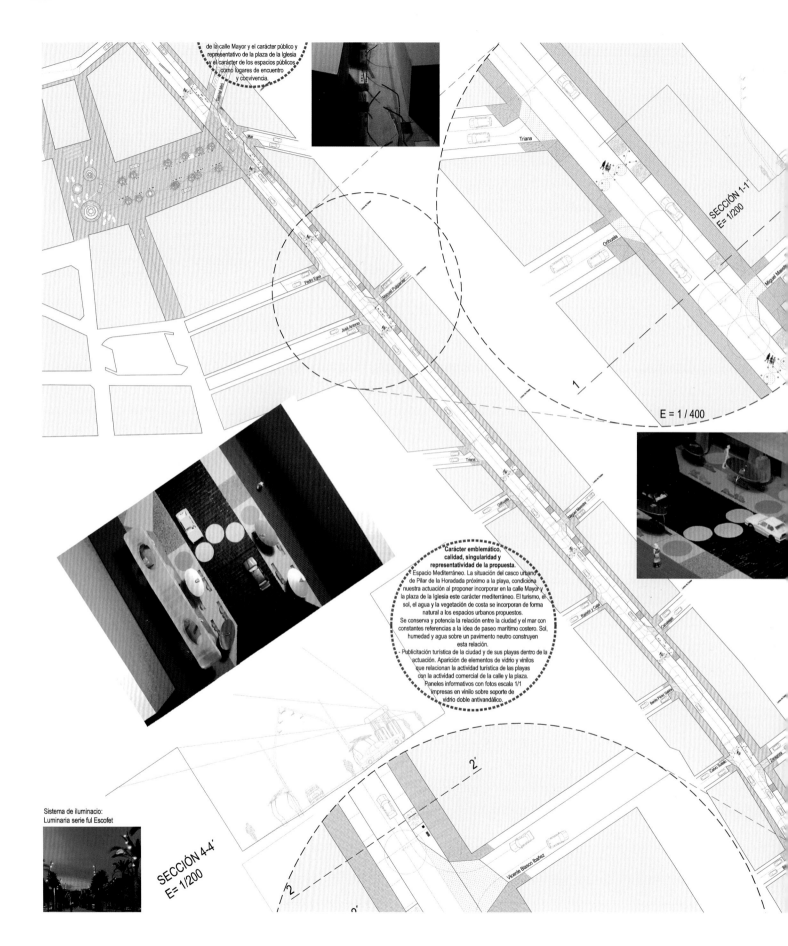

de la calle Mayor y el carácter público y
representativo de la plaza de la Iglesia
el carácter de los espacios públicos
como lugares de encuentro
y convivencia.

Triana

SECCIÓN 1-1
E= 1/200

Orihuela

Miguel Maura

Pedro Egea

Manuel Puigmoltar

José Antonio

1

E = 1 / 400

Triana

Orihuela

Miguel Maura

**Carácter emblemático,
calidad, singularidad y
representatividad de la propuesta.**

Espacio Mediterráneo. La situación del casco urbano
de Pilar de la Horadada próximo a la playa, condiciona
nuestra actuación al proponer incorporar en la calle Mayor y
la plaza de la Iglesia este carácter mediterráneo. El turismo, el
sol, el agua y la vegetación de costa se incorporan de forma
natural a los espacios urbanos propuestos.
Se conserva y potencia la relación entre la ciudad y el mar con
constantes referencias a la idea de paseo marítimo costero. Sol,
humedad y agua sobre un pavimento neutro construyen
esta relación.
Publicitación turística de la ciudad y de sus playas dentro de la
actuación. Aparición de elementos de vidrio y vinilos
que relacionan la actividad turística de las playas
con la actividad comercial de la calle y la plaza.
Paneles informativos con fotos escala 1/1
impresas en vinilo sobre soporte de
vidrio doble antivandálico.

Ramón y Cajal

Canalejas

Benito Pérez Galdós

Calvo Sotelo

Zaragoza

2'

Vicente Blasco Ibañez

2

2'

Sistema de iluminacio:
Luminaria serie ful Escofet

SECCIÓN 4-4'
E= 1/200

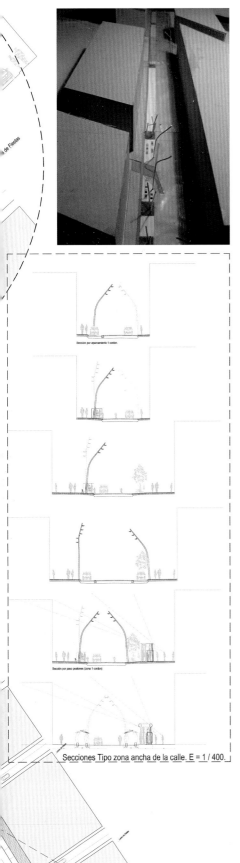

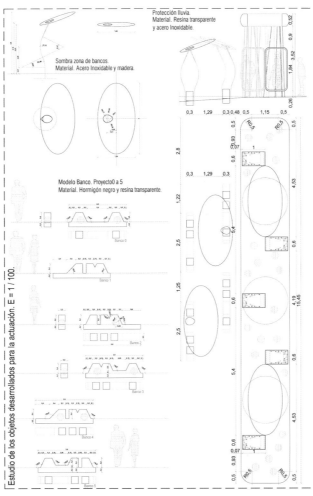

Protección lluvia.
Material. Resina transparente
y acero Inoxidable.

Sombra zona de bancos.
Material. Acero Inoxidable y madera.

Modelo Banco. Proyecto0 a 5
Material. Hormigón negro y resina transparente.

Banco 0

Banco 1

Banco 2

Banco 3

Banco 4

Banco 5

Estudio de los objetos desarrollados para la actuación. E = 1 / 100.

Sección por aparcamiento 1 cordon.

Sección por paso peatones (zona 1 cordon)

Secciones Tipo zona ancha de la calle. E = 1 / 400.

We have built one pedestrian level to go from the surroundings of the town to the church at the end of the walkway. There are no changes and no obstacles. We have divided the main street into several paths to order the different functions.

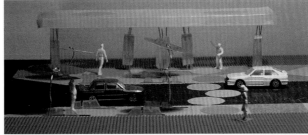

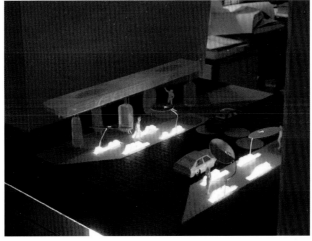

Design Drawing 1

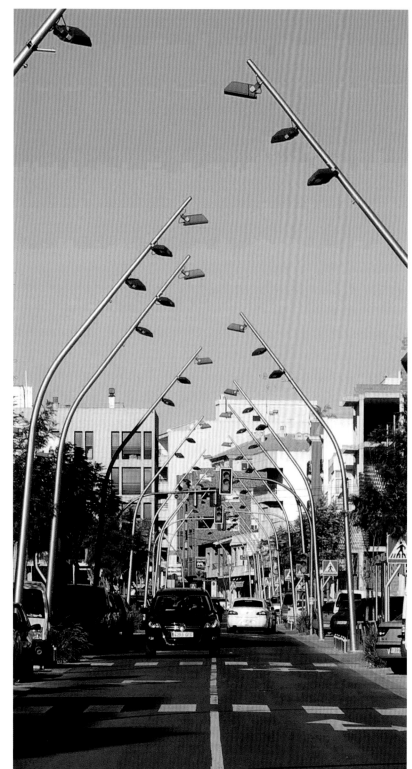

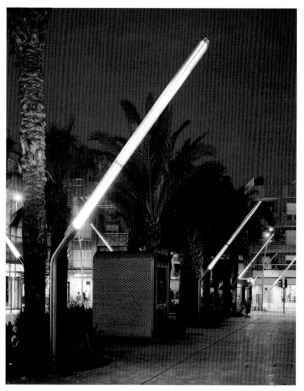

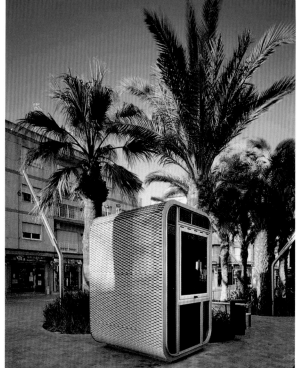

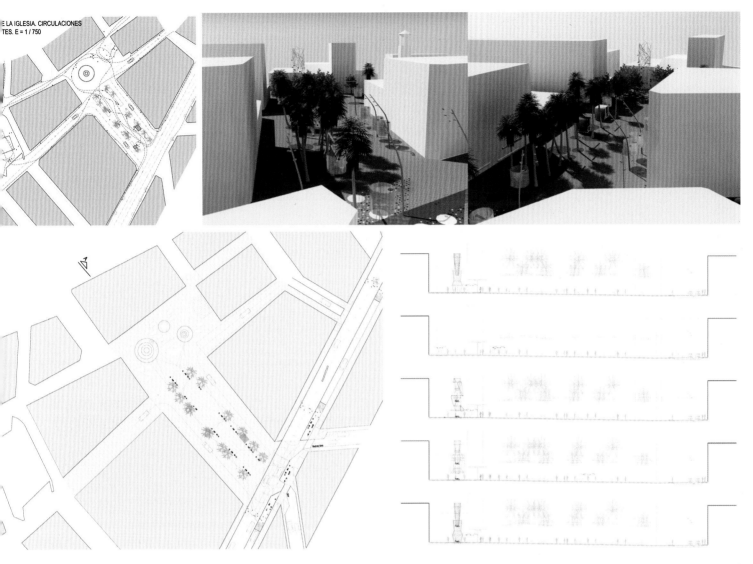

Design Drawing 2

The walkway for pedestrians was made with one stone that change the color and the brightness. It is call "Piedra del Cabezo" and it is a mixture of sensations similar than the one you have walking on the dry and moody sand. When you arrive to the square the car disappear and the stone cover everything and change the shape into a small slope to get to the main entrance of the Church.

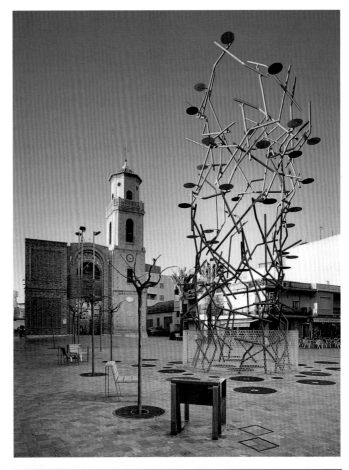

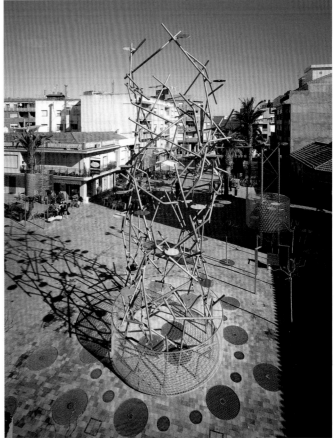

Design Drawing 3

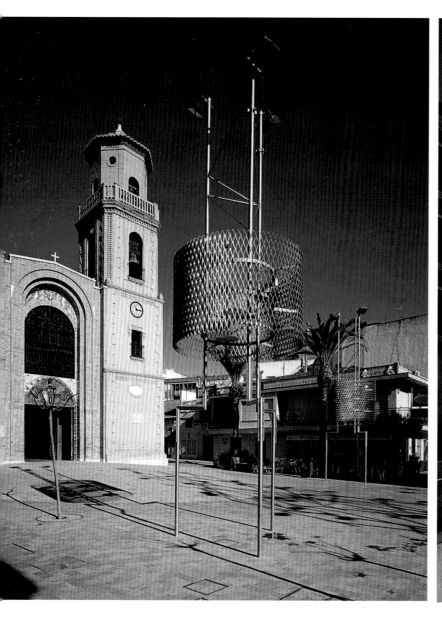

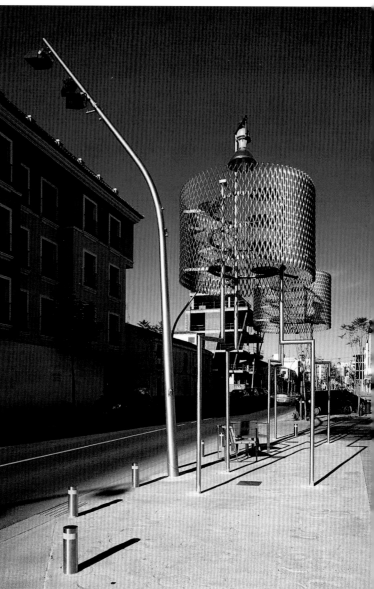

There is another path for several functions, parking, gardening, trees, signals, public lights and benches. Everything is connected with different surfaces using the treatment of the concrete. Washed, polished and printed concrete with flower shapes. In this mixture everything happens and at the same time there is a barrier between the people walking and the cars.

The materials we have been working with are stainless steel, color methacrylate, color polystyrene, water, several plants and trees in order to create the atmosphere of a promenade along the beach.

In your trip along the project you feel the wind, birds flying, sun on your face and humidity in your skin and the glimmering day and night lights. We tried to build a space for the citizen to meet your neighbors in a friendly way, to talk and go shopping in a casual walking and to feel the smell and humidity from the sea.

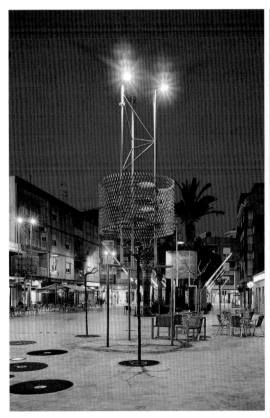
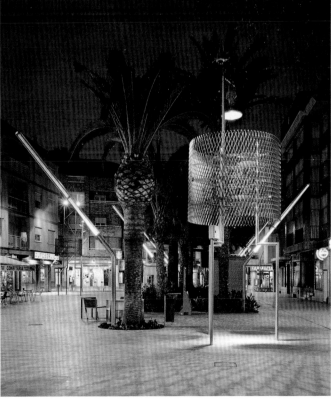

Royal Rice Field

Design Architects: *Apostrophy's*

Location: *Bangkok, Thailand*

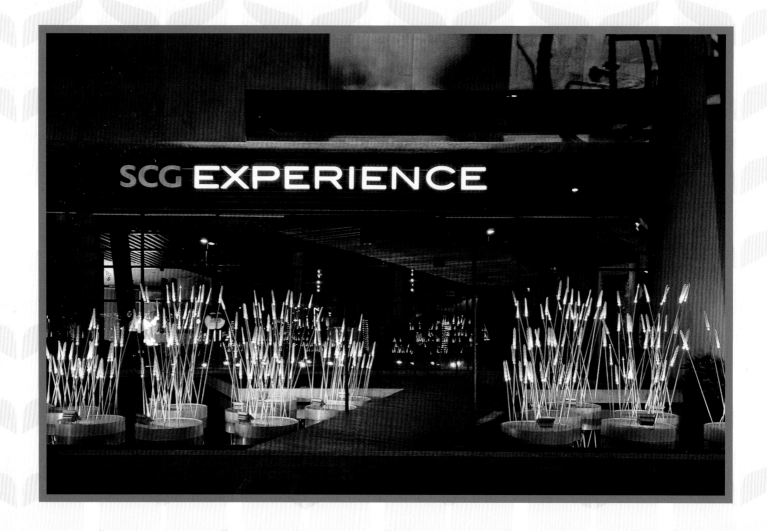

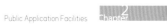

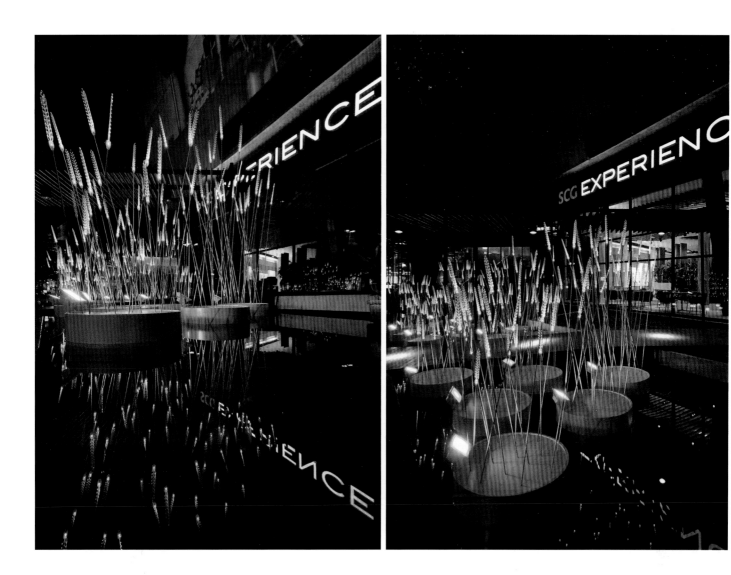

The lighting installation 'Royal rice field' is a new approaching to the main entrance of 'SCG experience' building as well as to exhibit and honor the intelligence of His Majesty the King Bhumibol particularly in Agriculture due to the best occasion to celebrate His Majesty the King's birthday in 5 December. It is represented by a grove of 'light spike' among the water mean the abundant of Thailand and also 'gold' is represented the brightness of His Majesty thought in agricultural which is the fundamental of Thai economics.

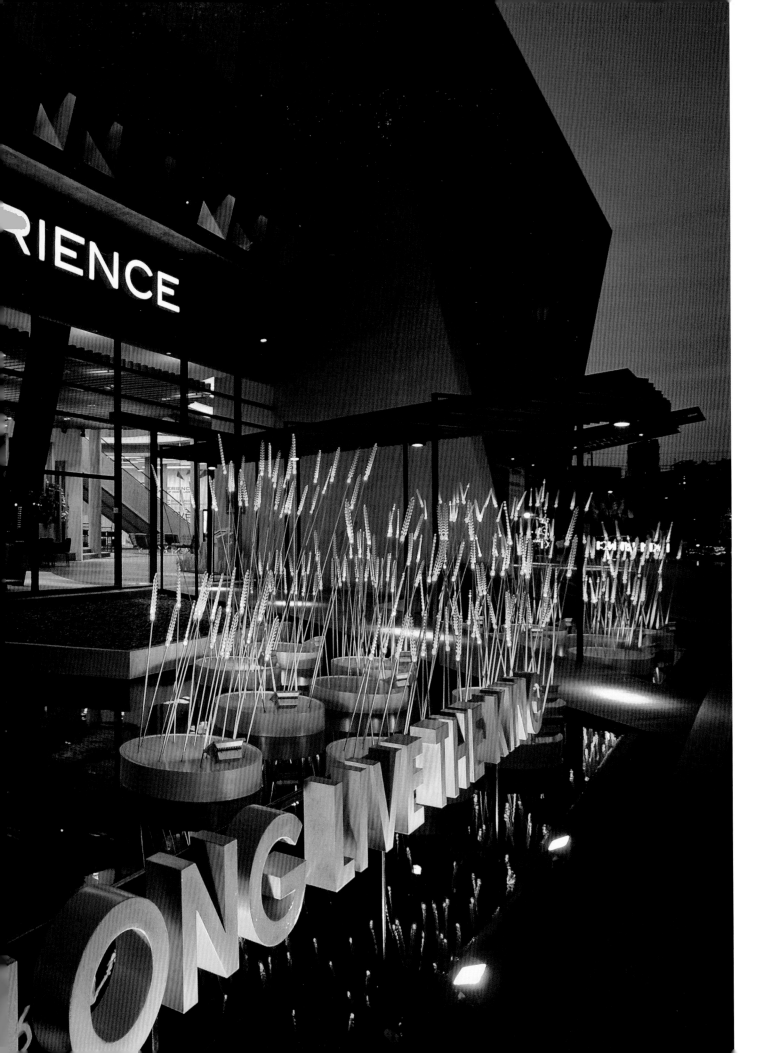

'Royal rice field' has been experimented for the best aesthetic form, suitable light bulb specification, material and also its composition. Finally, it is composed of 300 golden-yellow LED light bulbs, enclosed with rice spike shaped transparent acrylic sheet on the top of its golden stem which is made from steel tube inserted with LED wire inside. To imitate the characteristic of nature, each figure has been adjusted its height and composites randomly into 15 circular platform islands with an underwater electrical wiring system enhance with waterproof lighting to flood all the field and CNC plywood text 'Long live the king' with static golden light. Thus, their metallic gold is brilliant and stunning in the sunshine but dramatic glow at night as well as the reflection from the pool is created the glare dazzling onto the water surface for all time.

Essentially, the design team devote 'Royal rice field' to celebrated His Majesty the King's birthday and also hope this static lighting installation can be calm down your sentimental, awaken your consciousness and light you to find out any solution even personally or Thailand political crisis.

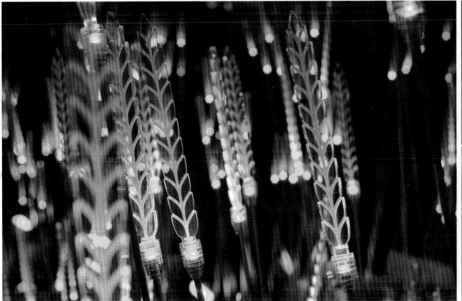
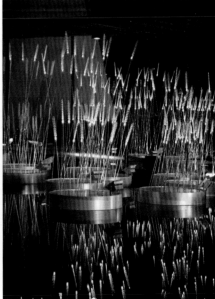

SPAR Gmunden

Design Architects: *Archinauten*

Building Area: *1,033 m²*

Area of Use: *680 m²*

Location: *Gmunden, Austria*

Photographer: *M.Dworschak*

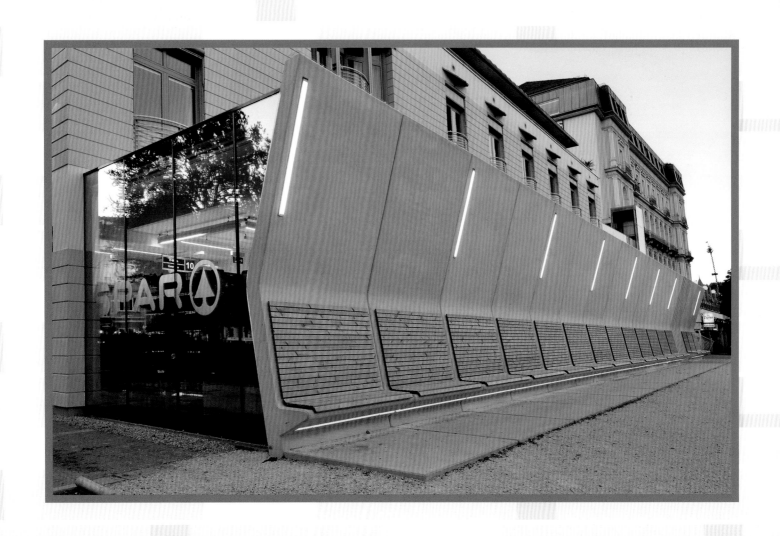

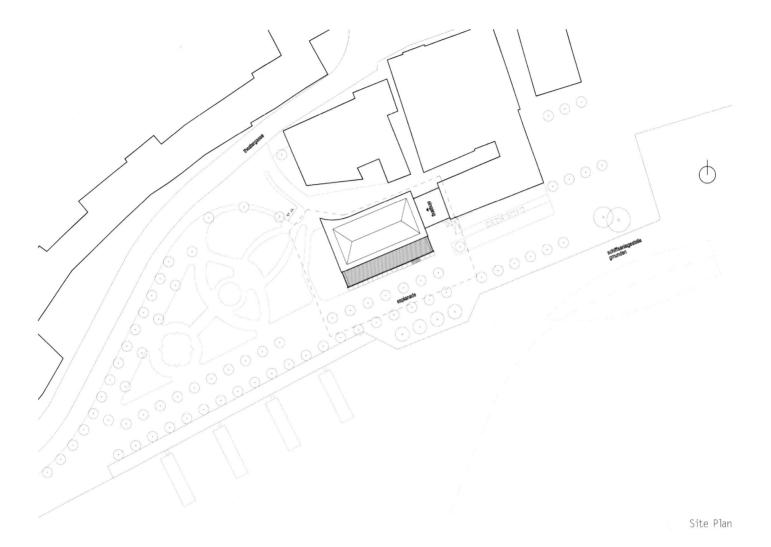

Site Plan

The spar supermarket on the bank of the lake traunsee, in the center of the town of Gmunden is to be enlarged. The expanded space results from a new design of the surrounding public space. An urban furnishing in the form of a "sunbed" presents a new attraction for the passers-by along the esplanade. The bench invites visitors to enjoy the panorama of the lake and the sunshine, and "performances" of all kinds can take place here as well. The slightly bent form of the bench offers shelter and is reminiscent of an alcove. The wooden seats provide comfortable seating especially during the change of seasons.

The bench is made of precast elements in architectural concrete. This high quality material with stone characteristics ensures long-lasting elegance. An indirect lighting under the seat illuminates the immediate vicinity and gives the bench a special quality at night. Behind this wall, designed as an urban furnishing, is the expanded space of the supermarket spar.

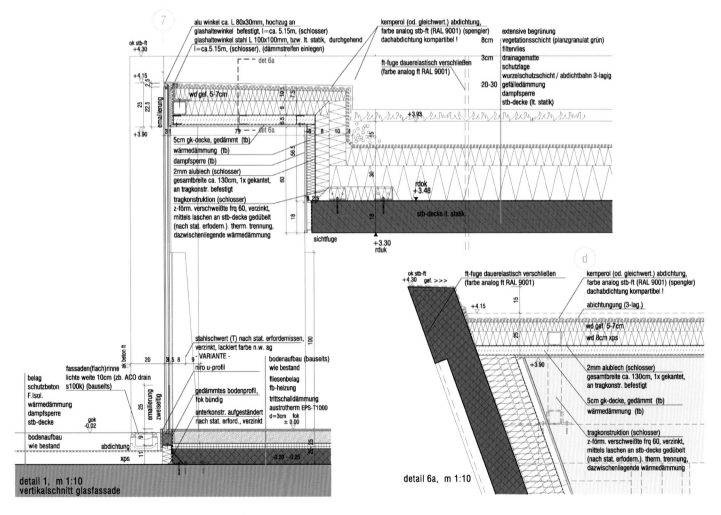

Details Design

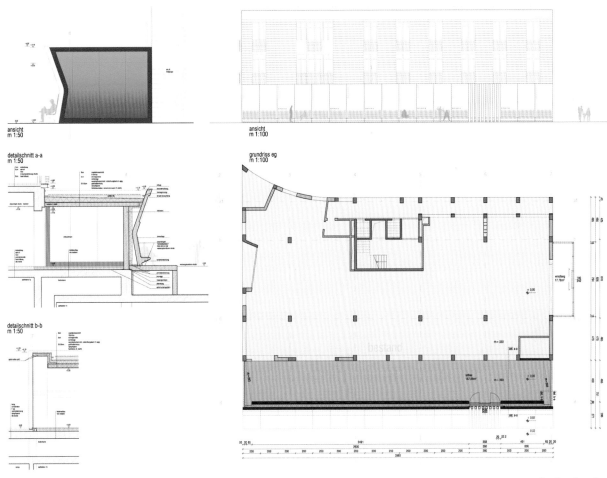

ansicht
m 1:50

detailschnitt a-a
m 1:50

detailschnitt b-b
m 1:50

ansicht
m 1:100

grundriss eg
m 1:100

Design Drawing

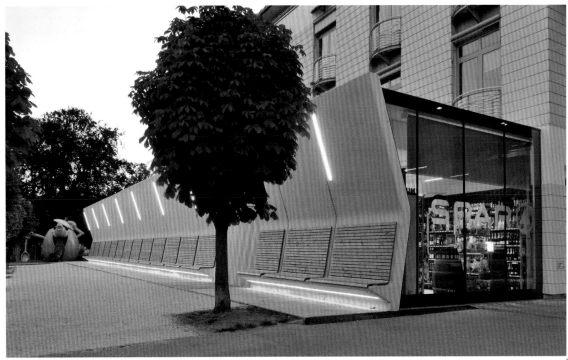

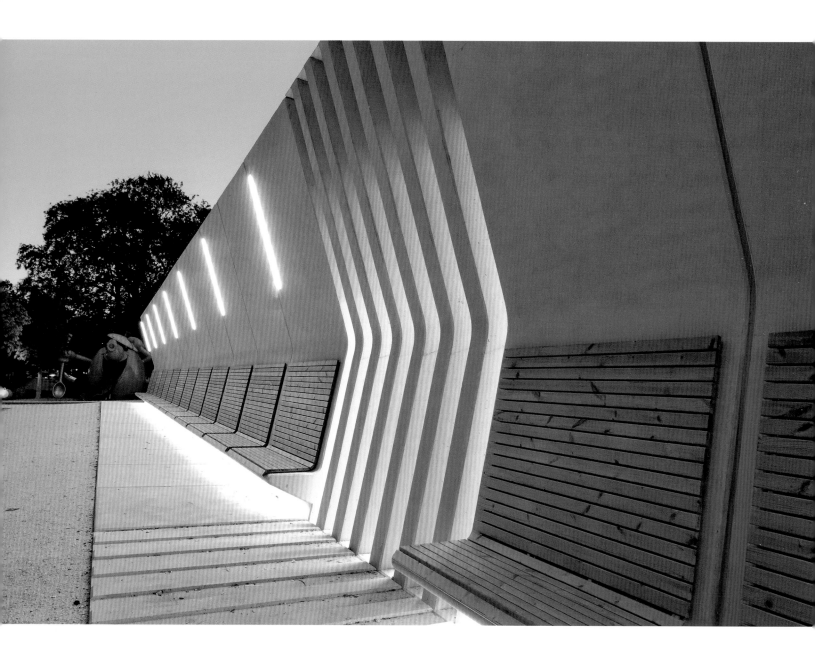

A new transparent glass facade encloses the new commercial space on the side. The contour of the old building

thus remains visible, and the inside can be seen from outside.

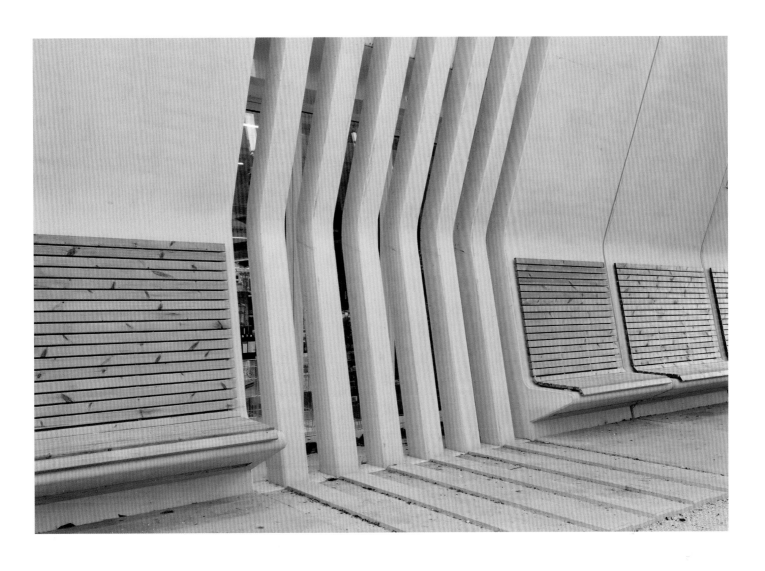

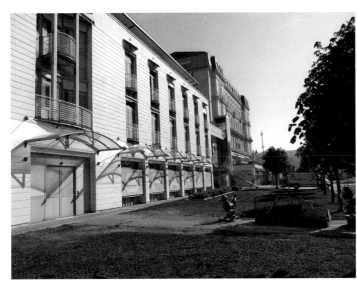

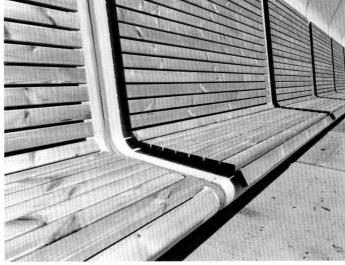

Public Toilets Lori

Design Architects: *DinellJohansson*

Location: *Stockholm, Sweden*

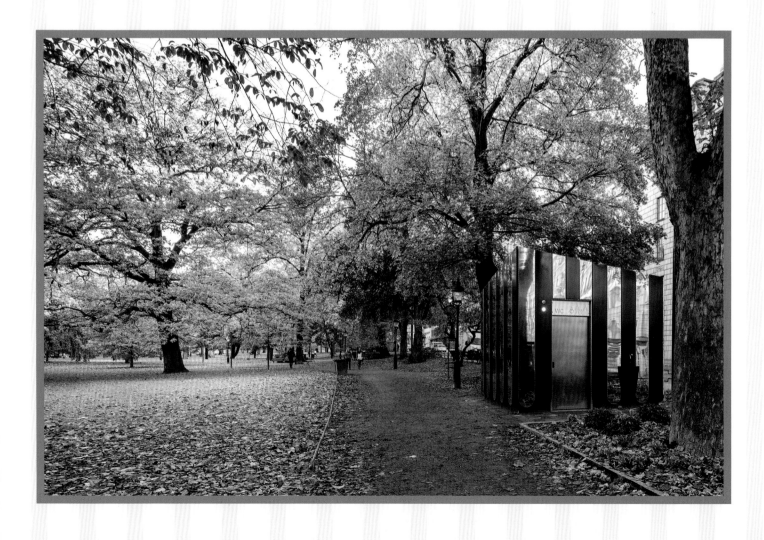

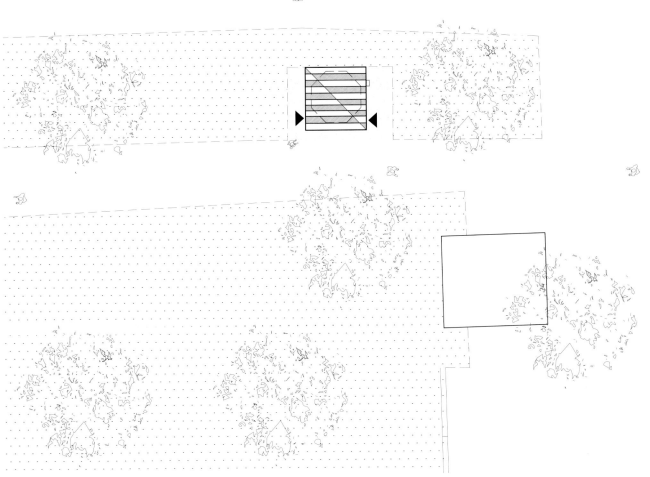

Site Plan

Lori is the new public toilet for the city of Stockholm. The first unit is now up in the central park of Humlegården. The model was already a developed product called "Fenix", but the city of Stockholm asked for a specific exterior design that would be unique and exclusive for Stockholm. The idea was to create a joyful and loveable pavilion like structure. A building to like and to hang around rather than to avoid until you are forced to use it. We have chosen to rename it Lori after the colorful and sociable bird species.

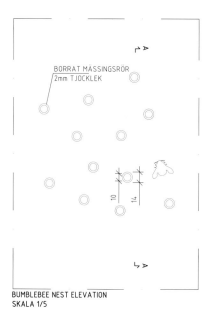

BORRAT MÄSSINGSRÖR
2mm TJOCKLEK

10 14

BUMBLEBEE NEST ELEVATION
SKALA 1/5

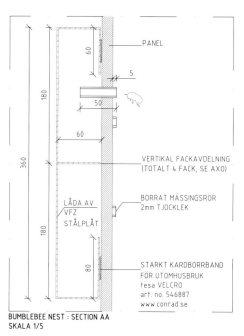

PANEL

60

5

50

180

60

VERTIKAL FACKAVDELNING
(TOTALT 4 FACK, SE AXO)

360

BORRAT MÄSSINGSRÖR
2mm TJOCKLEK

LÅDA AV
VFZ
STÅLPLÅT

180

80

STARKT KARDBORRBAND
FÖR UTOMHUSBRUK
tesa VELCRO
art. no. 546887
www.conrad.se

BUMBLEBEE NEST : SECTION AA
SKALA 1/5

Design Drawing

The facades are cladded with 5mm steel plate panels with different surface qualities and integrated functions. The design concept encourages that different locations will call for different coloring and different added functions in the panels – a bench, a hook for the dog, a bicycle pump, information board etc.

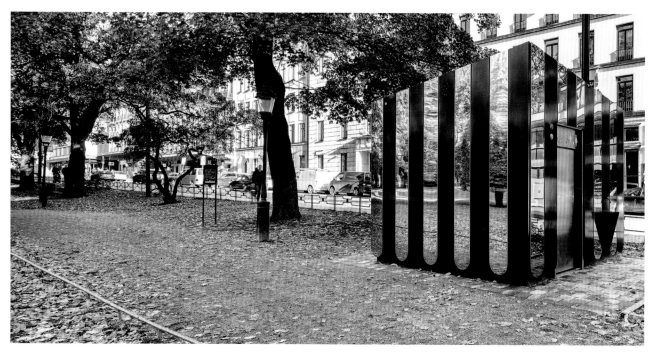

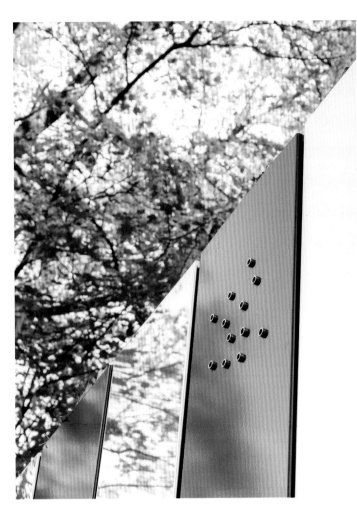

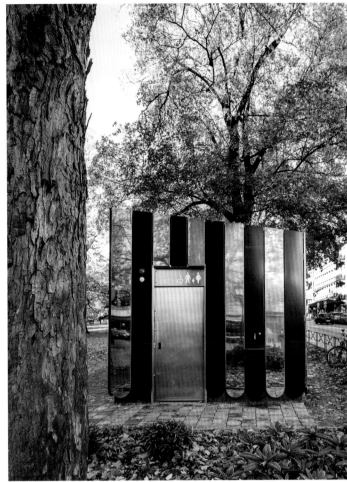

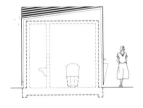

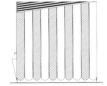

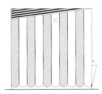

Elevation Drawing

In Humlegården every single panel is powder coated in dark green and polished, mirroring stainless steel. Additional functions are: drinking fountain for runners and passers-by and a bumblebees nest to offer a dwelling to the parks hardworking pollinators.

173

Urban Adapter

Design Architects: *Rocker-Lange Architects*

Project Size: *6.50 m x 1.35 m*

Materials: *MDF for the Prototype*

Location: *West Kowloon, Hong Kong, China*

Photographer: *Christian J. Lange*

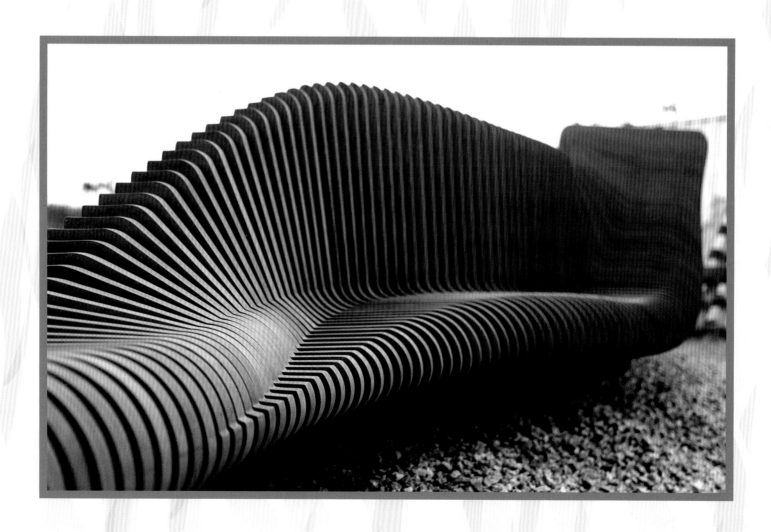

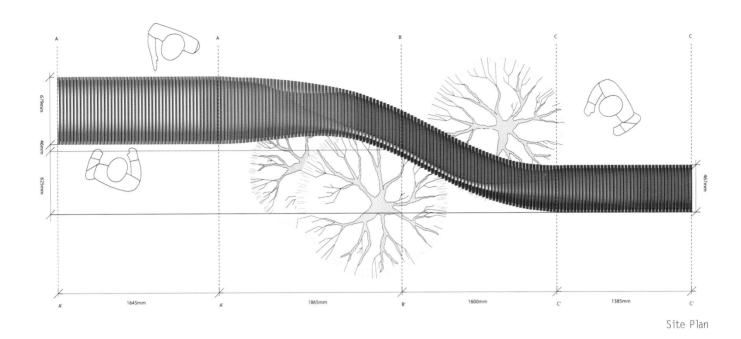

Site Plan

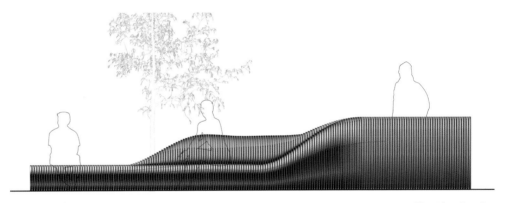

Elevation Drawing

"Urban Adapter" - New Urban Street Furniture for Hong Kong.

Hong Kong's urban furniture contains multiple functional objects. Each of them belongs to a different set of formal expression or is part of a different style. While variation is obvious in the style mix of Hong Kong's public furniture, there is a lack of uniformity that could foster a unique Hong Kong identity. This design proposal for a contemporary city bench seeks to understand the concept of street furniture typologies as a holistic design problem. Instead of offering only one single static design, this scheme suggests multiple varying solutions that meet specific fitness criteria.

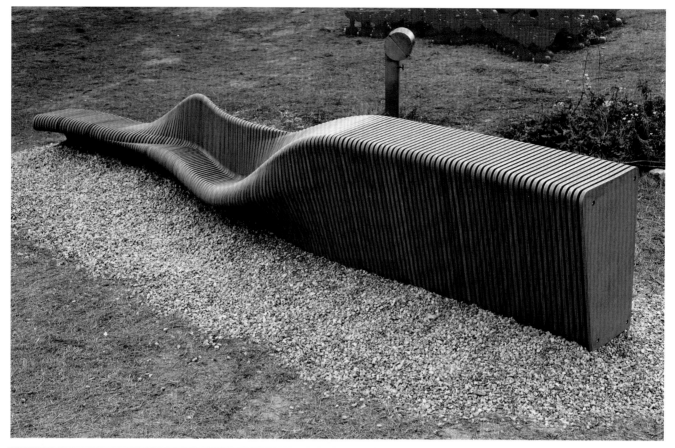

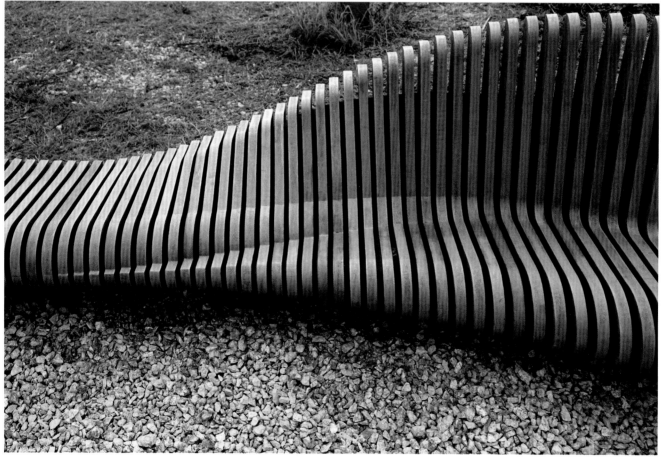

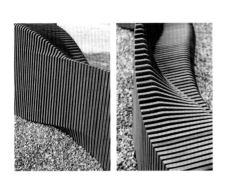 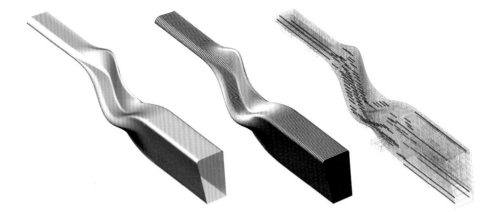

Diagram 1

The project is based on a digital parametric model. At its core the model utilizes explicit site information and programmatic data to react and interact with the environment.

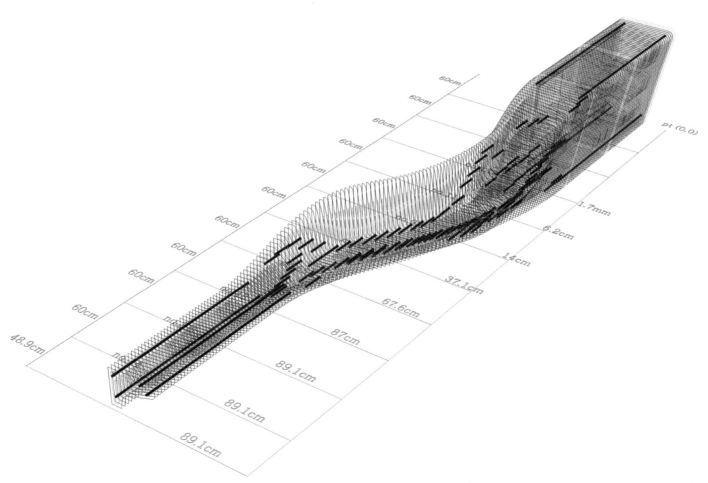

Digital Proto

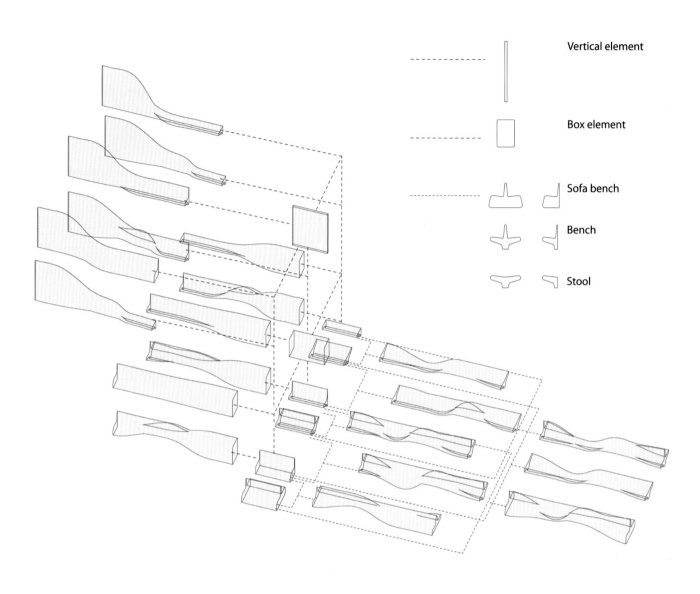

Vertical element

Box element

Sofa bench

Bench

Stool

Diagram 2

In this setup the model's DNA structure is capable of producing a variety of unique furniture typologies. Together they generate an endless family of new urban bench furniture. Rather than having a fixed form the members of the family can adapt to different site conditions and programmatic needs. While all of the designs have the ability to serve as a seating element, some have additional programmatic values added, such as recycling containers, flower buckets or billboards serving for advertisement or educational purposes. The assembly method further ensures the design's flexibility, in respect to its use but also in respect to its capacity to adapt to its site.

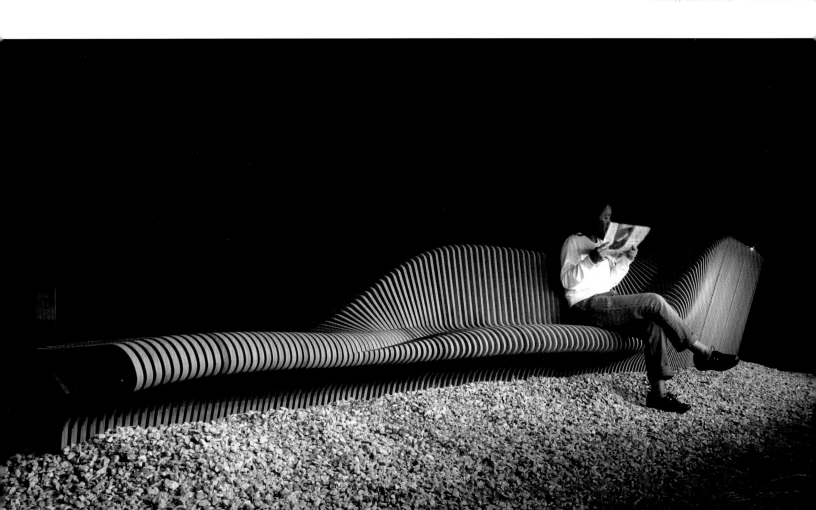

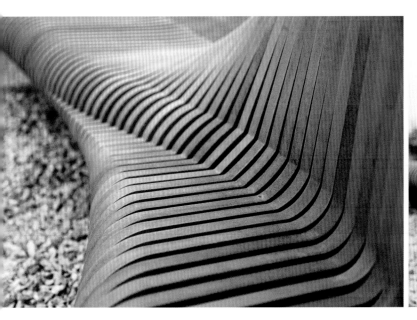

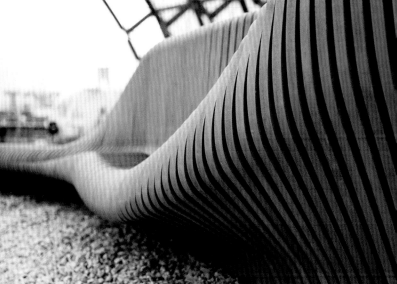

Xintiandi Installation

Design Architects: *UNStudio*

Site Dimension: *30 m long by 3 m wide*

Building Height: *2.7 m high*

Exterior Materials: *Substructure: Steel framing*

Envelope: inside surface: mirror stainless steel; outside surface: painted aluminum alloy

Location: *Shanghai, China*

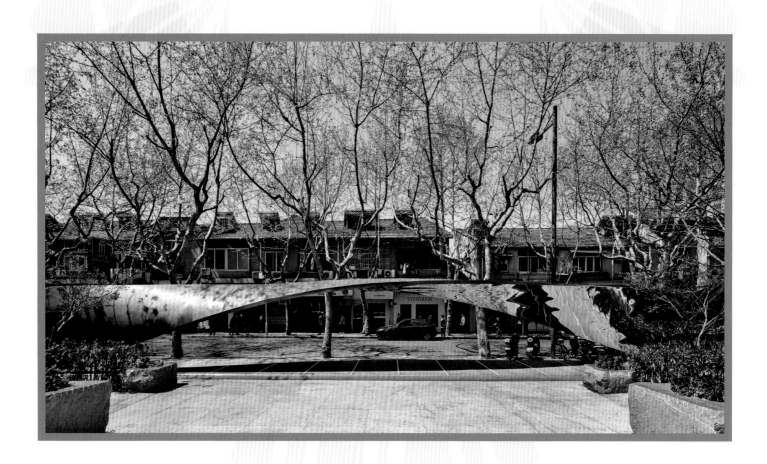

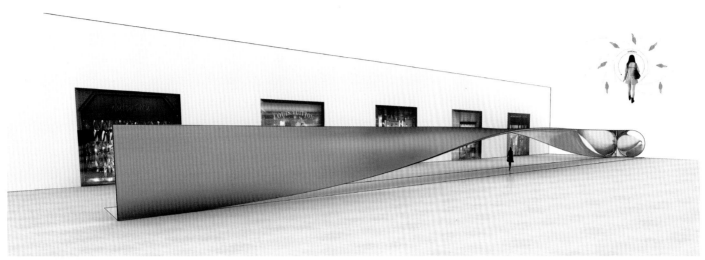

Site View

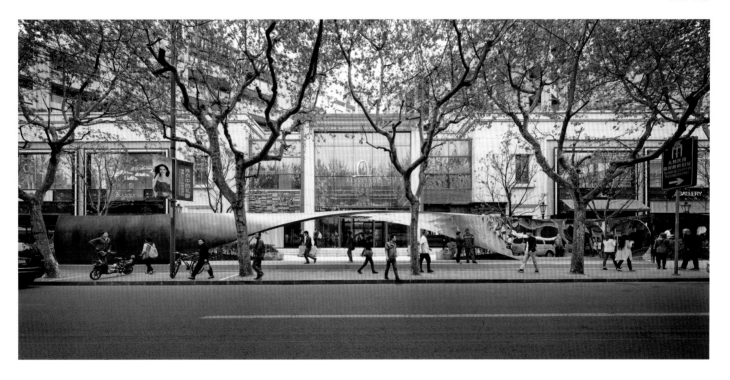

Designed by UNStudio, in collaboration with China Xintiandi, the project conceptually explores the role of display in Shanghai: the symbiotic relationship of cultural reflections that occur between the city's occupants and urban landscape.

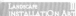

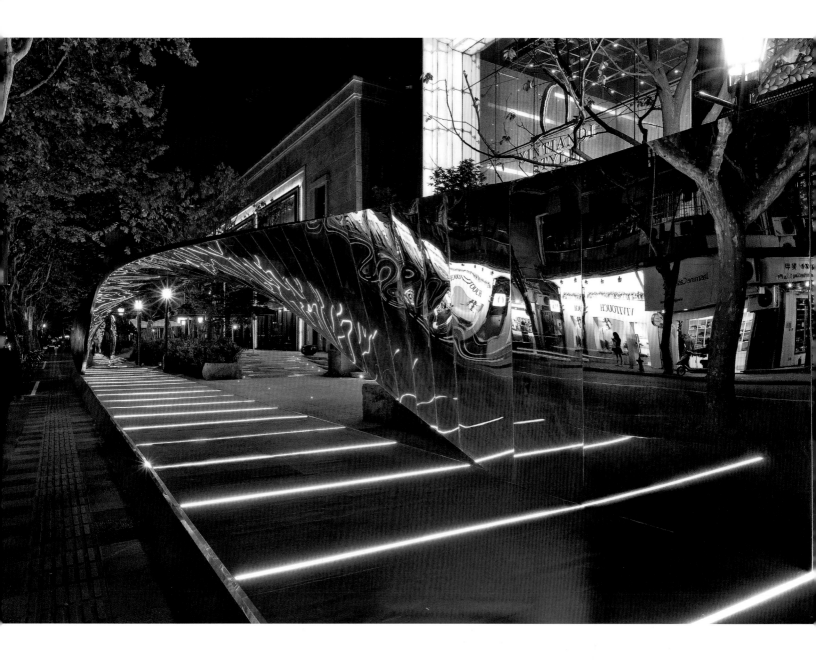

As an extended corridor archway that frames the entrance to Xintiandi Style Retail Mall, the project uses a single architectural gesture that transitions from wall to ceiling to wall, not only tracing pedestrians' movements along its trajectory, but translating them into a reflection that revolves and inverts around the visitors as they walk through the installation. Simultaneously, the pedestrians' reflections move between a sequence of three 'phases' of context: retail, ground, and urban landscape.

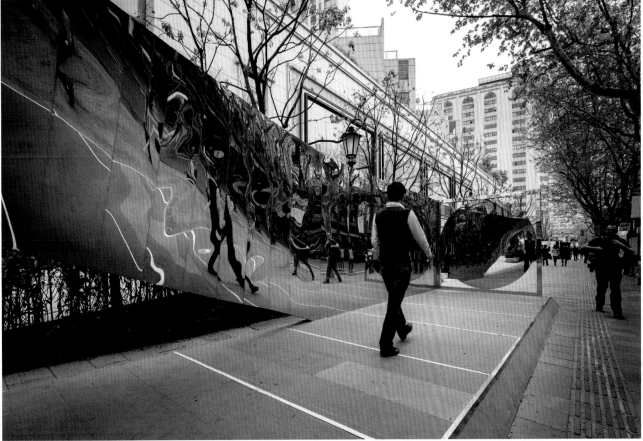

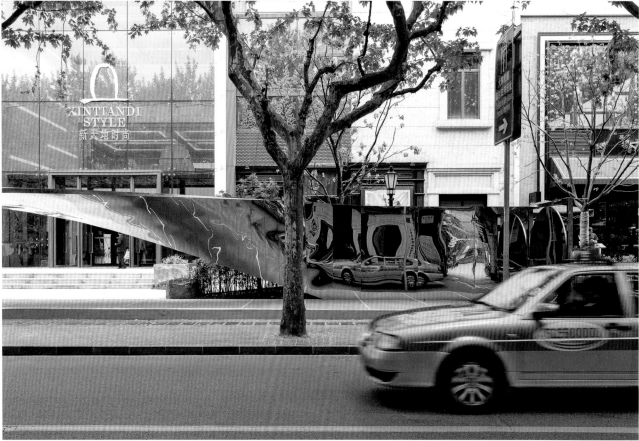

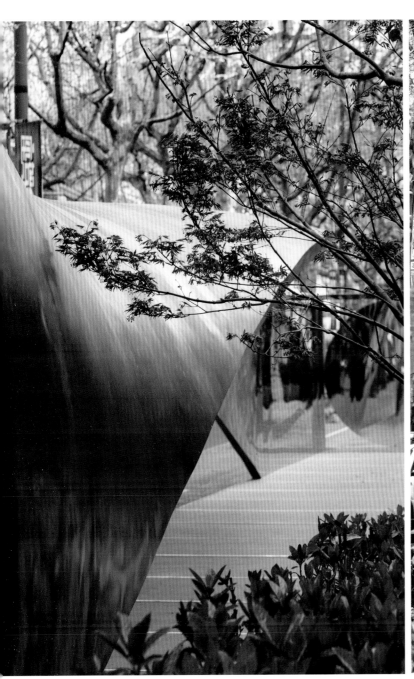

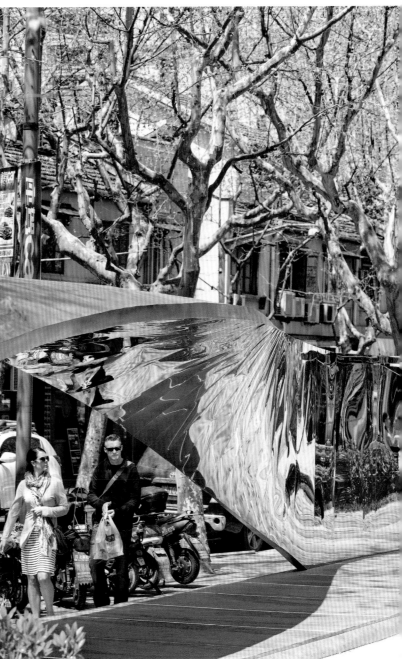

The large scale mirrors mounted at each end of the installation act as concentration points, capturing the whole lapse of the effect, and combining it into one moving image. The result is a reinterpretation of the relationship between urban context and the viewer, binding these together in a cultural setting of the retail, the city, and its inhabitants.

Chop Stick

Design Architects: *Visiondivision*

Duration: *Semi-permanent---The tree is likely to last 15 years. At that point it will be removed, leaving just the stump embedded horizontally within the kiosk.*

Dimensions / Technical Specs: *Wood and some steel structural components. The tree weighs 6 t and is 30 m long. The kiosk is approximately 4 m high.*

Total Costs: *$ 2,000,000*

Location: *100 Acres Art & Nature Park, Indianapolis, Indiana, the US*

Photographer: *Eric Lubrick (IMA), Donna Sink, Visiondivision*

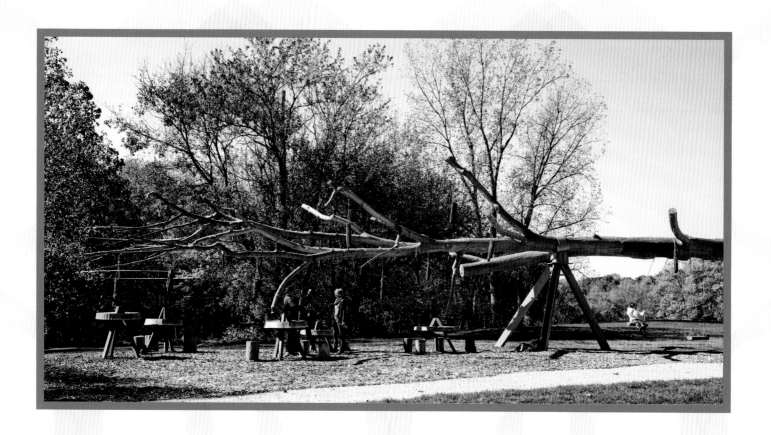

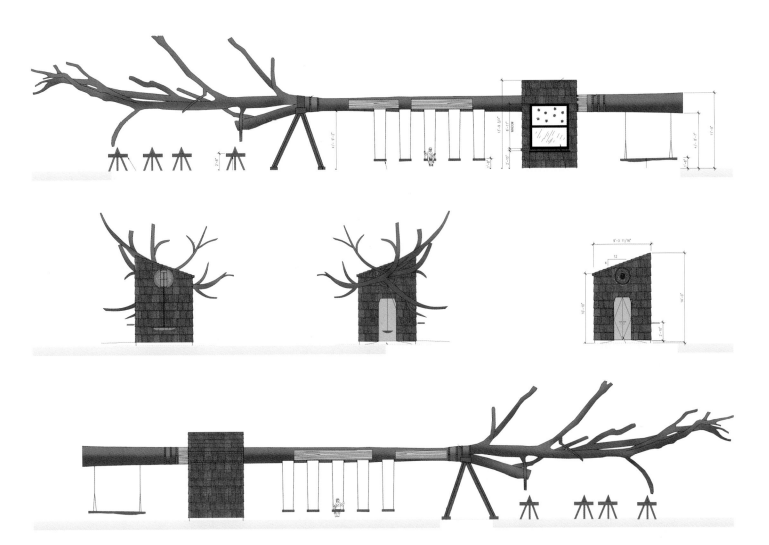

Facades Drawing

The design is based on the universal notion that you need to sacrifice something in order to make something new. Every product is a compound of different pieces of nature, whether it is a cell phone, a car, a stone floor or a wood board; they have all been harvested in one way or another. Our project is about trying to harvest something as gently as possible so that the source of what we harvest is displayed in a pure, pedagogic and respectful way—respectful to both the source itself and to everyone visiting the building.

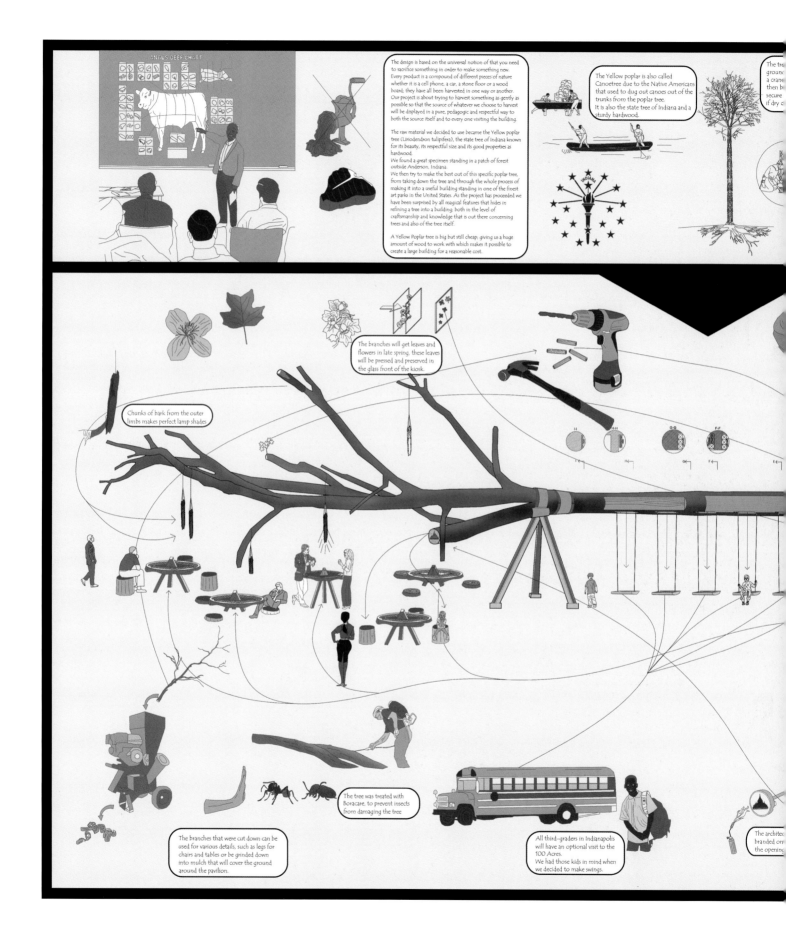

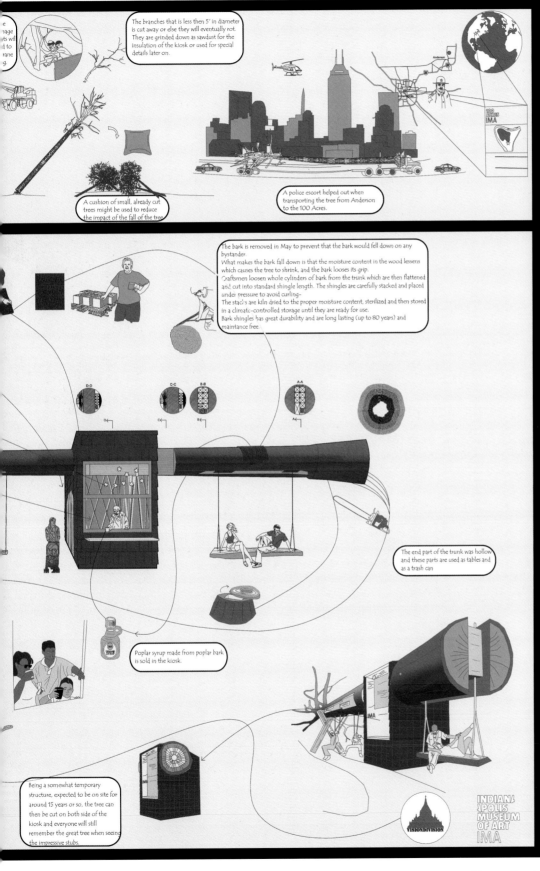

Diagram Drawing

The raw material we selected is a 100-foot yellow poplar tree, the state tree of Indiana, known for its beauty, respectable size, and good properties as hardwood. We found a great specimen standing in a patch of forest outside of Anderson, Indiana. Our goal was to make the best out of this specific poplar tree, from taking it down and through the whole process of transforming it into a useful building that is now part of one of the finest art parks in the United States.

As the project proceeded, we continued to be surprised by all of the marvelous features that where revealed in refining a tree into a building; both in the level of craftsmanship and knowledge of woodworkers and arborists, and also of the tree itself.

The tree was then transported to the park site, where it became the suspended horizontal beam of this new structure, which is almost entirely made out of the tree itself. The tree's bark was removed to prevent it from falling on bystanders, a process that occurs naturally as the moisture content in the wood drops, causing the tree to shrink and the bark to lose its grip. Craftsmen loosen entire cylinders of bark from the trunk that are then flattened and cut into a standard shingle length.

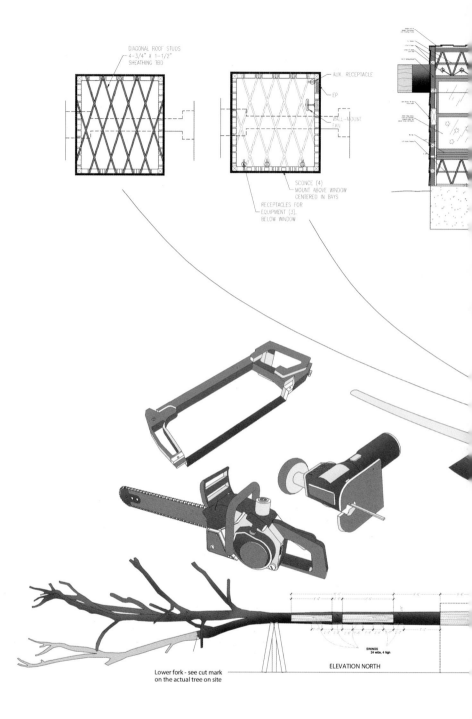

Lower fork - see cut mark
on the actual tree on site

ELEVATION NORTH

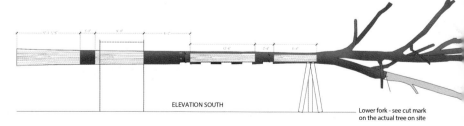

ELEVATION SOUTH

Lower fork - see cut mark
on the actual tree on site

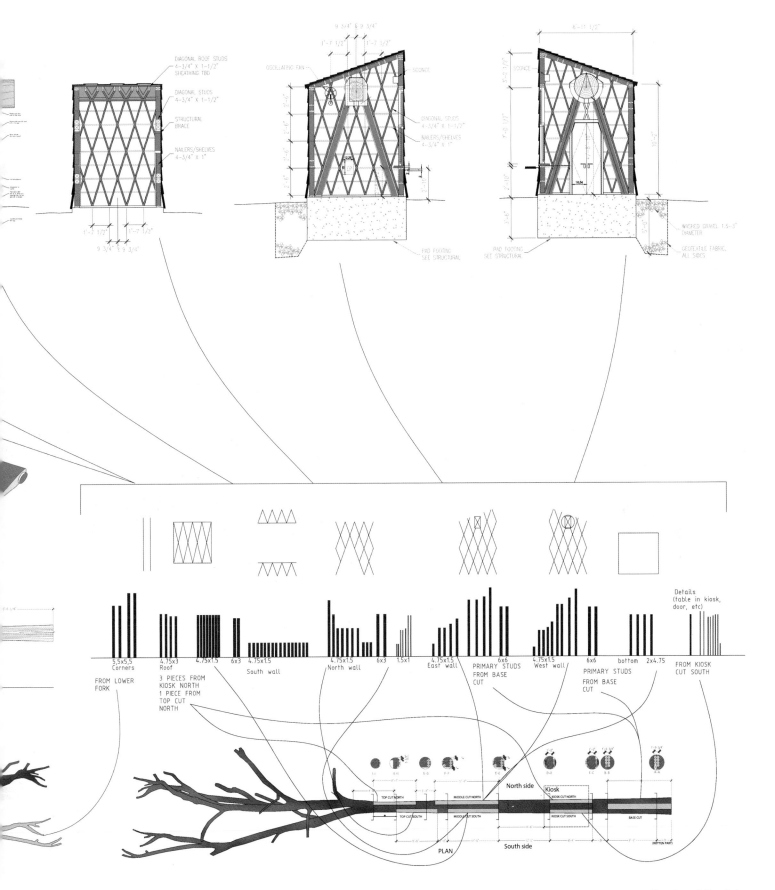

DIAGONAL ROOF STUDS
4-3/4" X 1-1/2"
SHEATHING TBD

DIAGONAL STUDS
4-3/4" X 1-1/2"

STRUCTURAL
BRACE

NAILERS/SHELVES
4-3/4" X 1"

OSCILLATING FAN

SCONCE

DIAGONAL STUDS
4-3/4" X 1-1/2"

NAILERS/SHELVES
4-3/4" X 1"

PAD FOOTING
SEE STRUCTURAL

SCONCE

PAD FOOTING
SEE STRUCTURAL

WASHED GRAVEL 1.5-3"
DIAMETER

GEOTEXTILE FABRIC,
ALL SIDES

Details
(table in kiosk,
door, etc)

5.5x5.5
Corners

4.75x3
Roof

4.75x1.5

6x3 4.75x1.5

South wall

North wall

6x3 1.5x1

4.75x1.5

East wall

6x6

PRIMARY STUDS
FROM BASE
CUT

4.75x1.5

West wall

6x6 bottom

PRIMARY STUDS
FROM BASE
CUT

2x4.75

FROM KIOSK
CUT SOUTH

FROM LOWER
FORK

3 PIECES FROM
KIOSK NORTH
1 PIECE FROM
TOP CUT
NORTH

North side Kiosk

TOP CUT NORTH MIDDLE CUT NORTH KIOSK CUT NORTH BASE CUT

TOP CUT SOUTH MIDDLE CUT SOUTH KIOSK CUT SOUTH (ROTTEN PART)

PLAN

South side

Drawing of the Cuts

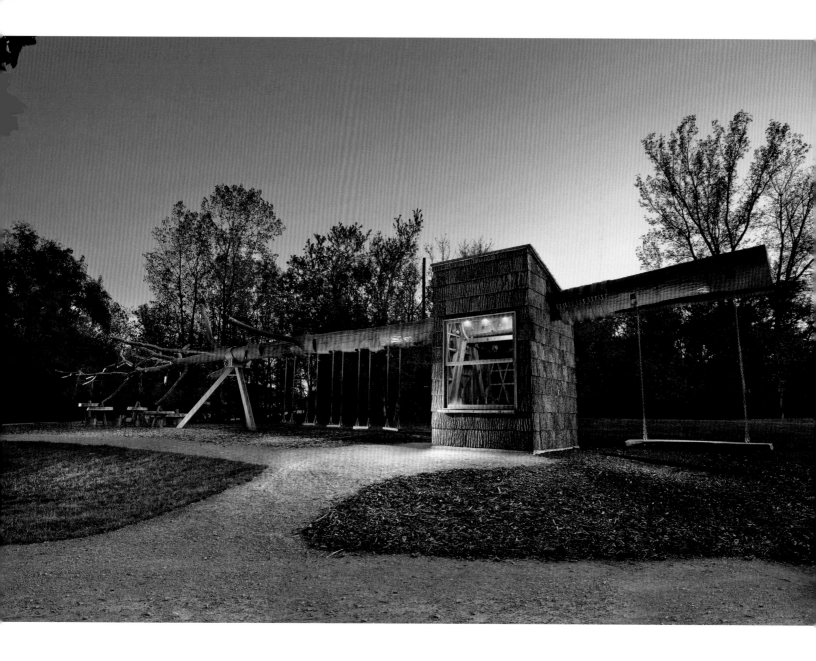

The shingles was carefully stacked and placed under pressure to avoid curling. The stacks were then kiln dried to the proper moisture content, sterilized, and kept in climate-controlled storage until they were ready for use. Bark shingles are very durable, long lasting (up to 80 years), and maintenance free.

After debarking, pieces of wood are extracted from the suspended tree and used for each of the components of the concession stand; structural support of the construction, pillars and studs for the kiosk, swings under the tree for kids, chairs and tables to be placed under the tree's crown, from which special fixtures made out of bark pieces will hang. Many school children visit 100 Acres, and we had those kids in mind when we decided to hang swings from the tree. On a smaller scale, we explored ways to use other parts of the tree in the concession stand, including pressed leaves and flowers that were taken from the tree and that became ornaments in the front glass of the kiosk.

We also made Yellow Poplar syrup that was extracted from the bark of the tree and that will be sold in the kiosk, thus meaning that you could actually eat a part of the building.

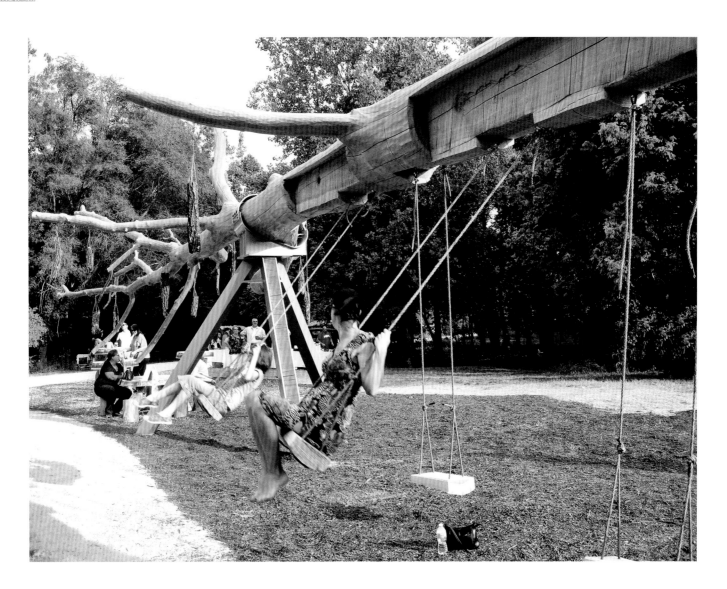

The delicate balance act of the risk of weakening the hovering tree with taking cuts from it versus having to have a certain amount of wood to stabilize and construct the kiosk and carrying the load from the tree itself was very challenging.

Many days was spent with the structural engineer trying different types of cuts in a computer model to optimize the structure.

To be able to fit all pieces that needed to be taken from the tree into the actual cuts we needed to make drawings for every single piece taken from the tree. We also needed to optimize the kiosk both in size and in its constructions since it would take a lot of weight from the hovering trunk. The kiosk got a truss frame construction with two larger pieces of wood that are right under the tree. Using the schematics from our engineers force diagram program, we concluded that the wall closer to the end of the tree was taking more load, thus we sized up the two larger pieces of wood in that specific wall. All these alterations really just made the project more beautiful since the design became more refined in terms of more balanced proportions.

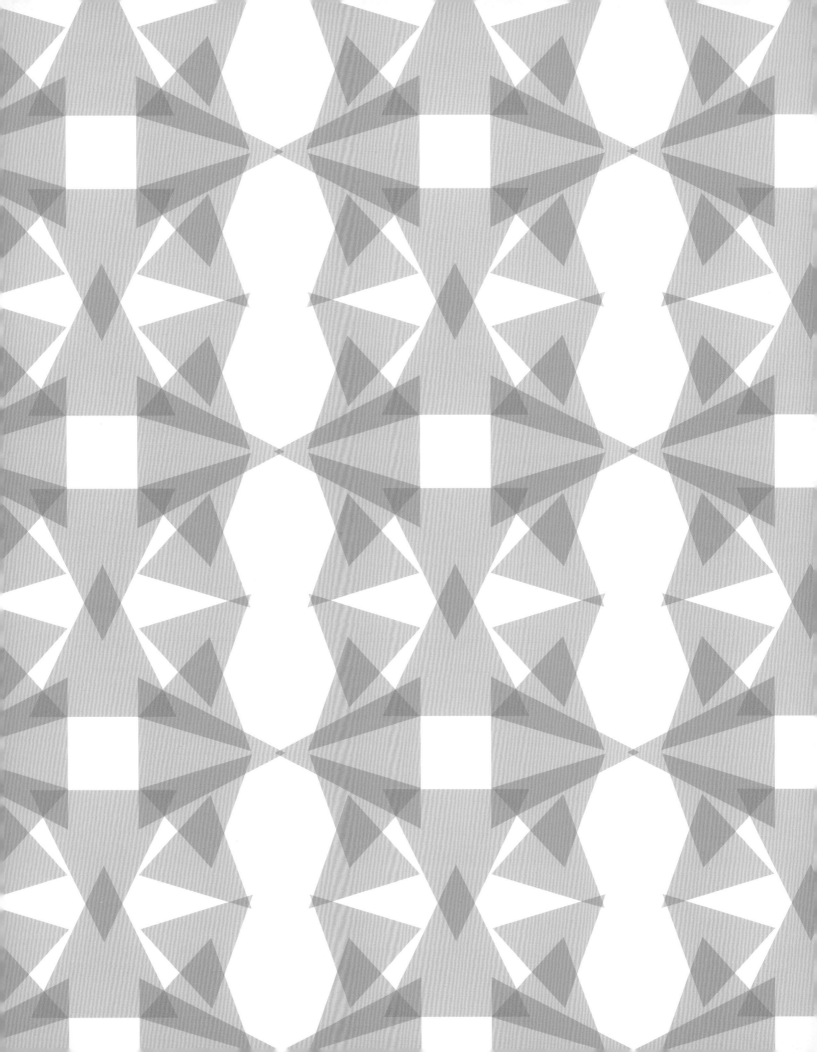

Chapter
3

Public Leisure **Facilities**

Vessel

Dimensions: 12 m diameter wide x 18 m high

Materials: Aluminum, stainless steel, laminated dichroic glass, beveled clear plate glass, concrete, landscape vegetation

Location: Seattle, Washington, USA

Photographer: Ed Carpenter

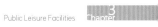

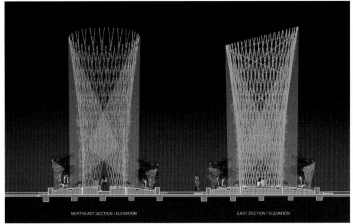

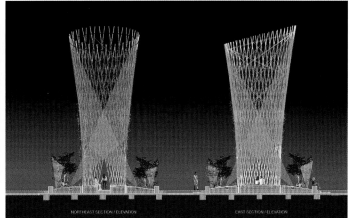

Structural Plan

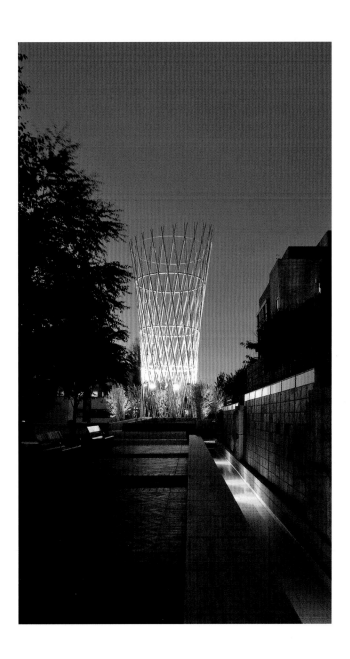

"Vessel", completed in July 2008, is a centerpiece for the Fred Hutchinson Cancer Research Center. Rising more than four stories in a transparent and searching gesture, this monumental but delicate sculpture employs light to represent the optimistic spirit of the institution. It is a luminous container for the aspirations and hopes of all involved. By juxtaposing native plantings with crystalline structure, it suggests a variety of dualistic metaphors: natural and technological, intuitive and rational, transparent and opaque, formal and informal. This "basket of light" expresses the dynamism of the Center in the way light and shadows play off, through and around the combinations of materials. Its interwoven structure represents the interconnected and collaborative nature of the Hutchinson Center.

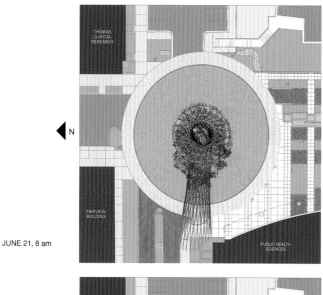

JUNE 21, 8 am

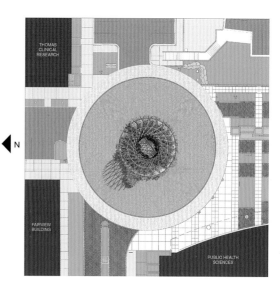

JUNE 21, 11 am

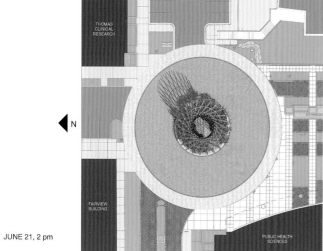

JUNE 21, 2 pm

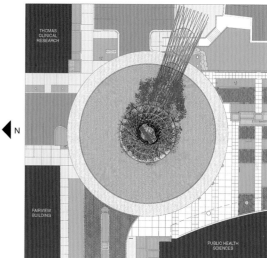

JUNE 21, 5 pm

Axonometric Assembly Diagram

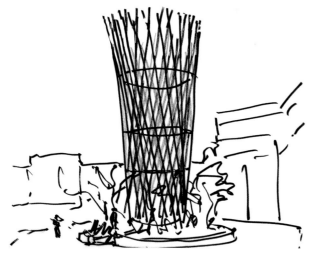

Axonometric Assembly Diagram

"Vessel" works on an urban scale, marking views along various axes, as well as on a human scale, allowing passage into and through the leafy core or the sculpture itself. As the vegetation surrounding "Vessel" matures and honeysuckle vines grow up its lattice structure, the interior space will be extraordinary for its delicate light and combination of intimacy and monumentality.

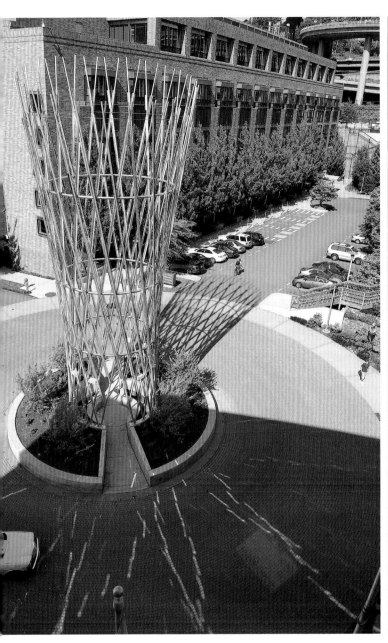

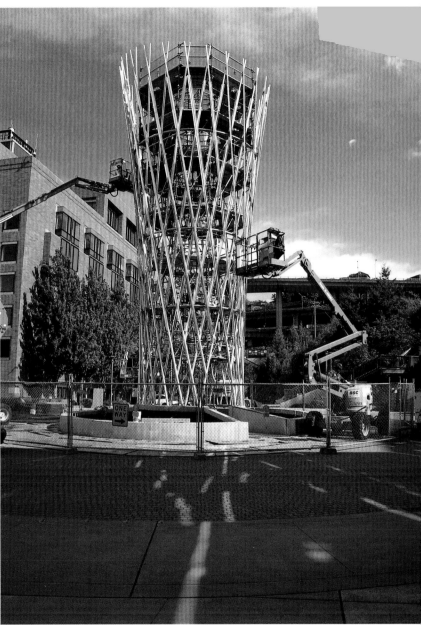

Hourly, daily, and seasonal changes in the light and vegetation will make the sculpture an abstract sundial as well as symbol of transformation. Its classic form, attractive materials, and hierarchy of scales will give "Vessel" universal appeal regardless of whether experienced from a passing car, adjacent building, or passage on foot through its center.

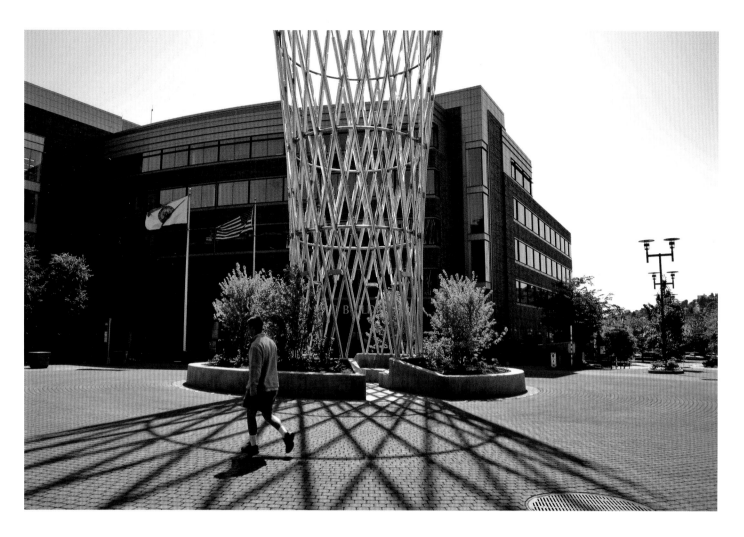

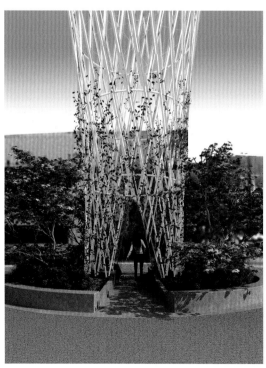

Axonometric Assembly Diagram

"Vessel" faced a challenging structural issue in that the site requires a tall sculpture to address axial views and to be in scale with surrounding buildings, but there are serious weight restrictions due to the load limits of the tunnel structure beneath. This dilemma was addressed with a design that is lightweight in spite of its monumentality.

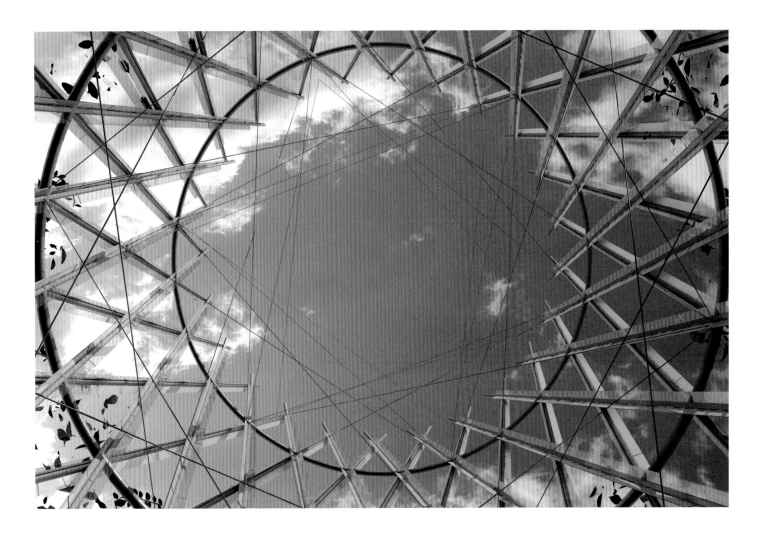

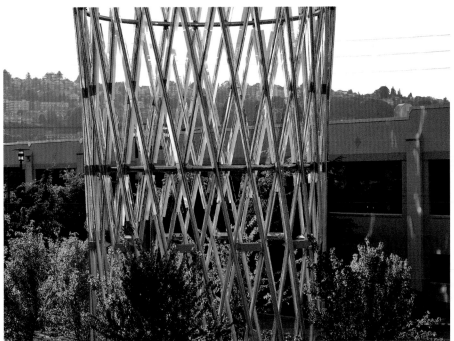

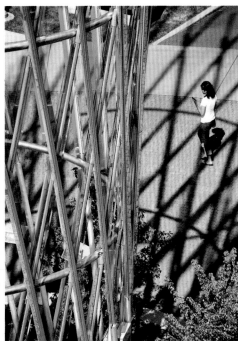

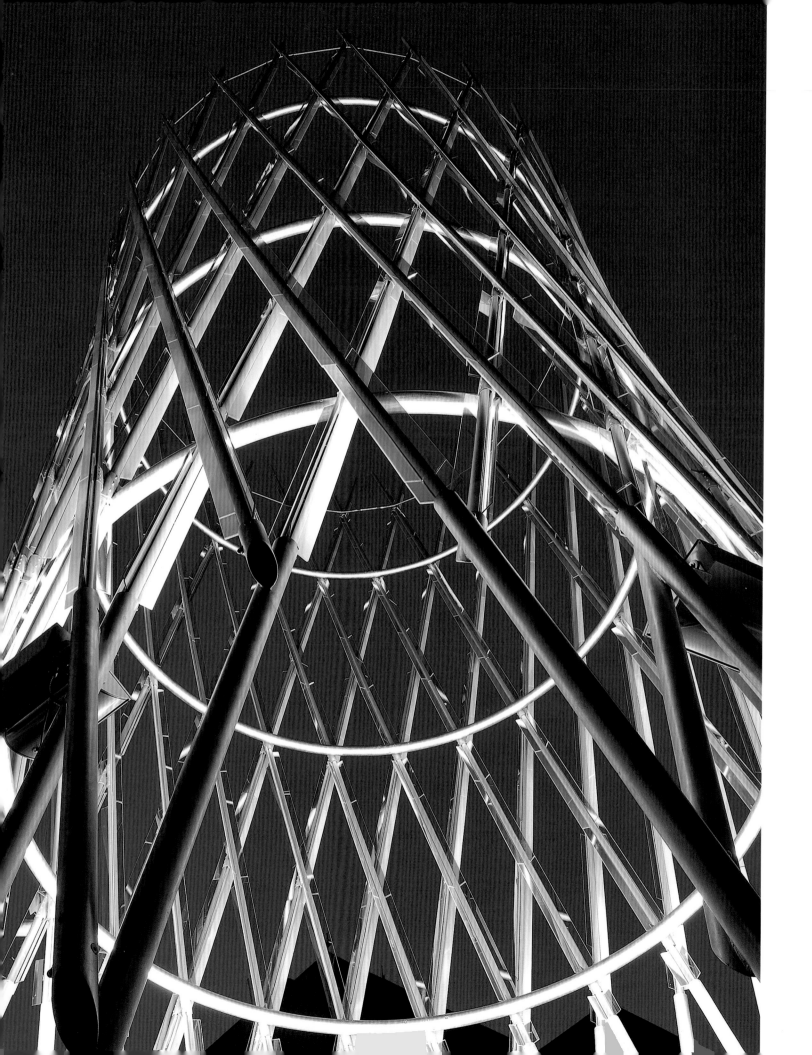

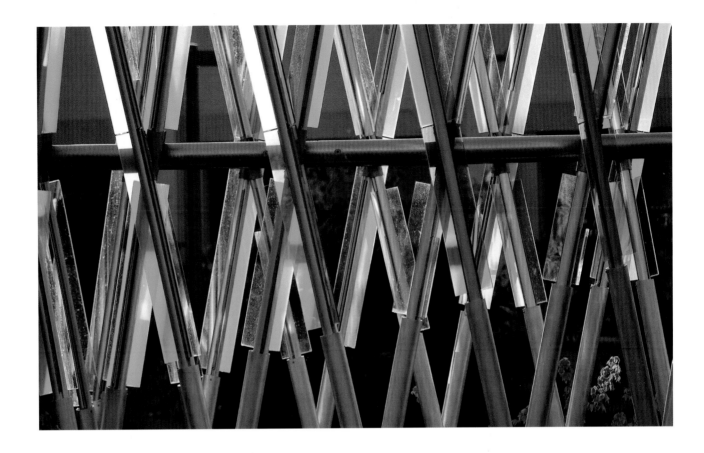

Employing aluminum, stainless steel, and slender strips of dichroic and beveled glass, the sculpture achieves both goals simultaneously. In an unusual innovation, laminated and tempered safety glasses were used structurally to strengthen the section of the aluminum members, allowing longer spans at lighter weight than with conventional methods.

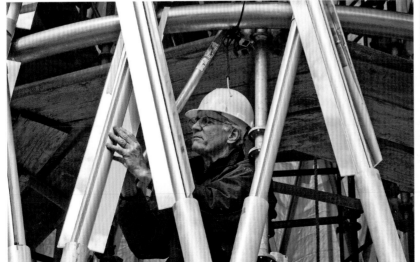

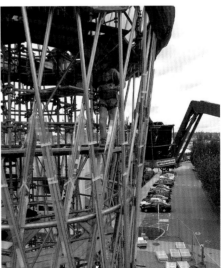

EU Pavilion – A Space for Contemplation

Design Architects: *Senat Haliti*

Location: *Shadërvan, Prizren, Republic of Kosovo*

Photographer: *Courtesy of S. Haliti & M. Azizi*

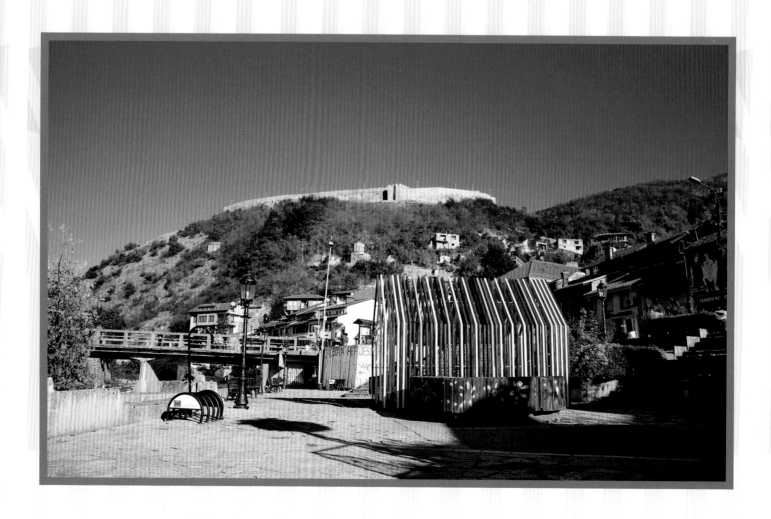

Dru breu / pine wood
140x42mm

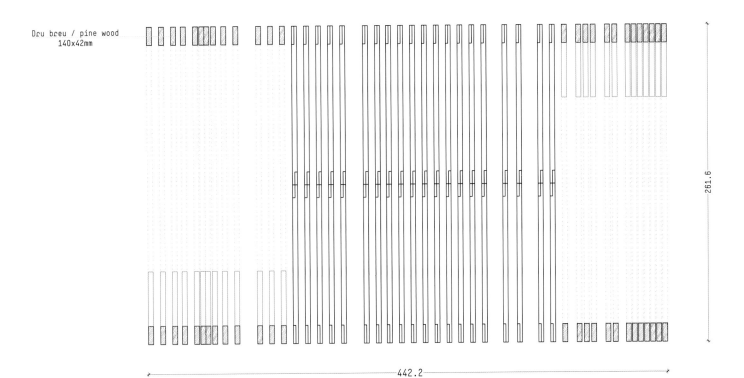

261.6

442.2

Site Plan

The idea of making a structure somebody could enter into, and be surrounded by, is a response to the need for an artwork that would transform a public space, reviving it. The EU Pavilion's idea came from the last stats regarding Kosovans readiness to Join EU (72%). Pavilion is designed to be occupied, providing a quiet space for contemplation with the potential to encourage building trust amongst people of different communities.

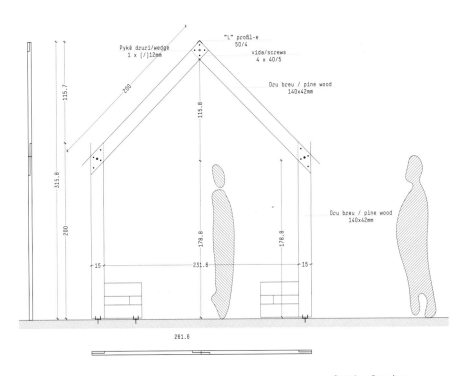

"L" profil-e
50/4
Pykë druri/wedge
1 x [/]12mm
vida/screws
4 x 40/5

Dru breu / pine wood
140x42mm

Dru breu / pine wood
140x42mm

115.7

315.8

200

115.8

178.8

178.8

15

231.6

15

261.6

Section Drawing

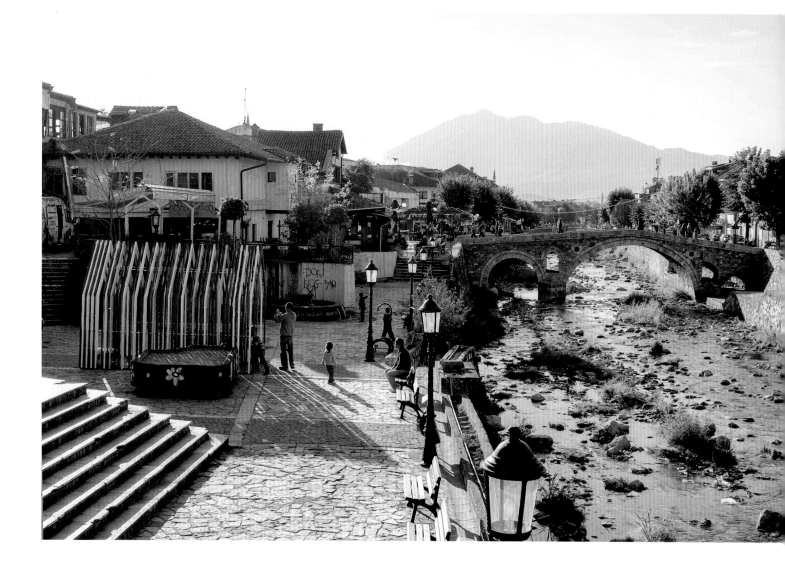

It is comprised of three elements: ground, space and structure. Roots and heritage are represented by the traditional carped interpreted on the ground while our European aspirations are represented by the structure itself. Based on "EU barcode" (AMO/ Rem Koolhaas, 2001) EU member's flags are layered and painted in recycled wood forming a house shaped space as most representative form of the "home", a shelter for all. The color richness is about differences and diversity as it stands also for harmony and beauty.

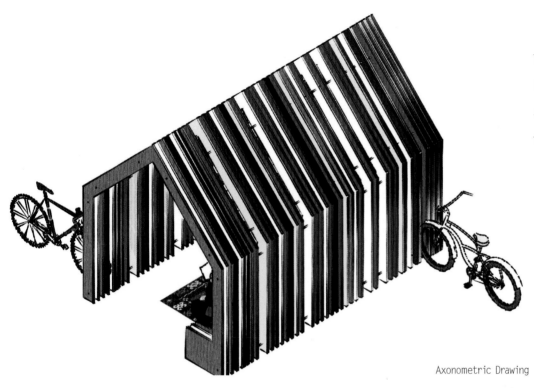

The contemplation space is created in between the roots and structure, a space where people can reflect about the past and future.

Axonometric Drawing

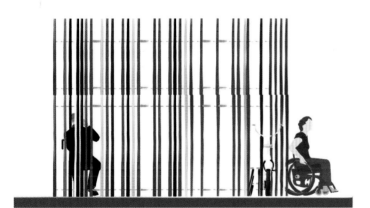

Rear View

Side View

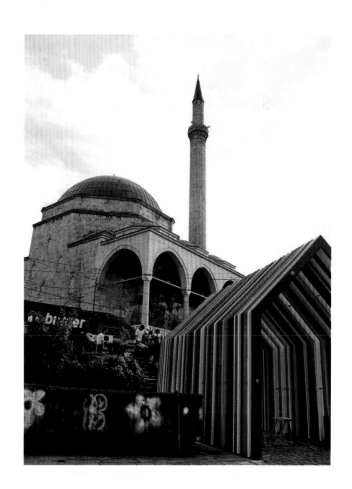

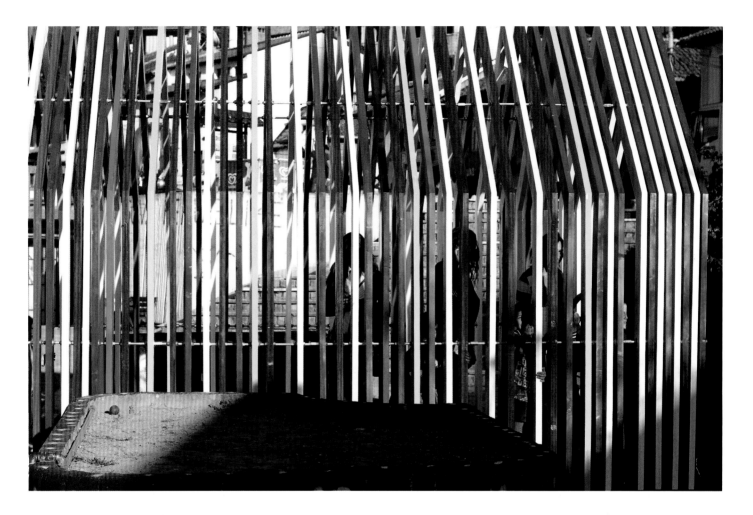

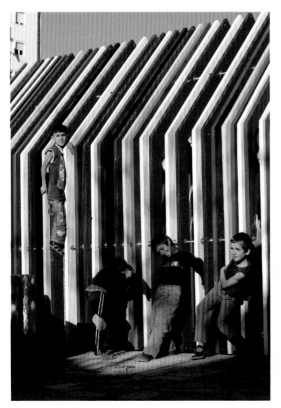

Amongst most popular phrases in Kosovo is "to get in EU". The pavilion aims to become an "EU HOME" for Kosovans, a space to give them the chance to "get in EU" every day. The recycled wooden frame forms a shaded space delimiting the boundary between the inside and outside of the structure. The base grounds the structure, and provides an informal seat.

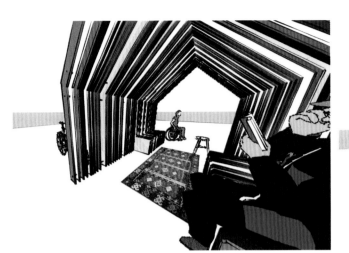

Perspective Drawing 1

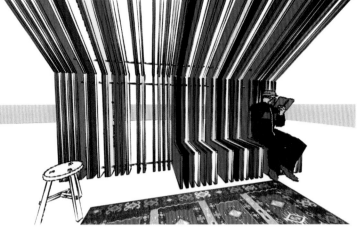

Perspective Drawing 2

There fundamental combined, create a bold, lively artwork, reflecting and answering to the vibrant energy that young Kosovans represent.

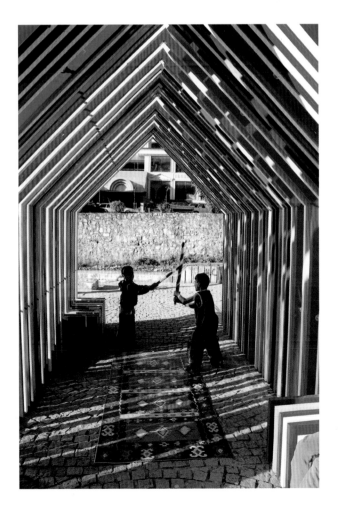

Plan

HygroSkin - Meteorosensitive Pavilion

Design Architects: *Achim Menges in collaboration with Oliver David Krieg and Steffen Reichert*

Location: *FRAC Centre, Orleans, France*

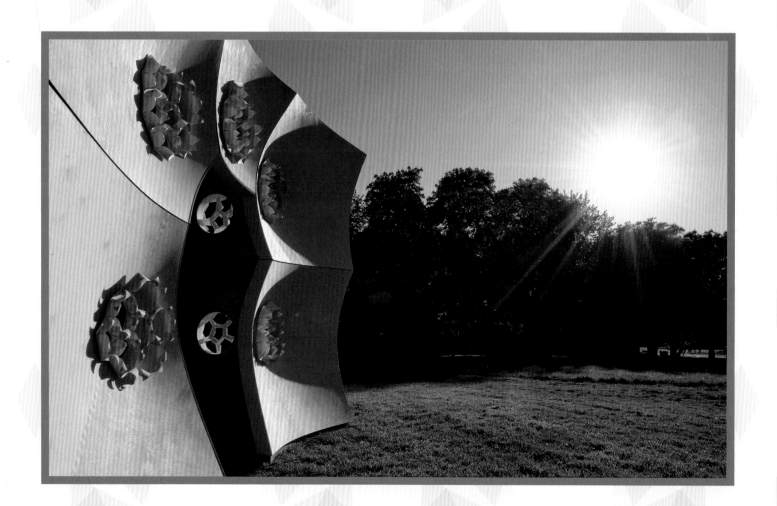

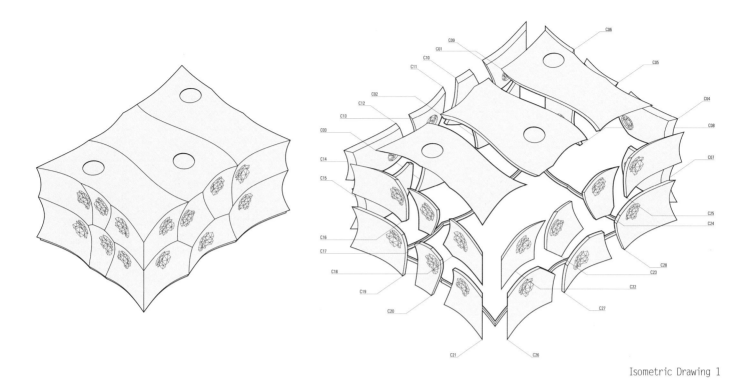

Isometric Drawing 1

Short Summary

The project HygroSkin - Meteorosensitive Pavilion explores a novel mode of climate-responsive architecture. While most attempts towards environmental responsiveness heavily rely on elaborate technical equipment superimposed on otherwise inert material constructs, this project uses the responsive capacity of the material itself. The dimensional instability of wood in relation to moisture content is employed to construct a meteorosensitive architectural skin that autonomously opens and closes in response to weather changes but neither requires the supply of operational energy nor any kind of mechanical or electronic control. Here, the material structure itself is the machine.

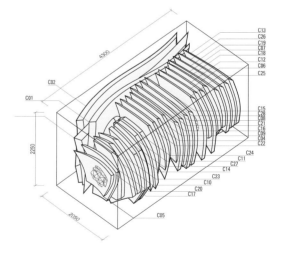

Isometric Drawing 2

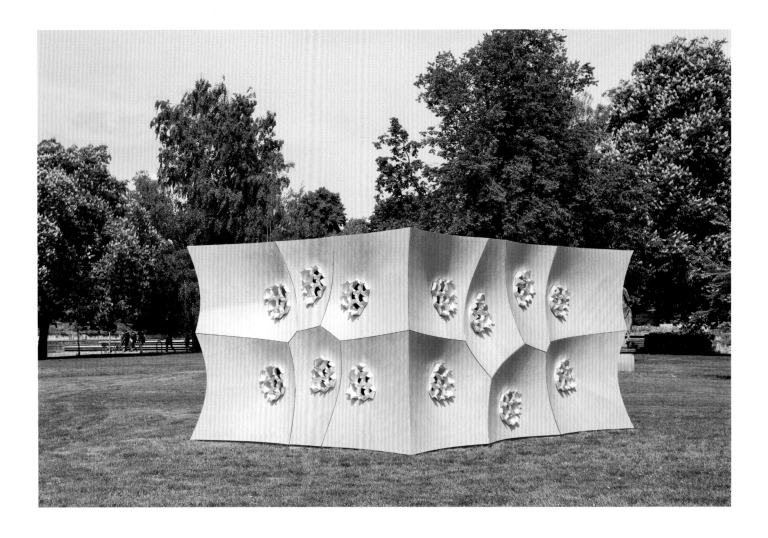

Project Concept

Climate-responsiveness in architecture is typically conceived as a technical function enabled by myriad mechanical and electronic sensing, actuating and regulating devices. In contrast to this superimposition of high-tech equipment on otherwise inert material, nature suggests a fundamentally different, no-tech strategy: In various biological systems the responsive capacity is quite literally ingrained in the material itself. This project employs similar design strategies of physically programming a responsive material system that requires neither extraneous mechanical or electronic controls, nor the supply of external energy. Here material computes form in unison with the environment.

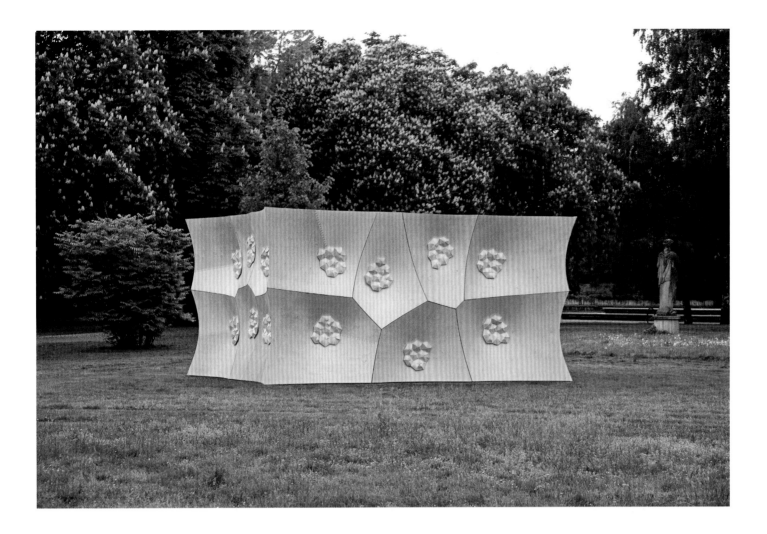

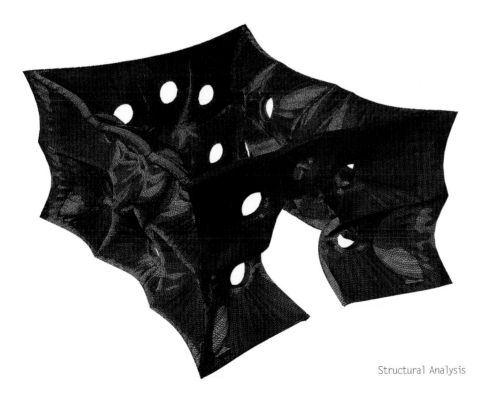

Structural Analysis

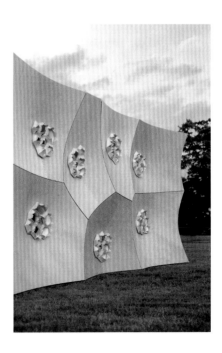

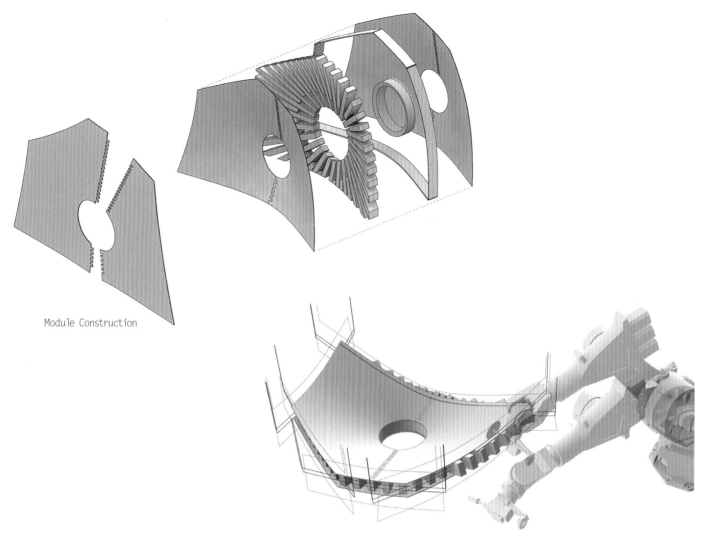

Module Construction

Robotic Fabrication Simulation

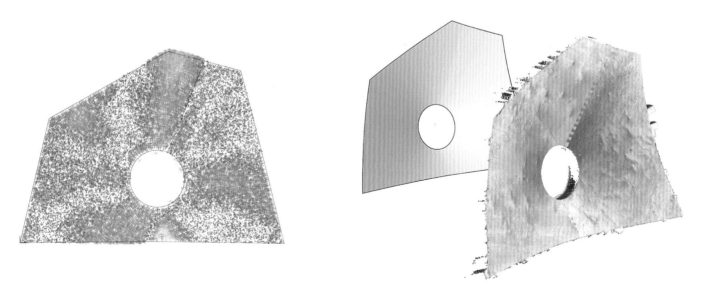

Laser Scan Comparison

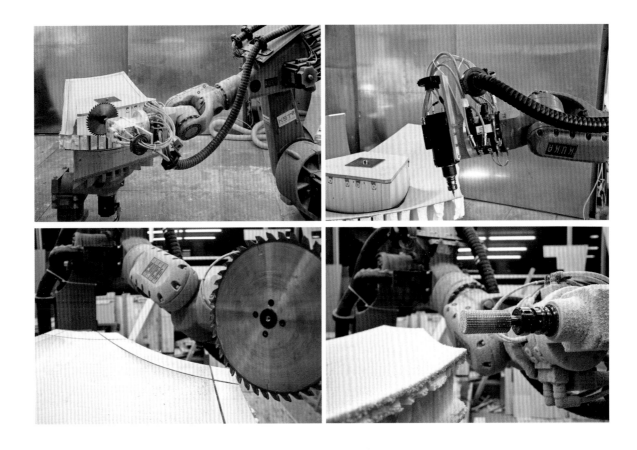

The project explores the tension between an archetypical architectural volume, the box, and a deep, undulating skin imbedding clusters of intricate, climate responsive apertures. The pavilion's envelope, which is at the same time load-bearing structure and meteorosensitive skin, is computationally derived from the elastic bending behavior of thin plywood sheets. The material's inherent capacity to form conical surfaces is employed in combination with 7-axis robotic manufacturing processes to construct 28 geometrically unique components housing 1,100 humidity responsive apertures.

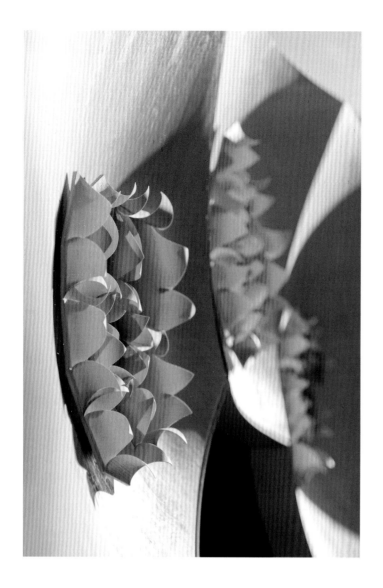

Spruce Cone

Spruce Cone Section

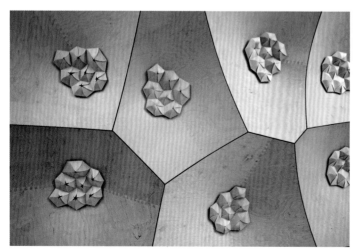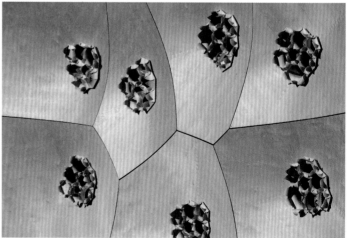

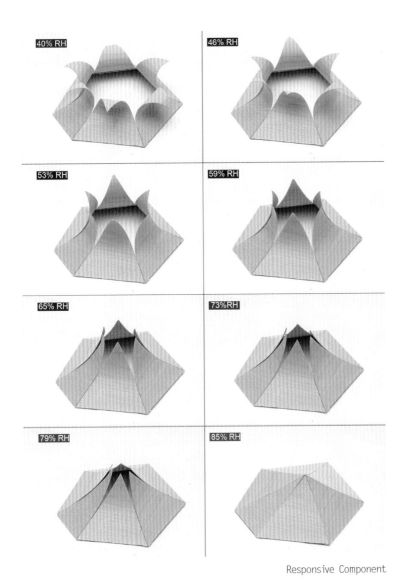

Responsive Component

The apertures respond to relative humidity changes within a range from 30% to 90%, which equals the humidity range from bright sunny to rainy weather in a moderate climate. In direct feedback with the local microclimate the pavilion constantly adjusts its degree of openness and porosity, modulating the light transmission and visual permeability of the envelope. This exchange results in constant fluctuations of enclosure, illumination and interiority of the internal space.

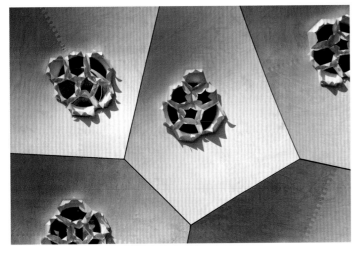

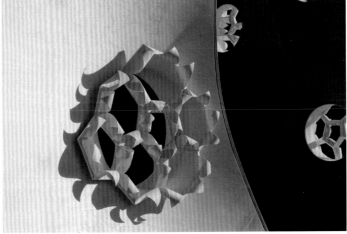

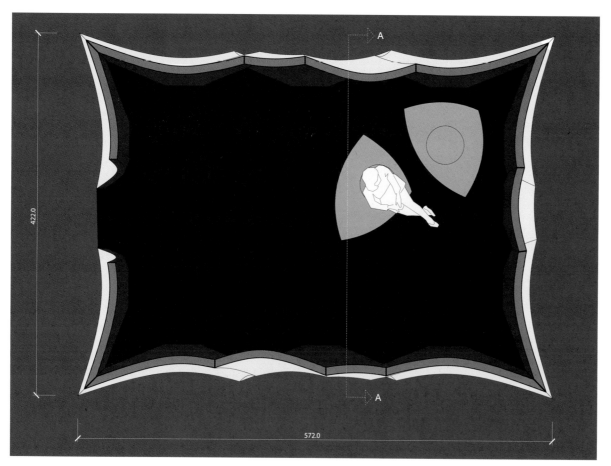

Section View

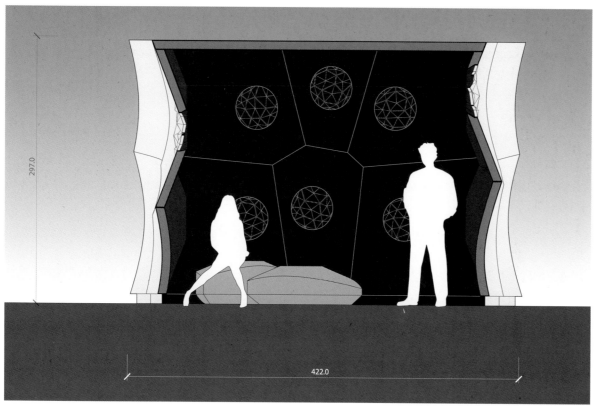

Plan View

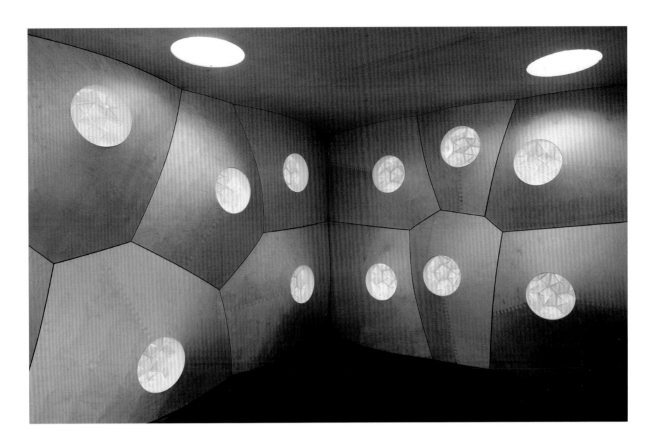

The hygroscopic actuation of the surface provides for a unique convergence of environmental and spatial experience; the perception of the delicate, locally varied, and ever changing environmental dynamics is intensified through the subtle and silent movement of the meteorosensitive architectural skin. The changing surface embodies the capacity to sense, actuate and react, all within the material itself.

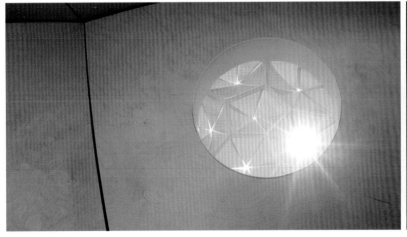

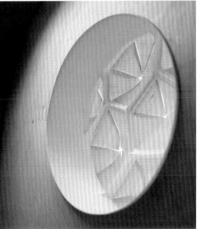

Love Tree

Project Materials: *Wood, White Paint & a Love Tree*

Project Size: *Length 3.5 m, Height 2.7 m, and Width 1.2 m*

Location: *Heemtuin (Botanical Garden) Leiderdorp, the Netherlands*

Photographer: *Rob Sweere*

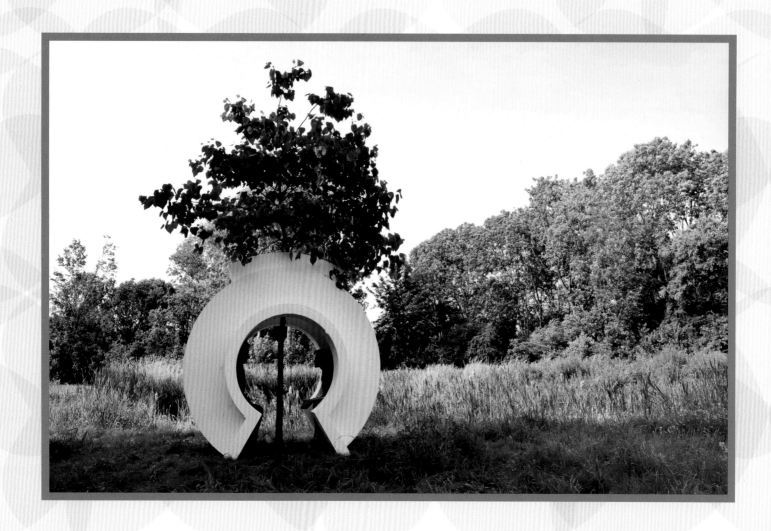

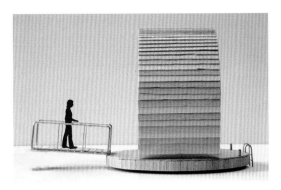

Axonometric Drawing 1

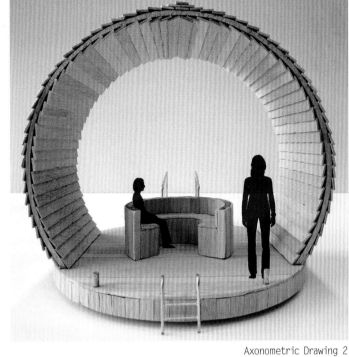

Axonometric Drawing 2

I was invited for an outdoor summer show at the Heemtuin (Botanical garden) at Leiderdorp. It is a well taken care of beautiful garden.

I could choose a location myself. I noticed this Love Tree standing free by itself next to a small lake. I loved the spot and designed the work for this. The tree is the central piece in the artwork. The work is build around it. It interested me that if two people meet the tree would be in between, as a witness. It's even blocking the view towards the other person. If you look up you can see the tree grow out of the ceiling into the sky.

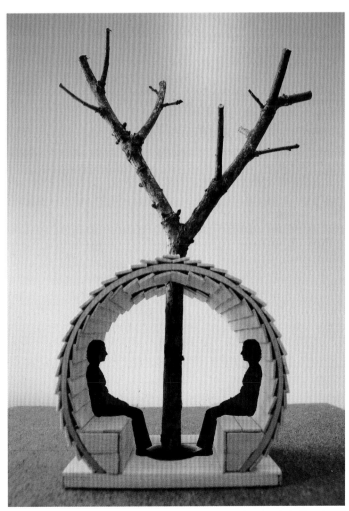

Axonometric Drawing 3

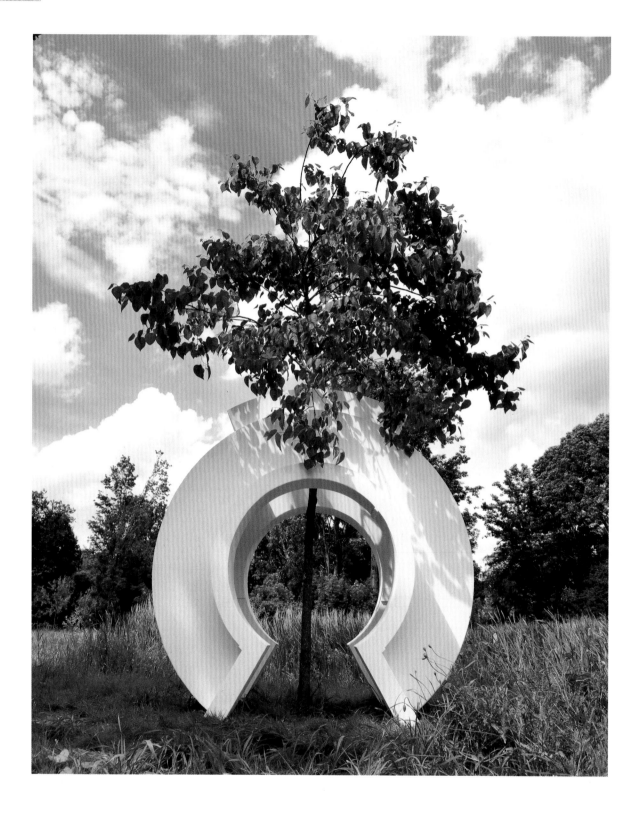

In dutch the name of the tree is: Judas Tree, after Judas of the Bible. It's a place to confess and share personal secrets to each other.

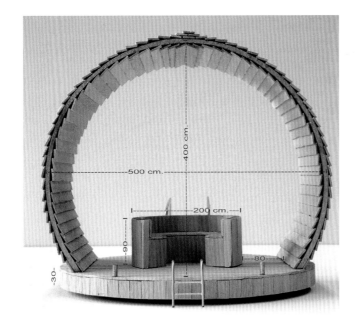

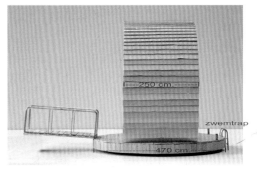

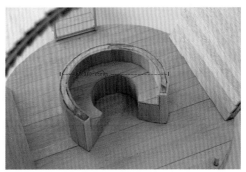

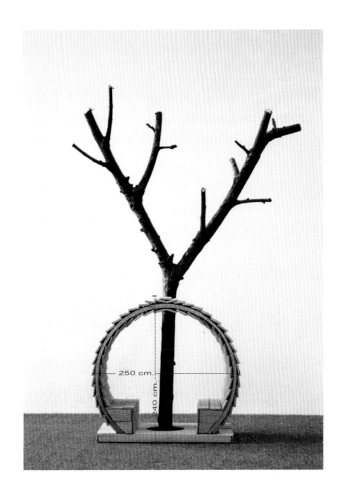

Primary Design Drawing

In other languages: Cercis siliquastrum (botanical), Arbre de Judée (french), Judasbaum / Herzbaum (german) also Judas. But in English it's called Love Tree, how interesting. I think because of the shape the leaves: heart shaped (see image)

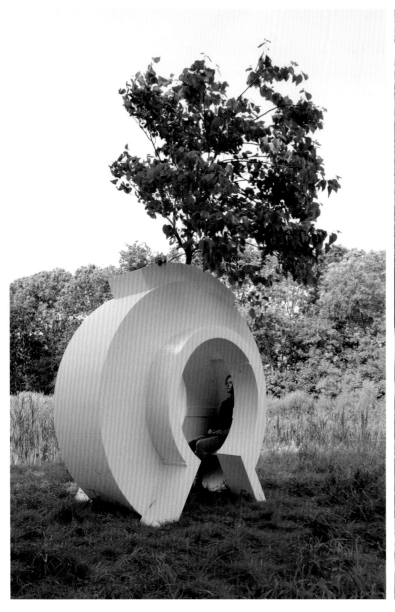

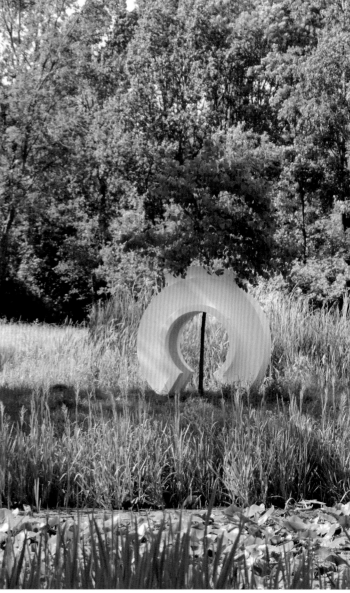

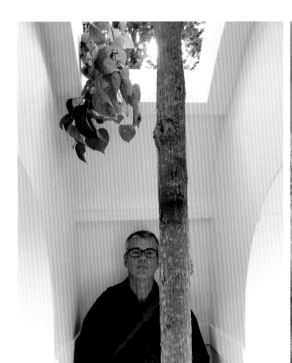
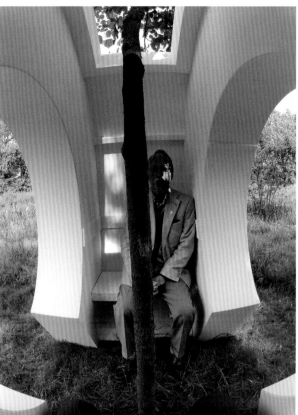

The artwork is painted white. There two reasons for that:

- I don't want to hide that the object is an artificial object made by a human and put in a natural landscape. It is better I think to show the object as a human intervention, instead of blending into the natural elements because it isn't natural, also because of the symmetrical shape.

-And with the white color the natural green of the vegetation and leaves looks even greener. So the white is like a canvas to show the beautiful colors of nature.

It is nature what this work is about and not the object. That's like a focusing device on the natural elements.

Mexico Public Seating Installation

Design Architects: *El Ultimo Grito*

Location: *Mexico City, Mexico*

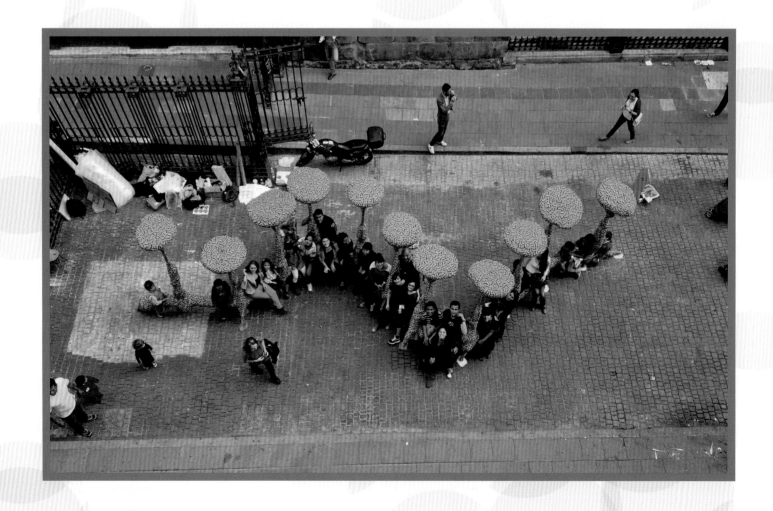

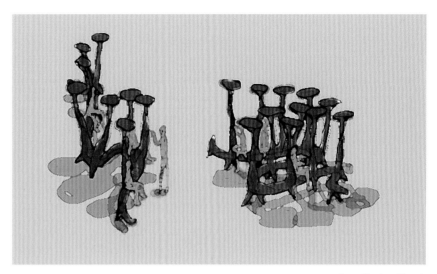

Installation Sketch

For the last few years we have been developing design and manufacture systems that would free us from the traditional methods of production. It marked a return to a kind of primitivism before tools and machines could inform the way we design and think about design. This system would have to allow us to use our bodies as tools to shape and create space-objects as we realized that working just with our hands does not produce the same results. Our hands too are trained; they respond to our brains in a comfortable way. We began to re-cycle packing materials because they are readily available, easy to work with and highly malleable. These materials allowed us to think with our bodies rather than our hands and their materiality did not have an associated aesthetic or a prescribed way to work with them. They can be cut, glued, joined, folded, twisted, etc. without any of the preciousness or skill required when dealing with other materials and their manipulation required us to develop more organic construction techniques that would bring structural integrity to our objects with a minimal use of material.

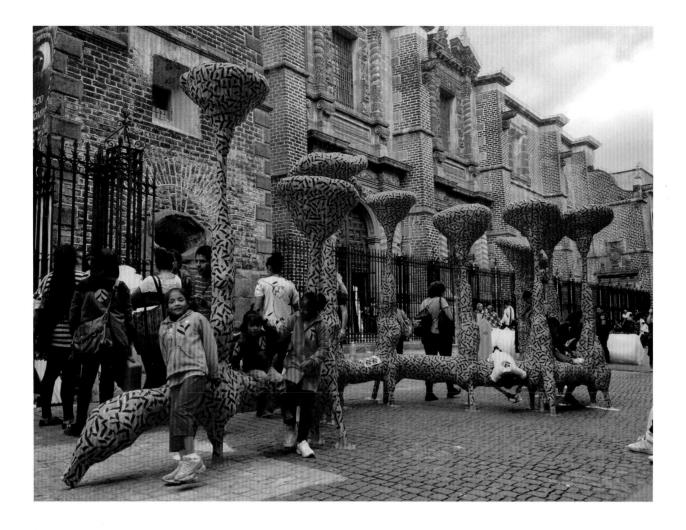

Since then, we have done many public installations and spaces utilizing this system and techniques. Of course, the system

has evolved. It is impossible not to develop a level of skill that would allow us to achieve more complex objects. We have also

experimented with different finishes. From gaffer tape and stickers, which we used as adhesive skin, that when applied over the

whole surface work both as a structural solution, producing a plastic skin that keeps all its parts together, and as a graphic layer,

designed to give identity to the objects by unifying them into a one single space-object. In these last years we started introducing

resin and fiber-glass in order to create an exo-skeleton cast over our hand crafted free-formed shapes which become a kind of

sacrificial mould, forever frozen inside.

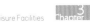

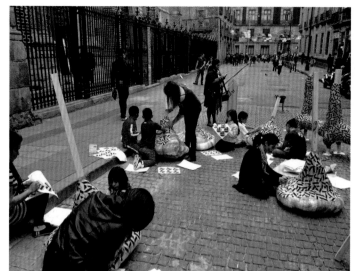
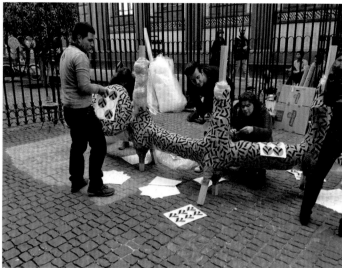

ABOUT THE EXPERIENCE

If you have never been to the historic centre of Mexico you don't know what it means to turn up all your senses full blast to 11... The noise, the colors, the smells, the proximity of the bodies of thousands of people up and down the street moving with ease around the cars, the 'vendedores ambulantes', the bicycles, the police, food stalls... and just around the corner from it all, a cul-de-sac, between the Palacio de Autonomia and the Templo Mayor. That is where we were. We must confess that this has been without a doubt our most 'public installation' in terms of social engagement with the local community while producing the work. In Mexico DF it is impossible not to be part of what happens in the street if you are working in the street, it absorbs you. We set to work with a team of volunteers organized by Abierto Mexicano de Diseño but very fast it became a much larger affair, children living in the area got involved within seconds, asking questions, playing with the bubble wrap, wanting to participate. On the first day we managed to finish the structure and to 'upholster it' with the packing materials, ready to be rendered with the stickers the day after. We find that people have a very different reaction to these installations before and after they are covered by stickers.

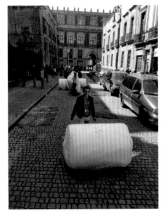 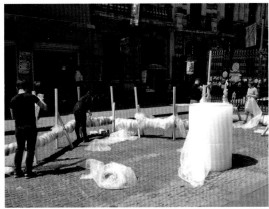 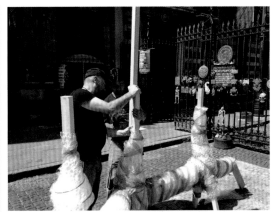

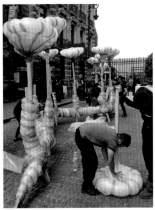 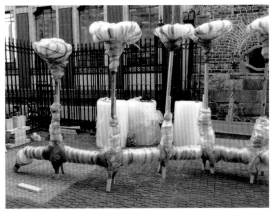 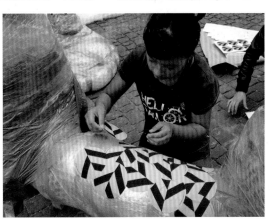

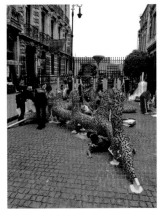 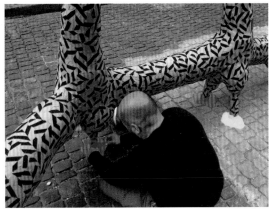

Before the structure looks weirdly naked, like an animal missing its skin, all the muscles and bones exposed... wood, bubble wrap, packing tape. It might even look like a pile of rubbish if you have never seen one finished before, certainly the people working and living in the area didn't seem so convinced when we left the first day. Are you going to leave this here? How long? What is this for?

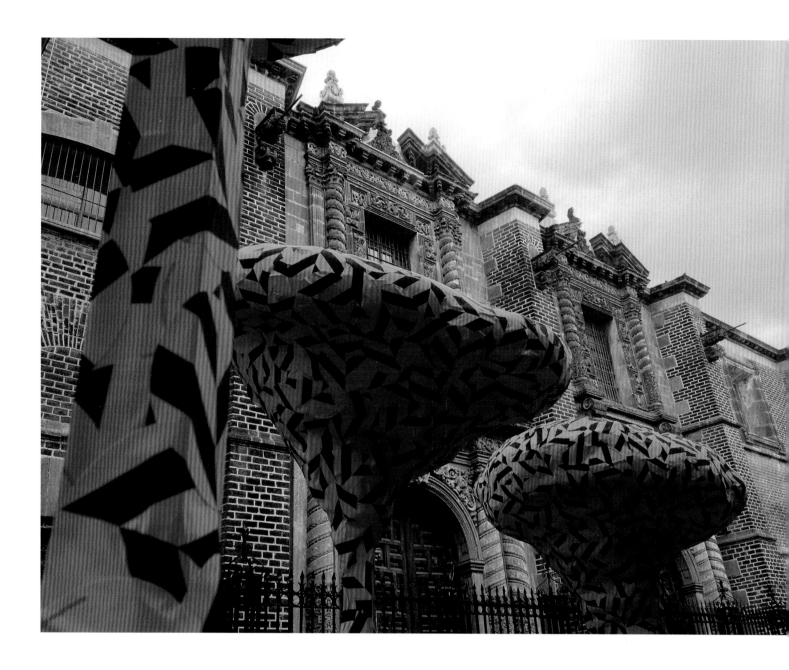

The day after it was a different story, as soon as we started rendering it with stickers it became a party, lots of people joined in, both working and looking, a near-by shop started playing music loudly, then more people arrived, little stalls selling food, we were in a street party!!

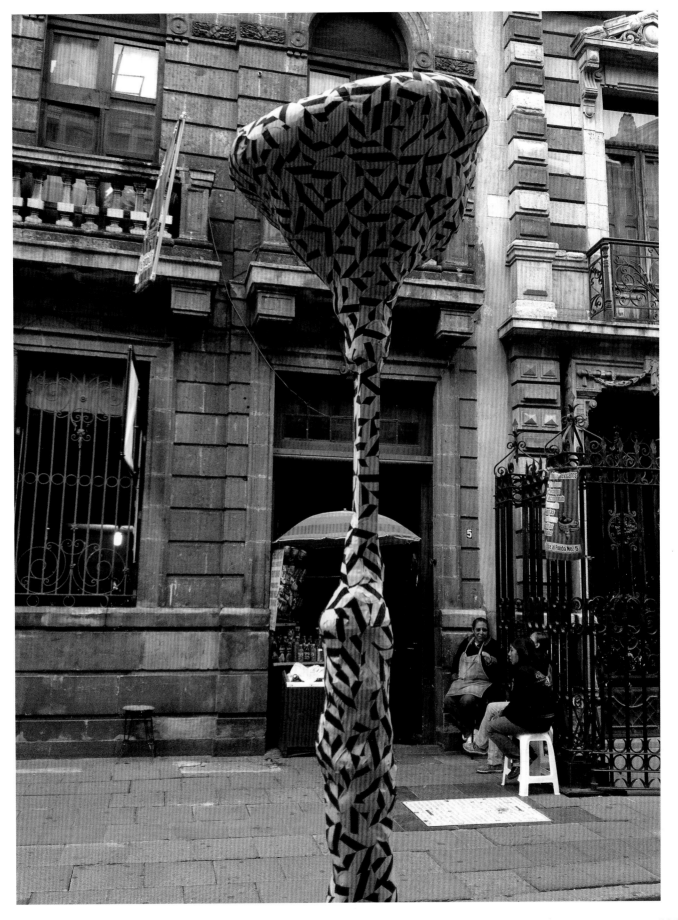

Noriega Parklet

Design Architects: *Matarozzi Pelsinger Design + Build*

Location: *Ocean Beach, San Francisco, the US*

Photographer: *Wells Campbell*

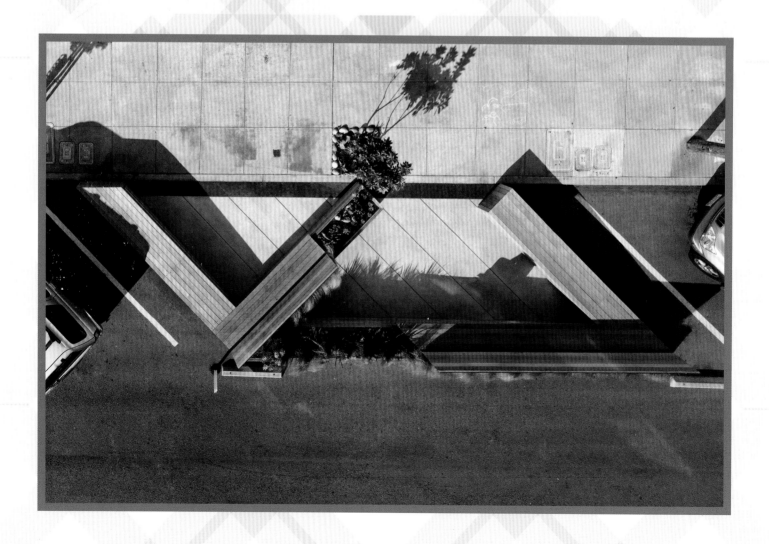

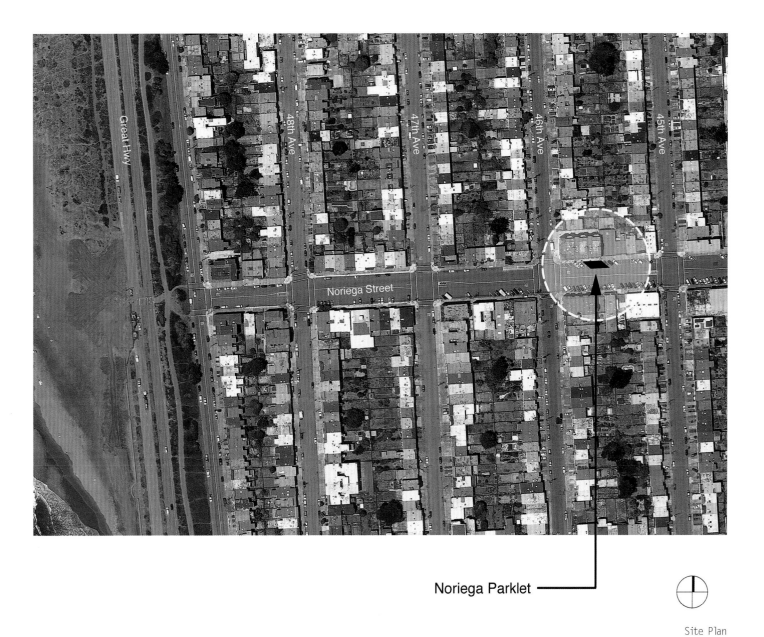

Noriega Parklet ———————

Site Plan

A new space for sitting, eating, and playing replaces 3 existing diagonal parking spaces in San Francisco's Outer Sunset District. The diagonal geometry of the existing parking becomes a unique design opportunity to create a usable, inviting installation suited to the parklet's diverse community.

237

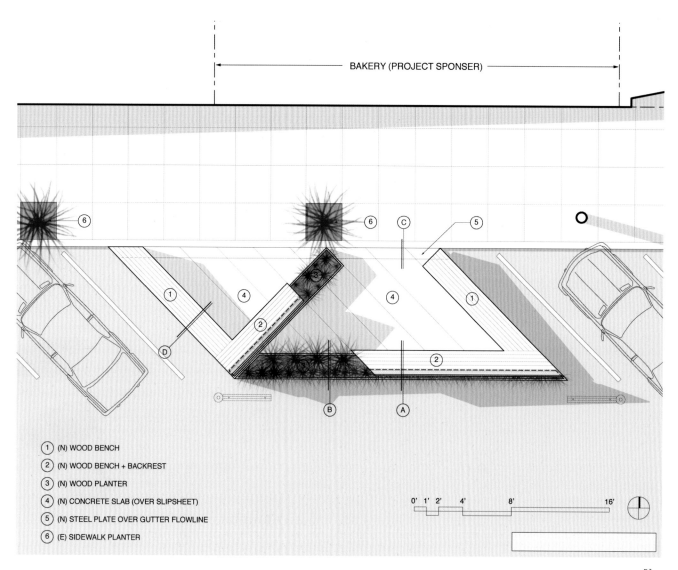

BAKERY (PROJECT SPONSER)

(1) (N) WOOD BENCH

(2) (N) WOOD BENCH + BACKREST

(3) (N) WOOD PLANTER

(4) (N) CONCRETE SLAB (OVER SLIPSHEET)

(5) (N) STEEL PLATE OVER GUTTER FLOWLINE

(6) (E) SIDEWALK PLANTER

0' 1' 2' 4' 8' 16'

Plan

The site, a 45° parallelogram, is subdivided into two separate spaces to help accommodate different kinds of user groups (dogs & children, young & old, quiet & loud, bikes & strollers). One space opens generously to the sidewalk, while the other is more protected and intimate. The required 3' setback from adjacent parking spaces is exploited to provide seating on both the interior and exterior of the extra-deep benches. The acute corners are embraced as areas for planting and "chaise lounge" seating, where tight plan geometry becomes an excuse to put your feet up.

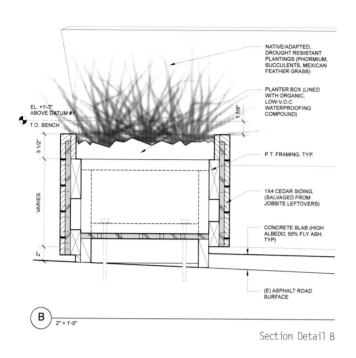

NATIVE/ADAPTED,
DROUGHT RESISTANT
PLANTINGS (PHORMIUM,
SUCCULENTS, MEXICAN
FEATHER GRASS)

PLANTER BOX (LINED
WITH ORGANIC,
LOW-V.O.C.
WATERPROOFING
COMPOUND)

P.T. FRAMING, TYP.

1X4 CEDAR SIDING,
(SALVAGED FROM
JOBSITE LEFTOVERS)

CONCRETE SLAB (HIGH
ALBEDO, 50% FLY ASH,
TYP)

EL. +1'-7"
ABOVE DATUM #1

T.O. BENCH

1 7/8"

3 1/2"

VARIES

2"

(E) ASPHALT ROAD
SURFACE

B 2" = 1'-0"

Section Detail B

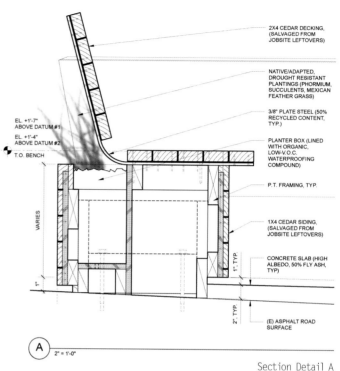

2X4 CEDAR DECKING,
(SALVAGED FROM
JOBSITE LEFTOVERS)

NATIVE/ADAPTED,
DROUGHT RESISTANT
PLANTINGS (PHORMIUM,
SUCCULENTS, MEXICAN
FEATHER GRASS)

3/8" PLATE STEEL (50%
RECYCLED CONTENT,
TYP.)

PLANTER BOX (LINED
WITH ORGANIC,
LOW-V.O.C.
WATERPROOFING
COMPOUND)

P.T. FRAMING, TYP.

1X4 CEDAR SIDING,
(SALVAGED FROM
JOBSITE LEFTOVERS)

CONCRETE SLAB (HIGH
ALBEDO, 50% FLY ASH,
TYP)

EL. +1'-7"
ABOVE DATUM #1
EL. +1'-4"
ABOVE DATUM #2

T.O. BENCH

VARIES

1"

1", TYP.

2", TYP.

(E) ASPHALT ROAD
SURFACE

A 2" = 1'-0"

Section Detail A

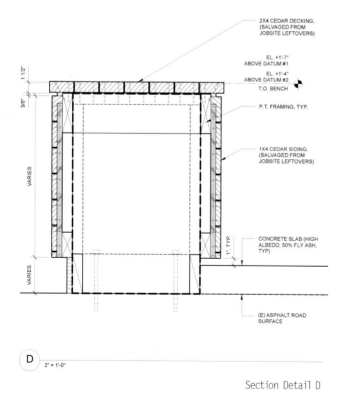

2X4 CEDAR DECKING,
(SALVAGED FROM
JOBSITE LEFTOVERS)

EL. +1'-7"
ABOVE DATUM #1
EL. +1'-4"
ABOVE DATUM #2

T.O. BENCH

P.T. FRAMING, TYP.

1X4 CEDAR SIDING,
(SALVAGED FROM
JOBSITE LEFTOVERS)

CONCRETE SLAB (HIGH
ALBEDO, 50% FLY ASH,
TYP)

1 1/2"

3/8"

VARIES

VARIES

1", TYP.

(E) ASPHALT ROAD
SURFACE

D 2" = 1'-0"

Section Detail D

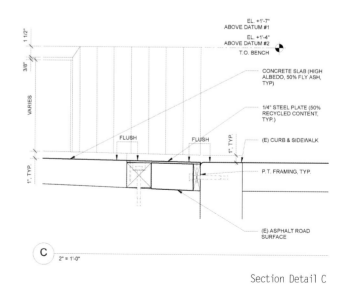

EL. +1'-7"
ABOVE DATUM #1
EL. +1'-4"
ABOVE DATUM #2

T.O. BENCH

CONCRETE SLAB (HIGH
ALBEDO, 50% FLY ASH,
TYP)

1/4" STEEL PLATE (50%
RECYCLED CONTENT,
TYP.)

(E) CURB & SIDEWALK

P.T. FRAMING, TYP.

(E) ASPHALT ROAD
SURFACE

1 1/2"

3/8"

VARIES

FLUSH FLUSH

1", TYP.

1", TYP.

C 2" = 1'-0"

Section Detail C

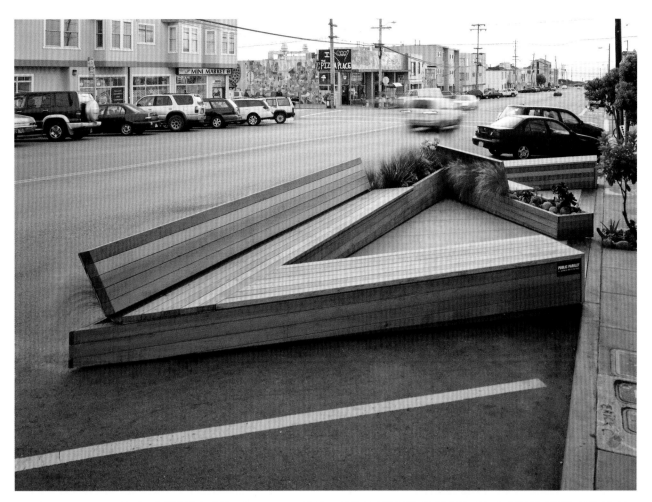

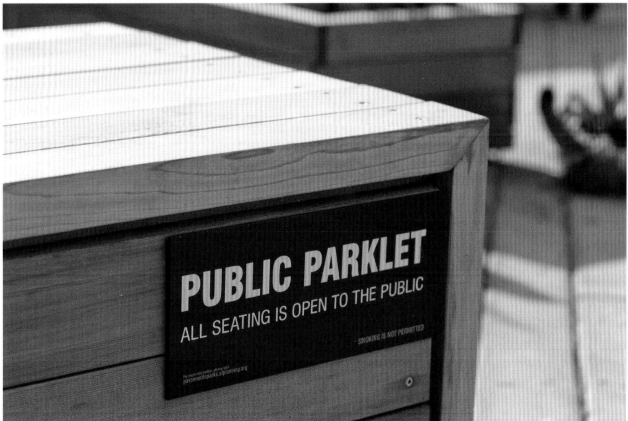

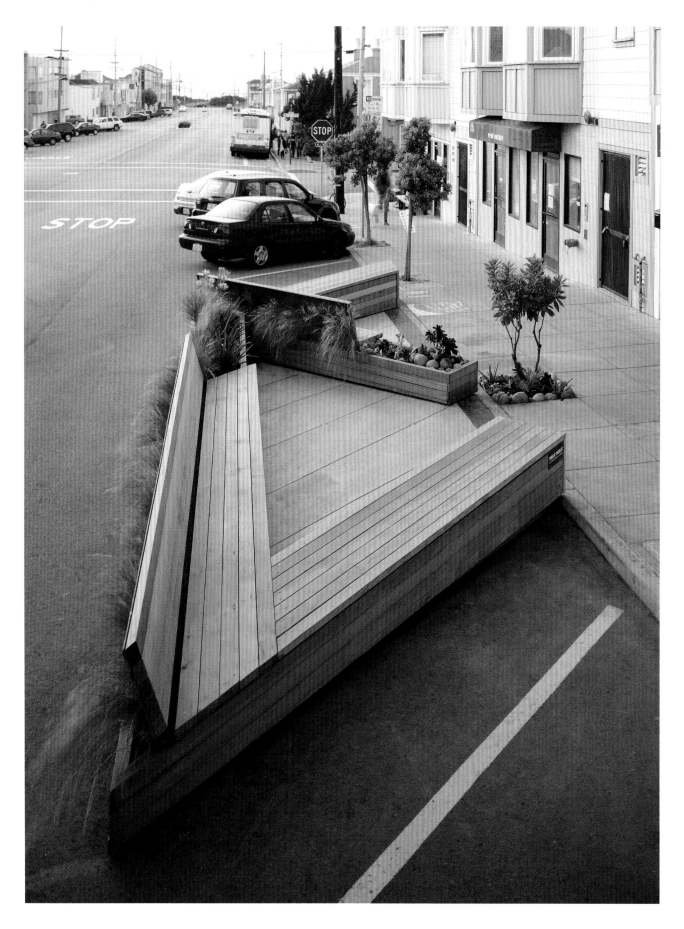

The parklet was designed pro-bono by Matarozz iPelsinger Design + Build and constructed at cost. All planting was done by neighbors (and their kids!). The succulent garden was assembled entirely from donated plants brought in by neighbors and bakery patrons.

The project recently received a 2012 San Francisco AIA design award.

Rollercoaster

Design Architects: *Interval Architects*

Site Area: *1,200 m²*

Location: *Huangzhuang Vocational School, Beijing, China*

Photographer: *Yunduan GU*

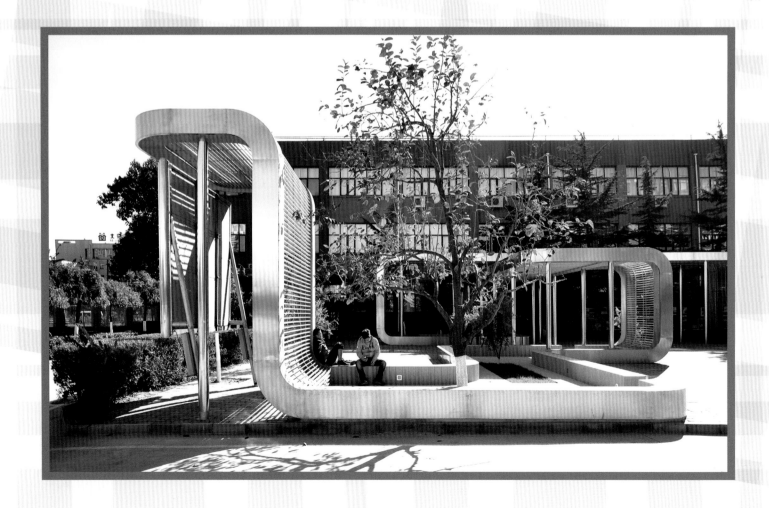

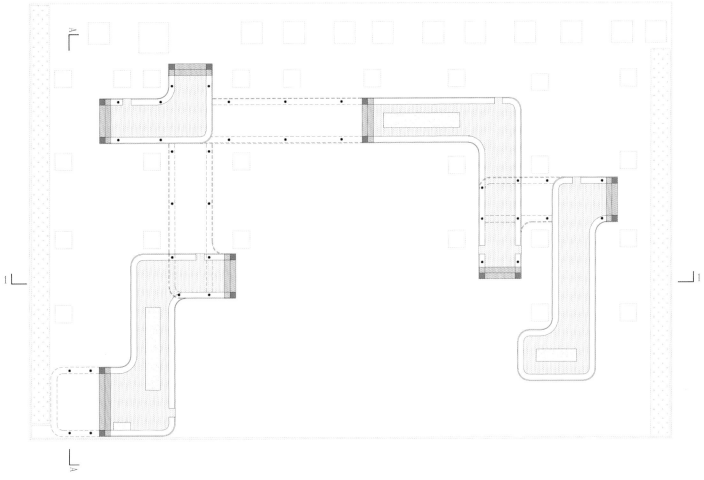

Ground Level Plan

1 : 150

Situated in a tranquil environment of one of the best vocational schools in Beijing, the project aims at providing an iconic

image to the institution as well as redefining the use of an existing public space on the central square of the campus.

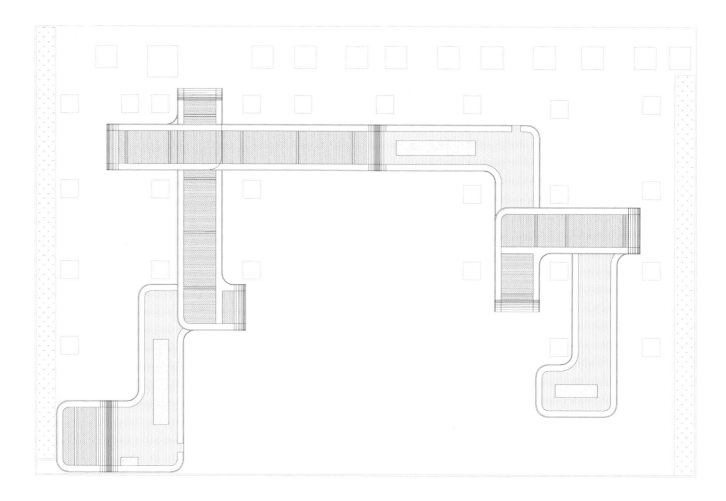

1:150

Roof Plan

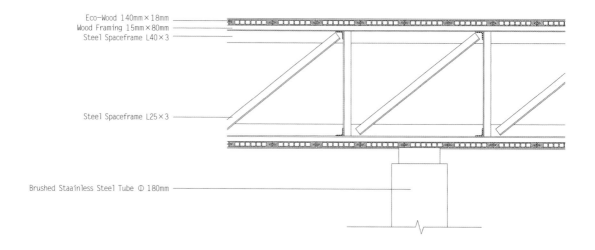

Eco-Wood 140mm×18mm
Wood Framing 15mm×80mm
Steel Spaceframe L40×3

Steel Spaceframe L25×3

Brushed Staainless Steel Tube Φ 180mm

1:10

Detail section through roof

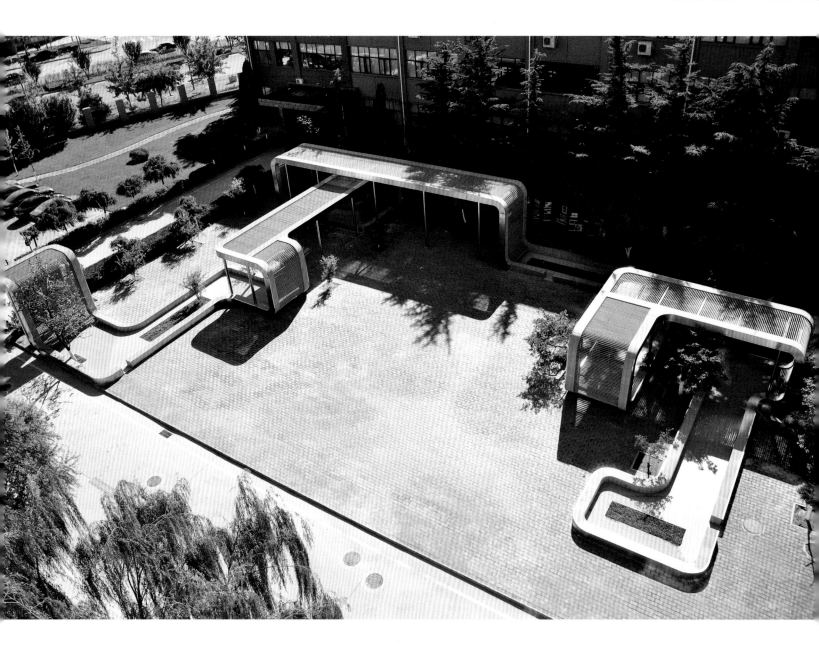

The central square was originally occupied by a monumental sculpture with a huge pedestal. However the obvious problem of the square is actually a severe lack of effective public space that would allow students to gather and communicate. What the school really needs is not a monument in the center of the campus, but a humanistic and functional gathering space for students and an event space for school activities.

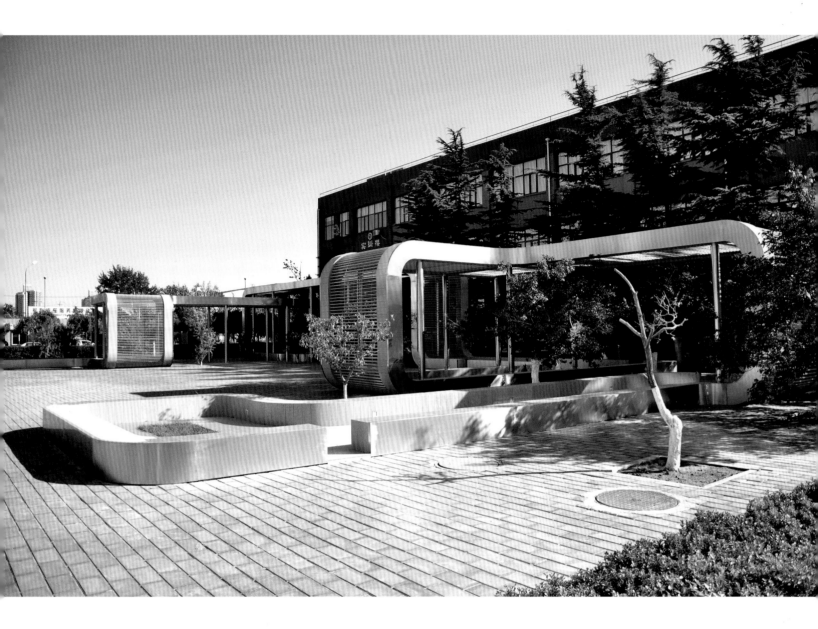

Therefore, with the intention to create an efficient public space, we proposed a continuous self-folding belt structure that resembles the image of a "roller coaster". The structure can be perceived as a ribbon that folds and bends three-dimensionally to create a series of spaces such as open gardens, shaded pavilions and exhibition corridors. As the roof beams of the pavilion bend downwards and become wall screens and benches, the structure expresses a formal continuity well combined with different functions. The pavilion snakes around the existing trees on the site so they are well-preserved and maximally utilized for shading.

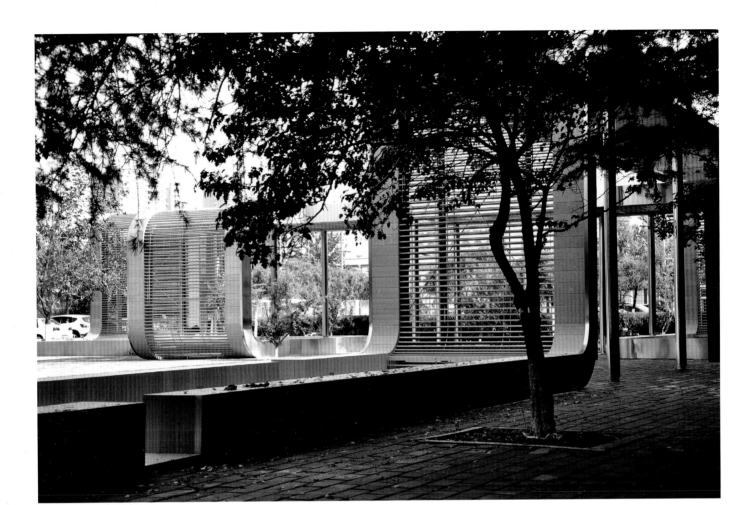

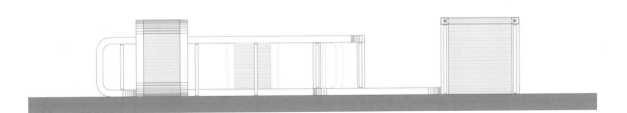

Section A—A

1:150

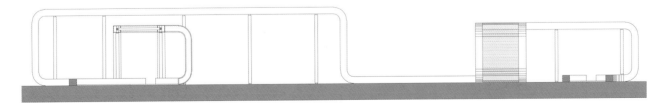

Section 1—1

1:150

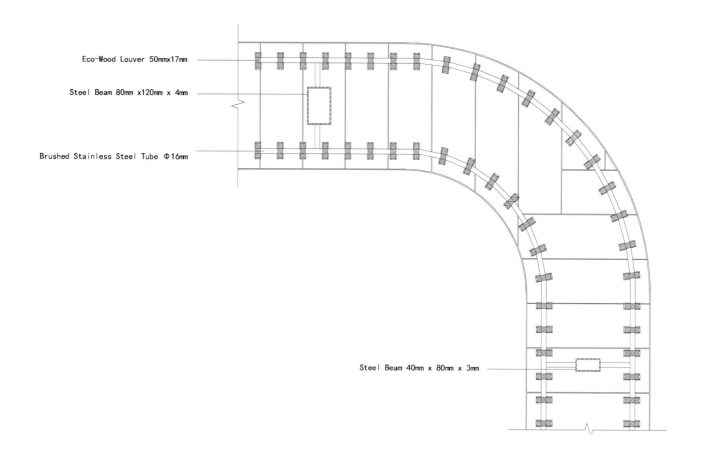

Eco-Wood Louver 50mmx17mm

Steel Beam 80mm x120mm x 4mm

Brushed Stainless Steel Tube Φ16mm

Steel Beam 40mm x 80mm x 3mm

1:10

Detail section through louver

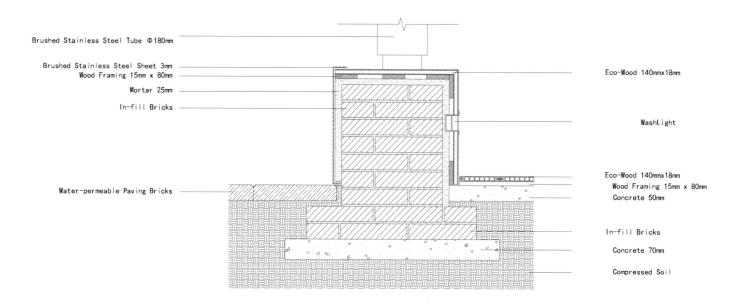

Brushed Stainless Steel Tube Φ180mm

Brushed Stainless Steel Sheet 3mm
Wood Framing 15mm x 80mm

Mortar 25mm

In-fill Bricks

Water-permeable Paving Bricks

Eco-Wood 140mmx18mm

WashLight

Eco-Wood 140mmx18mm
Wood Framing 15mm x 80mm
Concrete 50mm

In-fill Bricks

Concrete 70mm

Compressed Soil

1:10

Detail section through bench

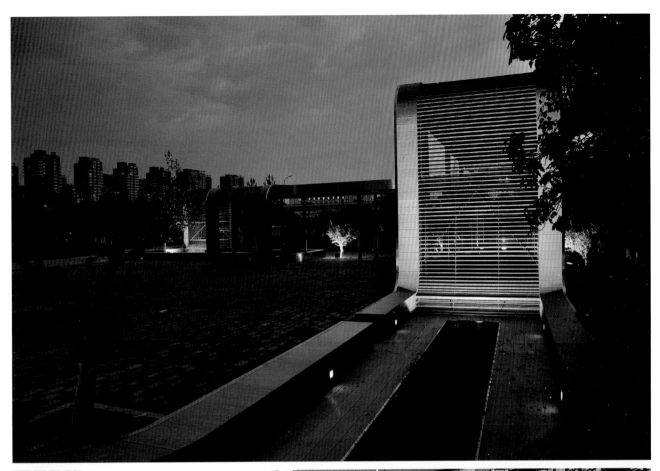

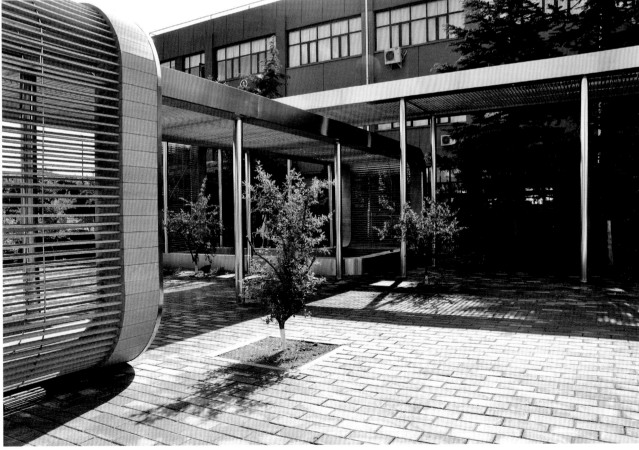

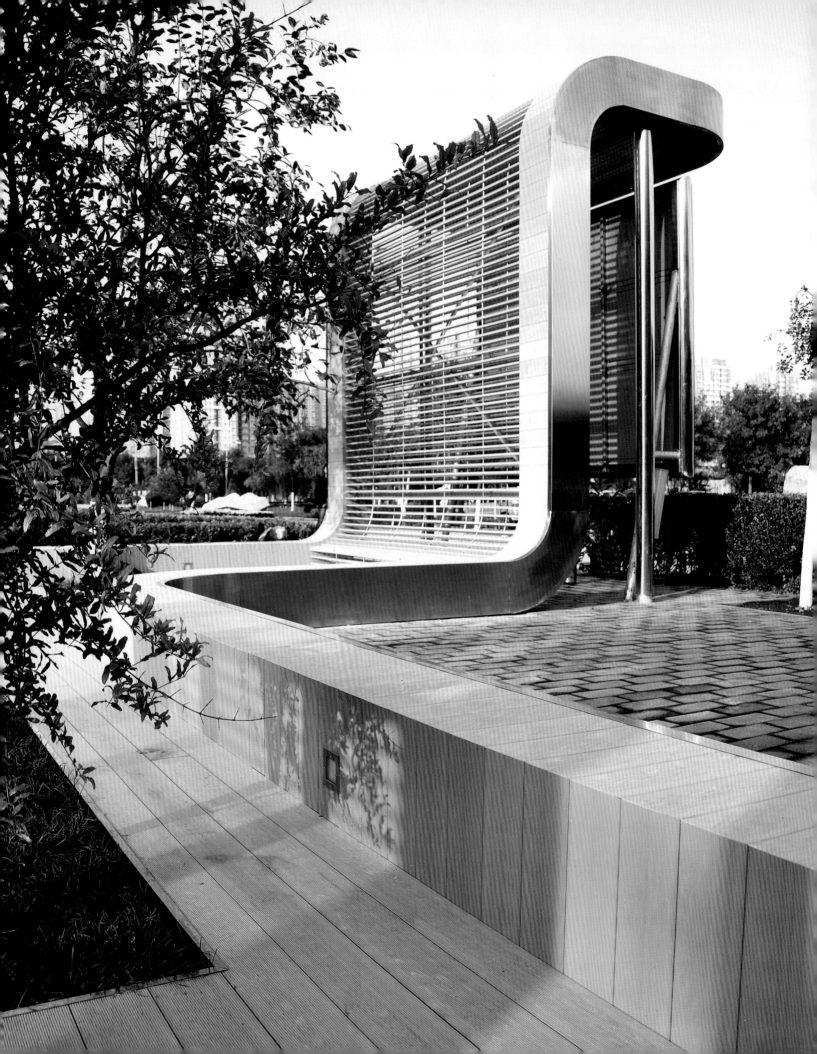

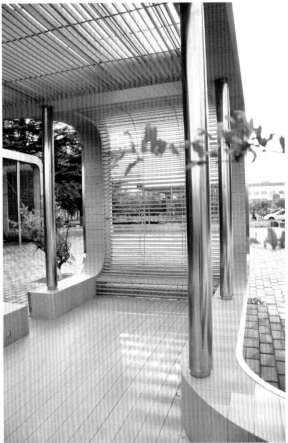

In terms of material, the pavilion is supported by a series of steel columns with stainless steel cladding. The blurry and distorted reflections on round stainless steel surface make the columns look skinnier and taller, which make the pavilion appears more spacious. Roof beams are made of steel space frame and eco-wood was used for exterior cladding. Wall and roof screens are made of eco-wood louvers which have a translucent effect when evenly spaced out. The pavilion looks lighter, more transparent and has a lantern effect when viewed at night.

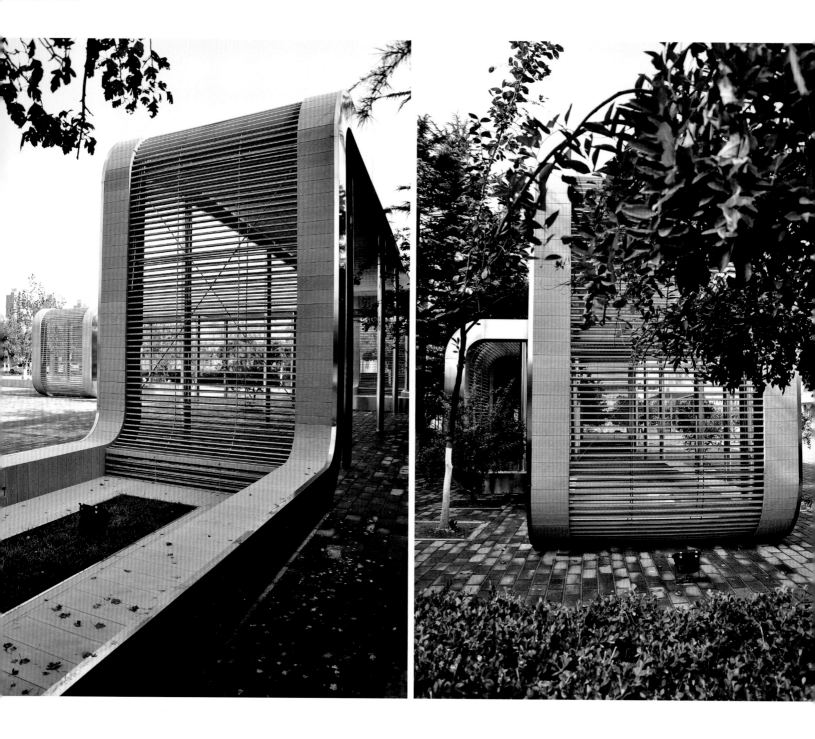

The rollercoaster-like pavilion presents a highly recognizable identity to the school as well as a fun image that was widely welcomed by the students.

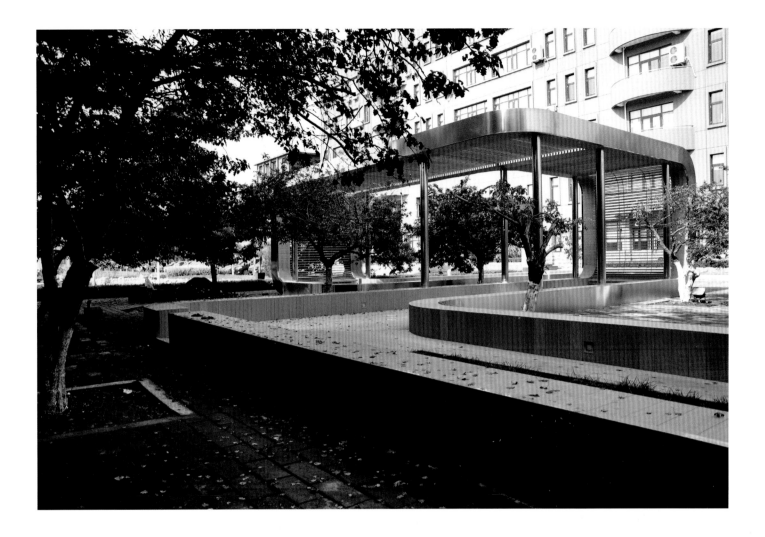

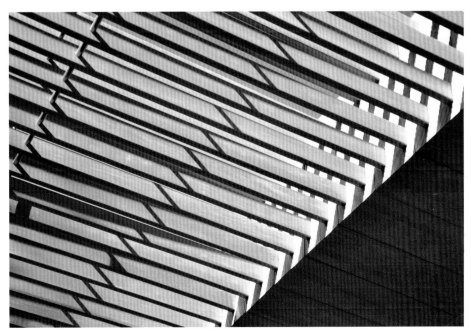

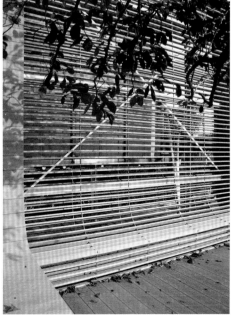

Hanging Bench Project

Design Architects: *Studio Consilio*

Project Size: *21 m in Length*

Materials: *Redwood donated by Big Creek Lumber, Steel L-beams, Solar Lights*

Location: *California Polytechnic State University, Architecture Building, San Luis Obispo, California, USA*

Photographer: *Kristen Fowler, Anna Bultema, Jessie Blote, Angelika Weissheim, Milena Charlemagne, Josef Kasperovich*

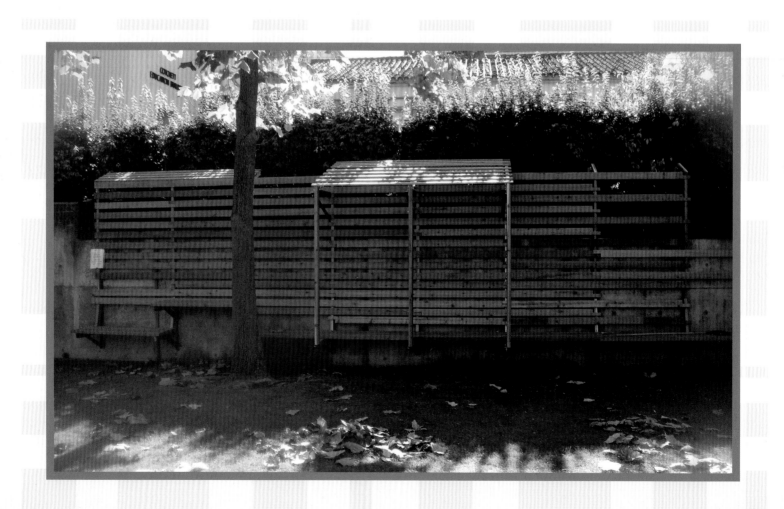

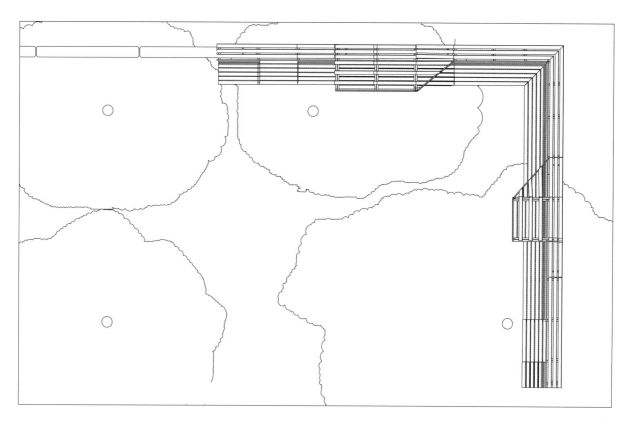

Site Plan

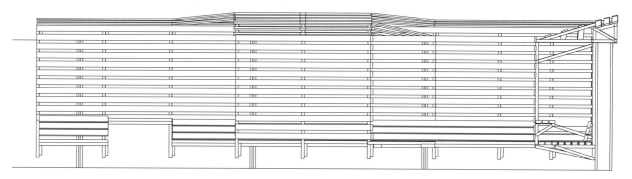

Section Drawing 1

Sitting serenely in the Architecture Building at California Polytechnic State University, is a small courtyard space that adds a beautiful green space to the otherwise concrete architectural fortress. However, due to the lack of benches in this area, it was sorely underused and ignored. In the efforts to revitalize this space, one ambitious professor with his students decided to reinvigorate this courtyard with a hanging bench system.

257

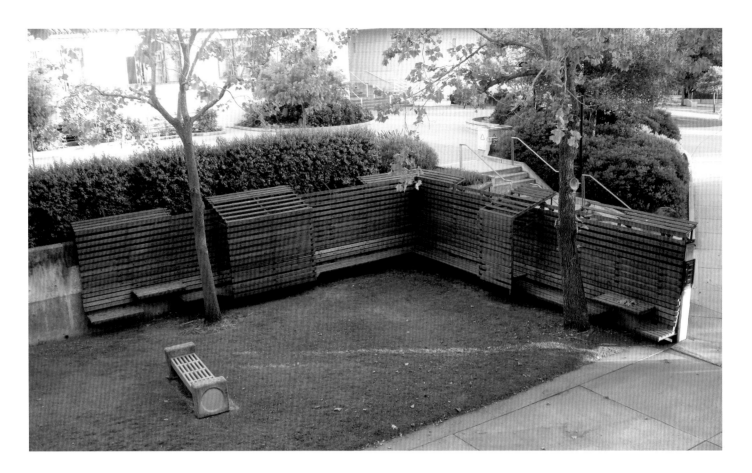

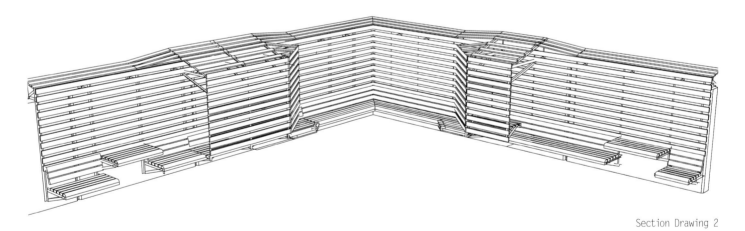

Section Drawing 2

Since so many people were involved in the design process, there were rounds of individual and group charrettes, resulting in the formation of a main design team concurrently working with a bracket design team. The rest of the students were involved in the construction and creation process.

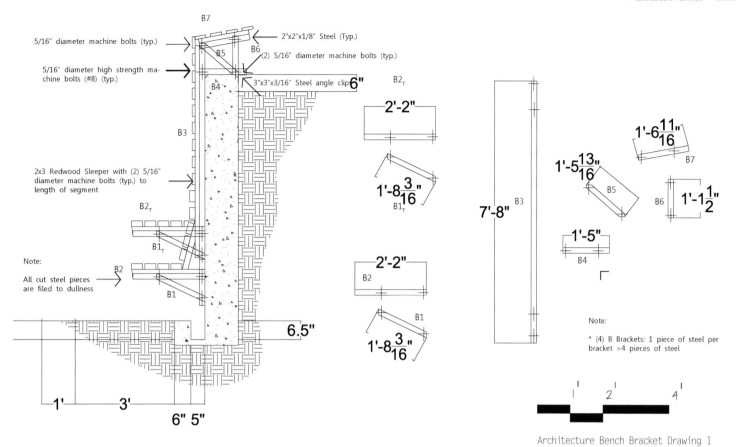

Architecture Bench Bracket Drawing 1

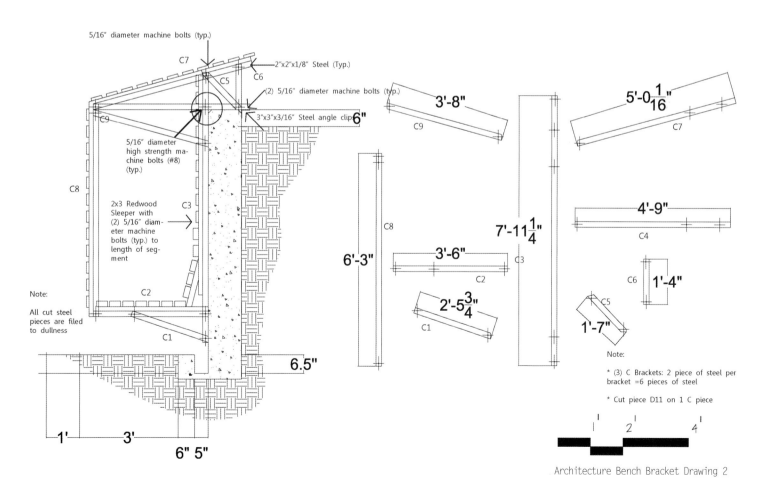

Architecture Bench Bracket Drawing 2

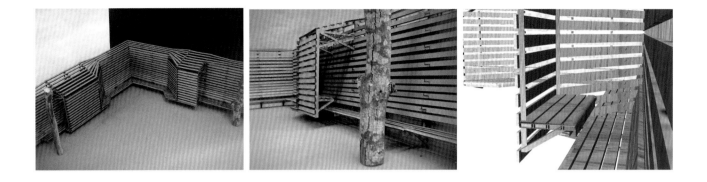

This system is completely freestanding with no permanent attachments to the concrete wall of the courtyard. It is held in place by tension and compression in the unique bracket design. The design of the bench itself consists of seating, tables, and coves. There are two coves, one for sleeping or lounging, and one that contains a table for studying or working. As well, the coves contain solar lights so that they can be utilized during the evening hours as well.

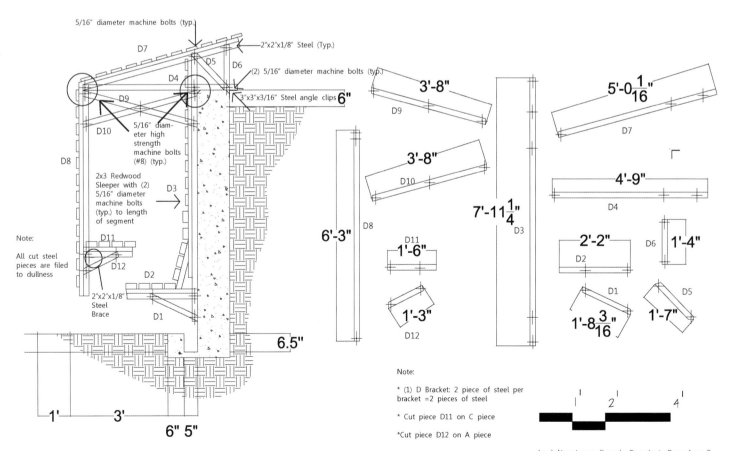

Architecture Bench Bracket Drawing 3

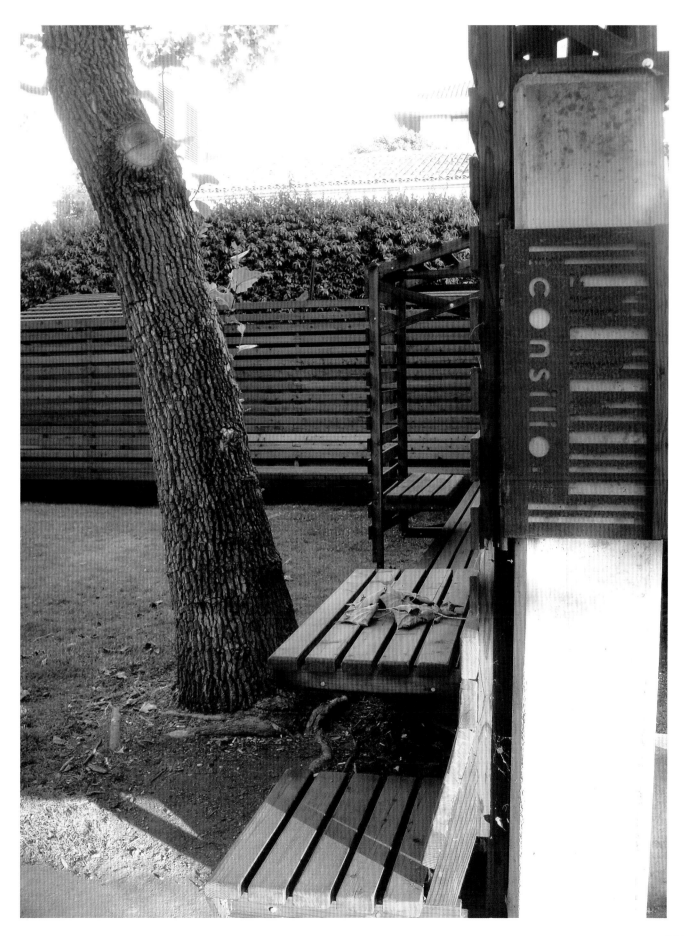

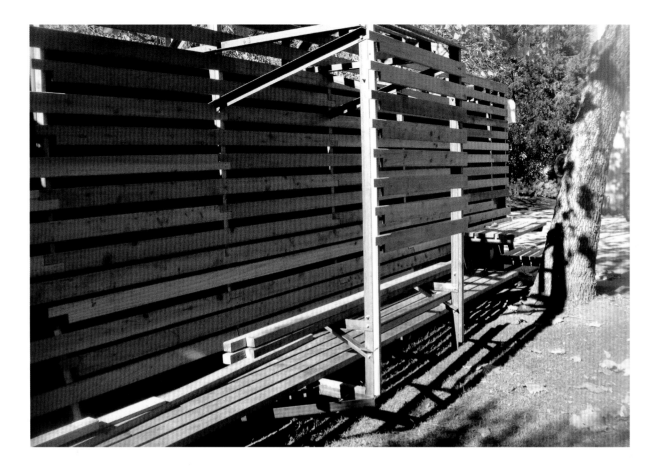

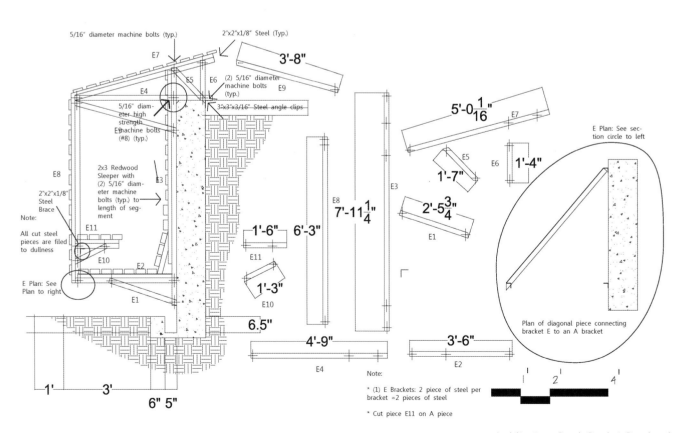

5/16" diameter machine bolts (typ.)

2"x2"x1/8" Steel (Typ.)

E7

E5

E6

(2) 5/16" diameter
machine bolts
(typ.)

E4

3'-8"

E9

5/16" diam-
eter high
strength
machine bolts
(#8) (typ.)

E9

3"x3"x3/16" Steel angle clips

5'-0 1/16"

E7

E8

2x3 Redwood
Sleeper with
(2) 5/16" diameter
machine bolts (typ.) to
length of seg-
ment

E3

E5

E6

1'-4"

E Plan: See sec-
tion circle to left

2"x2"x1/8"
Steel
Brace

1'-7"

Note:

E8

7'-11 1/4"

E3

2'-5 3/4"

All cut steel
pieces are filed
to dullness

E11

E1

1'-6"

6'-3"

E Plan: See
Plan to right

E10

E11

E2

E1

1'-3"

E10

6.5"

4'-9"

3'-6"

Plan of diagonal piece connecting
bracket E to an A bracket

E4

E2

1' 3'

Note:

1 2 4

6" 5"

* (1) E Brackets: 2 piece of steel per
bracket =2 pieces of steel

* Cut piece E11 on A piece

Architecture Bench Bracket Drawing 4

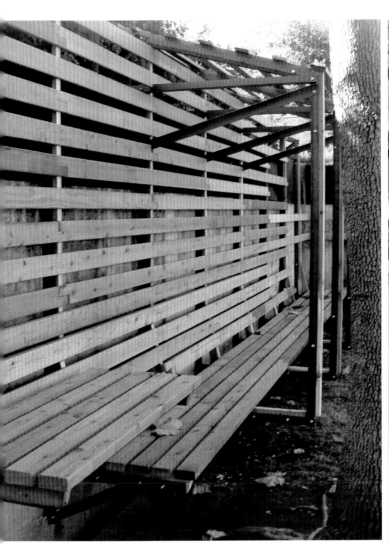
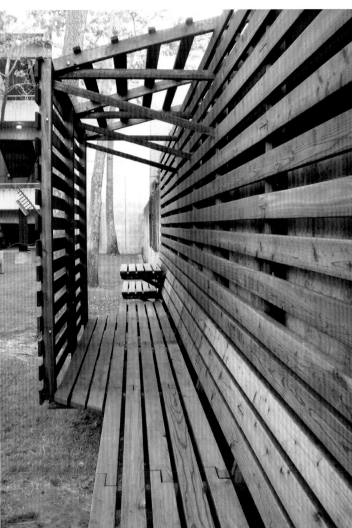

In order to maintain a sustainable ideal, Professor Reich was able to get a donation of lumber harvested in a sustainable manner from Big Creek Lumber in California. This allowed the project to continue in an environmentally and fiscally responsible manner. The brackets were made from steel L-beams designed to be cut and assembled into specific forms to fit the wall and designed areas appropriately. All components, brackets, and systems were made and assembled by the students involved in this project. It was a completely hands-on, design-build project.

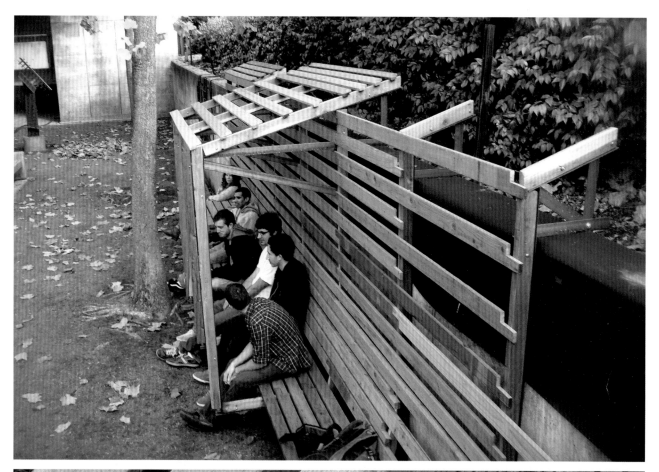

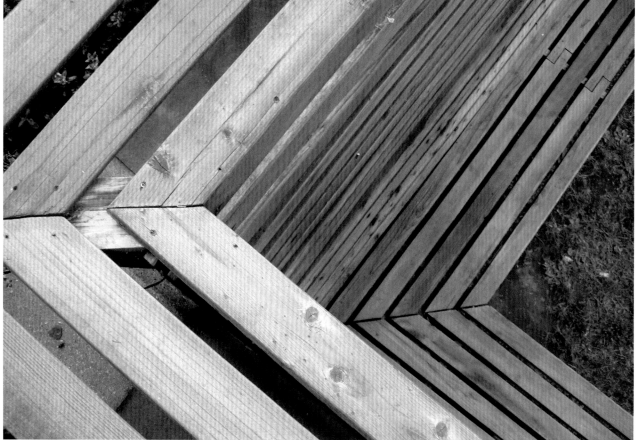

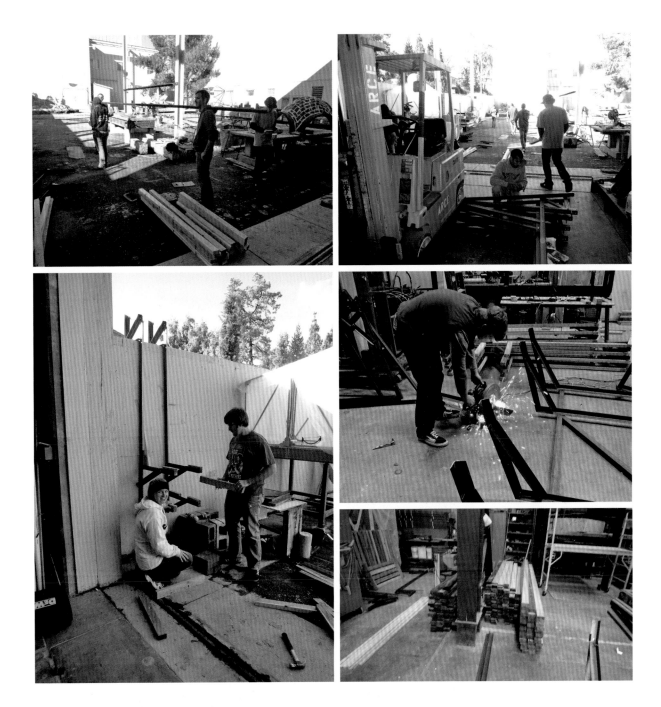

This bench and cove system was awarded the 2012 California Innovation in Wood Design Award.

Eusebiush of Arnhem

Design Team: *Strootman Landscape Architects*

Project Area: *1,570 m² + 670 m²*

Location: *Arnhem, the Netherlands*

Longitudinal-section Entrance courtyard

Seating Element Sections

Two courtyards for the city's council chambers

The Eusebiushof is an extension of the existing complex for the city's council chambers situated on the prestigious Eusebius singel in Arnhem. The complex includes three internal courtyards on top of an underground car park, each with distinctly different functions but related in form and detail. Strootman designed the layout of the entrance courtyard (Voorhof) and the central courtyard (Binnenhof). The design pays ample attention to the view of the gardens from above since that is where they are often viewed from. The organic forms of river stones are the inspiration for the design of paving and furniture. The dynamics of the pebble floor of a river has also been used in the informal paving pattern. The use of durable materials in organic forms gives the spaces a landscape feel while still being robust. The space between the concrete pebbles will be filled with grayish green crushed natural stone, creating an appealing contrast in texture.

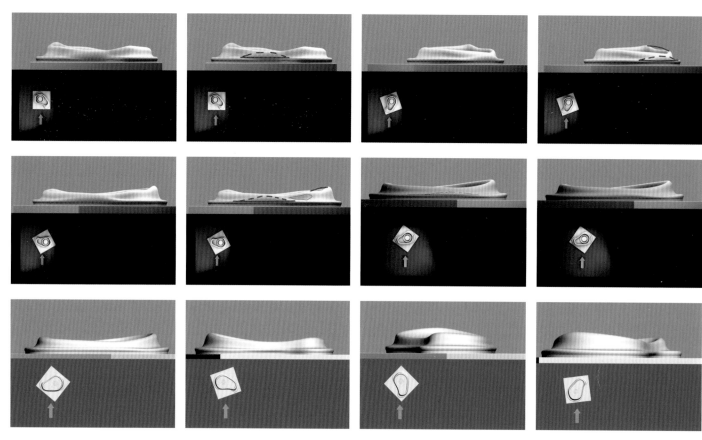

Seating Element Design

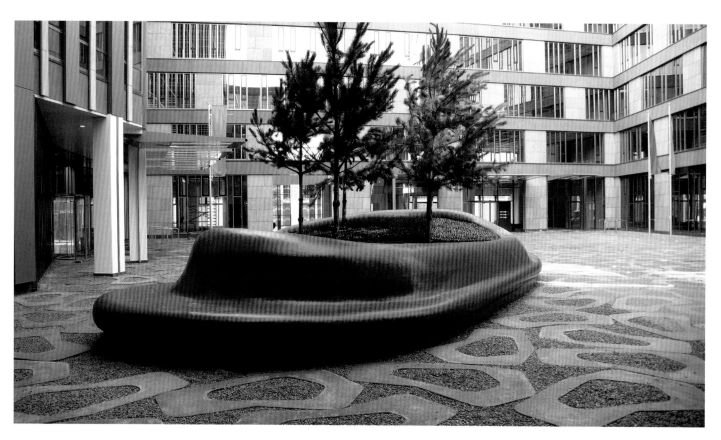

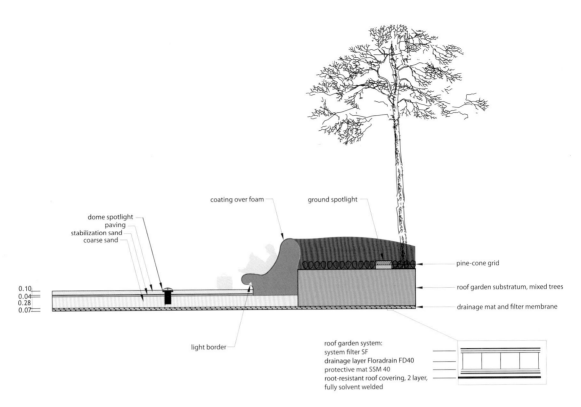

dome spotlight
paving
stabilization sand
coarse sand

coating over foam ground spotlight

pine-cone grid

roof garden substratum, mixed trees

drainage mat and filter membrane

0.10
0.04
0.28
0.07

light border

roof garden system:
system filter SF
drainage layer Floradrain FD40
protective mat SSM 40
root-resistant roof covering, 2 layer,
fully solvent welded

Cross—section of seating element and underlying layer

The entrance courtyard is both a thoroughfare and a seating area. This is the most formal of the spaces and resembles a hotel lobby. It is designed for a short stay and exudes representatives. The space can be accessed from the street through an entrance lined by a grilled gate. The space features a raised seating element shaped similarly to the design of the concrete pebbles. Five tall Scottish pines fill the space. Soft grey tones create a quiet background for the very bright Chinese red seating element, similar to the way a red bridge is highlighted in a Chinese garden.

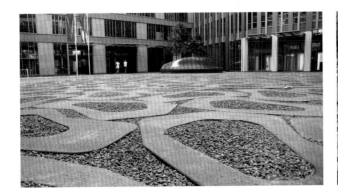

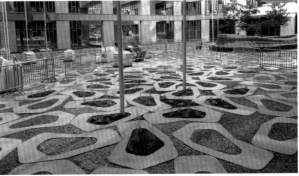

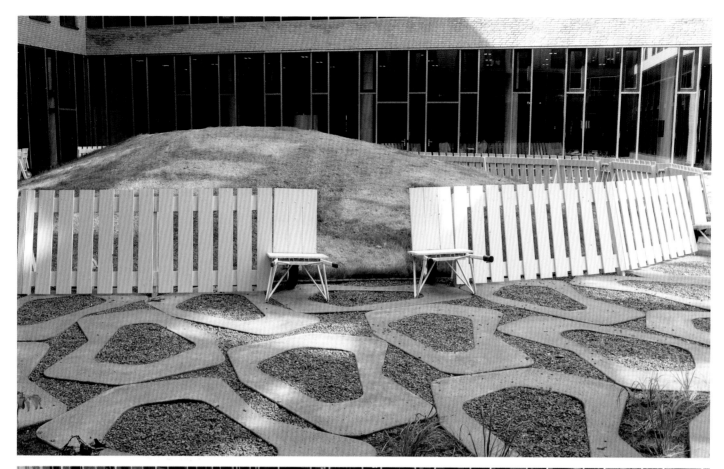

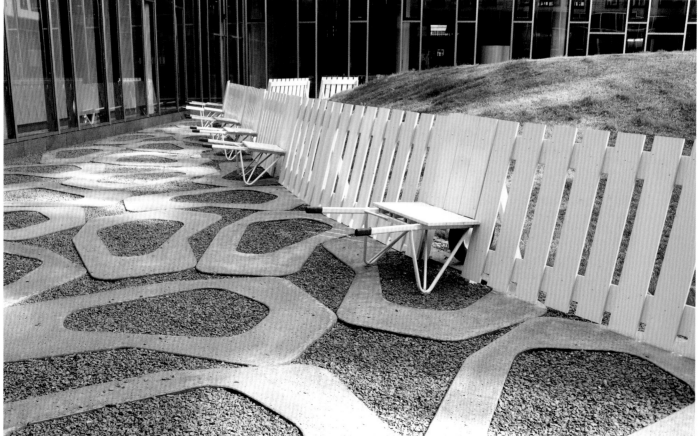

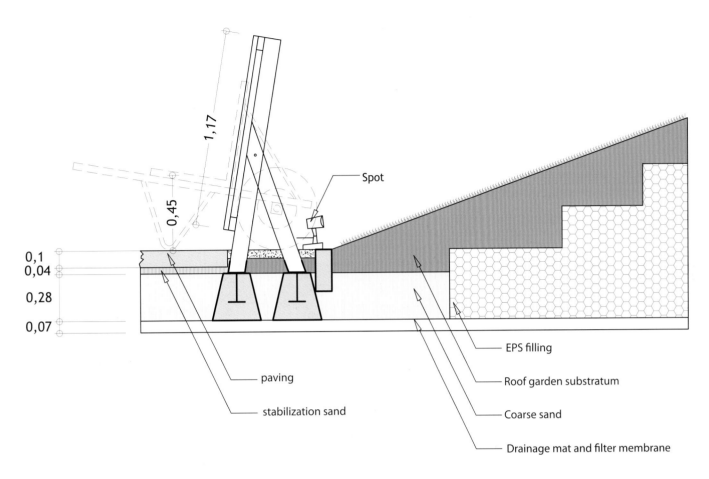

1,17

0,45

Spot

0,1
0,04

0,28

0,07

paving

stabilization sand

EPS filling

Roof garden substratum

Coarse sand

Drainage mat and filter membrane

Cross—section of the grass mound and the wooden frame

The central courtyard is softer and greener. This courtyard is primarily a visual amenity but will be used occasionally by workers and visitors. It is the heart of the complex, and a large green hill visible from the entry hall will draw visitors' attention. The hill is a stylized abstraction of a hillock and is designed to give the space a sense of largeness and otherness. It is maintained as a clipped lawn by mower robots in the shape of enlarged ladybirds and edged by a white wooden picket fence. The picket fence around the hill houses movable seating elements which can be wheeled and placed freely around the space. The seats are based on the design of wheelbarrows used to carry stone. The courtyard will also be paved with pebbles and crushed stone. The crushed stone will be omitted in some places, where ferns and hellebores will be planted, which will reinforce the courtyard's green character.

Landscape Installation Art II—Novel & Practical Public Facility
edited by Ifengspace

Originally published by
Tianjin Ifengspace Media Co., Ltd
R. 304, No. 240 Baidi Road,
Nankai District, Tianjin
P.R. China,
Postcode: 300192
Tel: +86 22 60262226 / 2227 / 2228-8038
Fax: +86 22 60266199

First English edition published and distributed in the world
excluding Chinese Mainland by
Basheer Graphic Books
#06-08, Braddell Tech
13, Lorong 8 Toa Payoh
319261, Singapore
Tel: +65 6336 0810
Fax: +65 6259 1608
Email: enquiry@basheergraphic.com

ISBN: 978-981-09-3369-2
Printed in China
First Print: Jan 2015